921 Polsky, Richard
Polsky, Richard.
I bought Andy Warhol
 $24.95

I BOUGHT ANDY WARHOL

I BOUGHT ANDY WARHOL

Richard Polsky

HARRY N. ABRAMS, INC., PUBLISHERS

EDITOR: Deborah Aaronson

DESIGN AND TYPESETTING: Arlene Lee

JACKET DESIGN AND TYPE GRAPHICS: Beth Middleworth

PRODUCTION MANAGER: Stanley Redfern

Library of Congress Cataloging-in-Publication Data

Polsky, Richard.
 I bought Andy Warhol / Richard Polsky.
 p. cm.
Includes bibliographical references and index.
 ISBN 0-8109-4271-2
 1. Polsky, Richard. 2. Art dealers—United States—Biography.
3. Art—Collectors and collecting—United States. 4. Warhol, Andy, 1928–
I. Title.

N8660.P65 A3 2003
709'.2—dc21

2002151482

Printed and bound in the U.S.A.
10 9 8 7 6 5 4 3 2 1

ABRAMS Harry N. Abrams, Inc.
 100 Fifth Avenue
 New York, N.Y. 10011
 www.abramsbooks.com

Abrams is a subsidiary of
LA MARTINIÈRE
G R O U P E

For Rachael

"Sometimes I lie, but this time I'm telling the truth."

—AN ANONYMOUS PRIVATE DEALER

CONTENTS

INTRODUCTION

IN 1987 I SET ASIDE $100,000—a considerable sum for me—to buy a painting by Andy Warhol. I needed to feel I had something to show for my efforts as an art dealer. So many paintings of such great worth had passed through my hands, and yet none of them actually belonged to me. I wanted something of my own, something that would speak to me, and of me, for years to come.

Although there were many artists whose work I greatly admired—I was a tremendous Ed Ruscha fan and worshipped Joseph Cornell's boxes—it was Warhol's I coveted. I was thrilled at the idea of living with a painting by the most important artist of the second half of the twentieth century. And, like virtually everyone else in the art world, I was mesmerized by Warhol himself and the life he led. Somehow, I imagined owning a Warhol would confer on me all the trappings of that life. I would join the elite group of people who recognized his brilliance and owned a small but glamorous part of it.

I was also convinced that Warhol's work was a smart investment. Anything I spent $100,000 on for myself would become a significant asset. Naturally, I wanted to make sure that I was buying an asset with plenty of upside. Years of market research had convinced me that the artists whose work appreciated the most were the innovators, the ones who would shape the market for years to come. Clearly, Warhol defined that category.

Warhol himself was keenly aware of the importance of money. When he was alive he used to bemoan the fact that his prices consistently lagged behind those of his peers. Roy Lichtenstein, Robert Rauschenberg, and Jasper Johns continually bested him at auction—the ultimate arbiter of market prowess. A quick perusal of *The Andy Warhol Diaries* reveals his thoughts on an auction that took place during the early 1980s: "Thomas (Ammann) bought a *Flower* painting for $40,000. It's worth a lot more, though. Someday...."

Well, "someday" finally arrived on May 14, 1998, at Sotheby's when his magnificent 40-by-40-inch painting of Marilyn Monroe, *Orange Marilyn* (1964), appeared on the auction block. Marilyn was beauty personified. Warhol portrayed her as a goddess with lemon-yellow hair, a pink face, ruby-red lips, blue-violet eye shadow, and shiny white teeth. She positively glowed against a background of deep, radiant orange. The auction catalogue gave the painting a presale estimate of $4–6 million, which felt like a tease—I sensed it had the potential to go much higher.

I knew the history of the painting well. *Orange Marilyn*'s first owner had been the legendary eccentric Leon Kraushar. He bought it in 1964 from the Leo Castelli Gallery for $1,800—not an outrageous amount, but real money during the early 1960s. About two years later, the July 1965 issue of *Life* magazine featured a color spread of Kraushar and two other major Pop collectors, publisher Harry N. Abrams and the taxi fleet moguls Robert and Ethel Scull. The article was sarcastically titled, "You Bought It Now Live With It." Both the Sculls and Abrams came off as regular people who just so happened to have a crush on the new art. But Kraushar portrayed himself as a man on a holy crusade. During his interview with a *Life* reporter, he was positively incandescent as he shouted, "These pictures are like IBM stock...and this is the time to buy!"

Readers of *Life* must have thought Kraushar was out of his mind. Warhol's canvases as valuable as shares of IBM? Preposterous! There was serious doubt whether Pop art itself would even survive, let alone hold up in value. Most thought the work was vulgar. The Abstract Expressionists of the previous generation, who painted with dripping brushstrokes laden with emotion, thought that the cool, detached new

art was blasphemous. At a gallery opening, one of the leaders of the Abstract Expressionists, Mark Rothko, refused to stand in the same room with any of the Pop artists.

Unfortunately, Kraushar didn't live long enough to see his prediction come true. Upon his death, in 1967, *Orange Marilyn* was sold to the German collector Karl Ströher for approximately $25,000. Certainly a nice jump in value, but nowhere near what was yet to come. Although Ströher himself passed away in 1988, the painting remained in his family for another ten years. In 1998, an heir of Ströher was convinced the time was right to put *Orange Marilyn* up to auction. The family consigned the Warhol to Sotheby's, which used all of its marketing muscle to promote the work—not as a painting, but as an icon. They even went as far as to throw a formal dinner party to display the painting for prospective buyers, with the orange invitation reading: "Guess Who's Coming to Dinner?"

I was there the night of the sale and couldn't recall ever feeling such an electric atmosphere in an auction room. A few dealers made bets on what the painting would bring. Those collectors who held a major Warhol were praying for a big price, while those still in the market to buy were hoping the modest estimate would prove accurate. Thanks, in part, to a booming economy and a reviving art market, *Orange Marilyn* was sold to publisher Si Newhouse for a whopping $17.3 million—per square inch the highest price ever paid for a work of Contemporary art. Had Andy Warhol lived to witness this event he would have heartily approved. He always knew his work was undervalued.

So did I.

Besides telling the story of my search for the ultimate Warhol, this book is also about doing business in the art world. Contrary to popular belief, art dealers do not observe life through limousine windows. There is surprisingly little jetting off on the Concorde to buy inventory in Europe. Nor does one wine and dine clients at Daniel in New York on a nightly basis. Instead, life as an art dealer is to a fair degree concerned with such mundane things as tracking down paintings lost in transit, securing proper insurance coverage, and filling out sales tax collection forms. You quickly learn that there's more to dealing pictures than just having a good time.

It may come as a mild shock, but anyone can become an art dealer—there's no test to pass and no such thing as certification. And because of that, everyone makes up the rules as they go along. Since most people become art dealers because they can afford to—the vast majority come to the table with plenty of operating capital—no one has to behave. As a result, concerns over connoisseurship, educating collectors, and developing worthwhile exhibition programs often take a back seat to focusing on that night's entertainment plans and gossip.

Perhaps that doesn't speak well of my profession. Quite the contrary. At the end of the day, virtually everyone in the art world admits to a passion for art and artists. Certainly I do. Perhaps my greatest pleasure has been derived from viewing works of art themselves. Taking in the magnificent Brancusi sculpture retrospective at the Philadelphia Museum of Art was an experience that I still relish. Walking through Walter de Maria's mind-boggling *Lightning Field* in New Mexico continues to feed my imagination. Seeing Salvador Dalí's jewel-like *Persistence of Memory* at the Museum of Modern Art has always recharged my batteries. In short, while the art business is full of potholes, it also offers its pleasures, and a lot of laughs.

When this book was first conceived, I received a number of comments that said in effect: "You're not Leo Castelli [the greatest dealer of my generation]—who are you to be telling your story about life as an art dealer?" My answer has always been: "You're correct—Castelli was unique." However, once you get beyond him, no one—except perhaps Ivan Karp—measures up. As a veteran dealer who's been buying and selling pictures since 1978, I've operated behind-the-scenes and have always taken notes on what I've witnessed. I don't have all of the answers, but I'm willing to go on the record.

What you are about to read—the absurd conversations, bad manners, and ridiculous antics—are accurate portrayals of how much of the art world conducts itself. Interacting with a quirky accountant is as much a part of being an art dealer as attending an auction. Worrying about which hotel you're staying at, and how it affects people's perception of you, is as integral to being a dealer as being able to identify a great painting when you see it.

The characters who appear in this story, such as Jim Corcoran, Jonathan Novak, and Chuck Arnoldi, are not household names. Yet, they are all successful and representative of the colorful personalities who inhabit the art world. It doesn't matter that they have yet to be featured in *Vanity Fair*. They deserve the fifteen minutes of fame Warhol promised all of us.

VINCENT FREMONT

HAVE YOU EVER WALKED INTO AN AUTO showroom and been assaulted by their sales force hell-bent on selling you a new car? If you have, you probably recall how these desperate individuals couldn't do enough for you. Want the car yesterday? No problem. Would you like some floor mats thrown in at no charge? They're yours. Care for tinted glass? You've got it. Whether you are a repeat customer or a first-time buyer, the salesman does whatever it takes to close a deal. Perhaps that's why it irked me one day that the Andy Warhol estate's exclusive sales agent, Vincent Fremont, couldn't be bothered to return my calls—despite my having purchased hundreds of thousands of dollars of Warhols from him over the years.

It was April 2002 and, fortunately, I was no longer preoccupied with my twelve-year-long quest to buy a Warhol for my own collection. All I was trying to do was buy a painting of a lobster for inventory. As an art dealer, I had dedicated the last fifteen years of my life to learning the intricacies of the Warhol market. Not long before, that hard-won knowledge had allowed me to buy the Warhol of my dreams. But life goes on and now I was preoccupied with the necessity of making a living. If I could convince Fremont to sell me the lobster, I had a ready buyer waiting in the wings.

At this point, Warhol had been dead for fifteen years. When he died in 1987, he left behind approximately 4,100 paintings and sculptures.

Fremont was given the lucrative task of selling them in order to fund the newly formed Andy Warhol Foundation for the Visual Arts. The board of directors had agreed to pay him a 10 percent commisson on everything that he sold (reduced to 6 percent many years later), which made him a millionaire. As Warhol's work appreciated dramatically in value, Fremont became increasingly selective as to whom he chose to sell paintings to. If I wasn't willing to bow down to him in order to buy the lobster, there were a couple of dozen people in line behind me who would be only too happy to do so.

Vincent Fremont was a character in his own right. Back in 1969, at the age of nineteen, he had left his native San Diego and showed up on the doorstep of the Factory, Warhol's silver foil–covered studio in New York City. Somehow, he charmed Warhol into hiring him to sweep the floors, paint the walls, and perform various other basic functions. Fremont impressed his boss with his seriousness and reliability. His maturity stood out in stark contrast to the studio's menagerie of flakes. As time went on, he won Warhol's trust and was given the responsibility of opening and locking up the Factory each day.

Eventually, his position evolved into developing television projects, including MTV's *Andy Warhol's Fifteen Minutes*. Upon Warhol's death, Fremont was appointed to sit on the Foundation's board of directors. Once it became apparent that they needed someone with integrity to disperse the art work, he became the logical choice. To avoid a conflict of interest, he was asked to resign his seat on the board, but was rewarded with a contract to handle all sales.

Fremont summed up his mandate by saying, "My job was to raise money so the Foundation could give it away." As he plunged into his new position, he must have been overwhelmed by the enormity of the task. The first order of business was to determine which paintings should be designated for placement in the new Andy Warhol Museum in Pittsburgh, Andy's hometown. Roughly a third of the estate's paintings were donated to the institution. Included in this group were many of the most important and valuable remaining canvases.

Once the museum was squared away, Fremont opened up an eighteen-month window to other American museums, allowing them to buy Warhol paintings at 50 percent of "book" value. Many of the

nation's institutions eagerly took advantage of this extraordinary offer. To Fremont's credit, he tried to do the right thing by distributing the work in a way that benefited Warhol's reputation most. For instance, both the San Francisco Museum of Modern Art and the Museum of Modern Art in New York had put dibs on *National Velvet*. This oversized silver masterpiece featured a young Elizabeth Taylor on horseback, repeated forty-two times. It was the only painting that Warhol had done of this particular image. Its appraised value was approximately $700,000, which meant the winning candidate would pay only $350,000 for it. Fremont and the board elected to sell the painting to San Francisco's museum. Their thinking was that there were already many more important Warhols in New York than in San Francisco.

After the museums had made their selections, Fremont moved on to lining up shows with Warhol's longtime dealers. He based his decisions on loyalty—Warhol patrons who were early supporters were given first crack at the remaining paintings. Those dealers wanting to exhibit an entire series of work had to commit to buying the majority of them. What's more, they were also expected to promote the work by producing a scholarly catalogue along with an extensive advertising campaign for the show.

In this way, bodies of work that were largely unknown to the public received exposure. New York's Gagosian Gallery bought and exhibited the *Shadows, Rorschachs, Camouflages, Diamond Dust Shoes*, and *Ladies and Gentlemen* (a series of paintings of transvestites). Thanks to Fremont's adroit handling, Warhol's memory was further honored and the awareness of his oeuvre was expanded. As fresh bodies of work were exhibited, especially from the underexposed 1980s, the art world began to grasp the depth of his achievement.

Fremont was also open to selling works out of the warehouse, which explains why I was waiting by the phone just as April was coming to an end. I fought off pangs of exasperation and summoned the courage to call him one last time. Right before placing the call, I looked at the image of the lobster that one of his assistants had e-mailed me. Just getting that JPEG had been an ordeal that had taken almost two weeks of back-and-forth phone calls. Toward the end of his career, Warhol had

done perhaps a dozen paintings of lobsters. Each one measured 20 by 16 inches. Typical of Warhol, he had painted them in different color combinations. The one I was vying for featured a black lobster, claws outstretched, on a kelly green background, with silkscreened overlays of pink and white lines that defined the lobster. While this wasn't a significant painting, it was quite decorative.

The last Warhol lobster to sell at auction came up at Sotheby's in 1998. It carried an estimate of $35,000–$45,000 and sold for an impressive $57,500. But that was four years ago and now the market for Warhol was even stronger. The good news was that Fremont would sell me the painting for only $26,000. This sizable discount was intentional. The idea was to encourage legitimate collectors and museums to buy paintings by keeping their prices artificially low. These buyers effectively removed work from the market, which increased the scarcity and value of Warhols.

Even though I was primarily a private dealer and so couldn't be counted on to hold onto the painting personally for very long, Fremont dealt with me because I had previously written a number of articles that said very positive things about the Warhol market. Our relationship had progressed nicely over the years. I can vividly remember a wild martini-filled evening when we bonded. But recently our friendship had taken a hit.

Here's what happened. The previous year, I had acquired two Warhol paintings of sea turtles from the estate. Each was relatively large (42 by 50 inches) and very colorful. When asked what I intended to do with the paintings, I hinted around that I would try to keep at least one of them. Nodding his approval, Fremont sold the canvases to me for $55,000 each. Not long after buying them, I came under intense financial pressure and was forced to sell them. Not that it was Fremont's concern, but I was a dealer who had to play things close to the edge. Unlike most dealers, I had no family backing or spousal money behind me. Nor did I make my fortune in another field—which is typical of many businessmen-turned-art dealers. My margin for error was almost nonexistent. My selling the paintings would have been fine with the estate, as long as I placed them with a collector. But when I found no takers, I was forced to approach a fellow dealer. He bought the paintings and I made a

substantial profit. But then he turned around and consigned the sea turtles to Christie's. It was a purely speculative play—exactly what the estate sought to discourage.

I knew that Fremont would consider this to be a grave violation of our unspoken agreement that the paintings would not end up at auction. In his mind, this was the equivalent of the United States testing a nuclear device after signing a treaty with Russia not to. Once I saw the day and evening auction catalogues that contained the aquatic reptiles, I immediately got on the phone to alert him.

"Hi. I know this isn't going to thrill you, but those turtles that you just sold me are coming up next month at Christie's."

"Both of them?" said Fremont, with a hint of anger in his voice.

"I apologize. I sold them to a dealer and didn't expect him to flip them at auction," I said, none too convincingly.

"Both of them?" repeated Fremont.

Swallowing before speaking, I said, "Yeah, both of them. One's coming up in the evening sale, the other one's in the day sale."

"What are the estimates?"

"They have both turtles at $150,000–$200,000."

"So, what did you sell them for?"

"A lot less than that," I said, trying to play it cool.

There was a pregnant pause.

"Not good," was all Fremont could muster.

As I hung up, my first thoughts were that he might cut me off from buying paintings in the future. I wasn't too worried though, because I knew there was little work of quality left in the estate. Still, I felt badly because I had let Fremont down. I felt doubly guilty because of the role he had played in my quest to find the right Warhol for myself—a role I never would have anticipated.

Given what had happened, it felt like a minor miracle that Fremont was now even considering selling me another painting. Apparently, enough time had passed and he had mellowed out. But that still didn't mean he would make it easy for me to buy the lobster.

Even though I had seen an image of the painting and had been quoted a price, I still needed to see it in person. The Foundation had a policy that nothing could be sent on approval. What this meant was that I had

to schedule a trip to Manhattan (I lived in San Francisco). Sometimes a dealer will commit to buy a painting solely on seeing a transparency, but I always believed that rule number one of art collecting is to see the work in the flesh. There is no substitute.

Going to New York to inspect the painting was not a problem. Getting Fremont to return my calls was. I needed him to give me a firm date for our meeting so that I could book my plane ticket, secure a hotel reservation, and take care of all the other small details that go into planning a trip. Whenever I managed to reach Fremont by circumventing his wife, who dutifully screened his calls, he would insist that he was busy and would get back to me. Naturally, he never did. I tried sending him a fax. I tried sending him e-mails. I even got up at 6:00 A.M. West Coast time to try and catch him at 9:00 A.M. in New York—just as he came in to work. Once, I sent a FedEx letter to his tiny poodle, Matilda, asking her master to get in touch with me. None of these increasingly desperate tactics did the trick.

I decided to go for broke. Late one morning, I drove down to the city's world famous Fisherman's Wharf. I hadn't been there in years and had forgotten how tacky it was. Among the bustling tourists, fishmongers cried out, "Walk-a-way shrimp cocktails!" "Fresh Dungeness Crab—just off the boat—we crack and clean!" "San Francisco's finest sourdough bread!" While all of those descriptions conjured up visions of a tasty meal, the reality was far different. The meager shrimp cocktails with their blobs of tired cocktail sauce weren't so fresh. The sourdough bread had little flavor compared to the heavenly loaves from the Bay Area's Acme Bakery. The crabs were decent, but had the tourists known to shop in one of the city's many neighborhood markets, they could have bought two for the price of one.

I hadn't planned to eat at the Wharf. Unfortunately, it was lunchtime and the tantalizing smell of boiled crabs completely destroyed my willpower. I walked over to the stand that looked the most appetizing and said, "I'd like a crabmeat cocktail."

The tough looking Italian fisherman behind the counter slid a champagne glass over to me that was filled mostly with shredded lettuce and a smattering of crabmeat. I handed him six dollars and said, "How about a little more crab?"

"How about another six dollars?"

Feeling semifortified, I began to comb the wharf's souvenir shops for the object that would allow me to complete my master plan for getting Fremont's attention—a rubber lobster. After striking out at half-a-dozen shops—plenty of crabs, but no lobsters—I hit pay dirt. In a shop crammed with kitsch T-shirts ("I Got Crabs at Fisherman's Wharf") I spotted a pile of red lobsters. Each fake crustacean was only $4.95—perhaps the only bargain at the entire wharf. I immediately bought one and went back to my car.

At the local Mail Boxes Etc. on Fillmore Street, I scribbled a note that read: "Hi, Vincent! I'm Larry the Lobster and I want to remind you to call Richard!" I taped the message to one of the creature's extended claws, shoved it in a mid-size FedEx box, and sent it off to Fremont Enterprises.

The next day, I anxiously waited for Fremont to respond. I envisioned a call in which he praised my humor and cordially arranged an appointment to view the painting. Instead, I heard nothing. Another day came and went and still no call from Fremont. The following day, I swallowed my pride and phoned him. His wife, Shelly, answered and sympathetically put me through to her husband.

"Hi, Vincent. Did you get the lobster?"

"Yeah, so?"

Taken aback by his lack of emotion, I said, "Did you think it was funny?"

"Sort of. Listen, I'm busy. I've got someone on the other line and I'm trying to get out of here. What do you want?"

"I just want to make an appointment to come to New York and view the painting."

Without responding to my request, he said, "Oh, by the way, I also have a painting of a crab—same size, same year, and it's a thousand dollars less than the lobster."

"Really? I might be interested in buying it, too. But we still need to set up a time to get together."

"Tell you what, I'm completely booked this week and I have only Tuesday of next week at 11:30 available," said Fremont.

Without hesitation, I said, "Great—I'll take it!"

"See you then."

That was it. I hung up and quickly got on the phone to United Airlines, cashing in mileage because I didn't want to buy a ticket that forced you to stay over Saturday night.

The day after I arrived in New York, I made my way down to Chelsea to meet Fremont at Crozier's warehouse. The Warhol estate stored their paintings there and also used it for viewings. At the assigned hour, I took the freight elevator up to the seventh floor and was greeted by Fremont.

With his horn-rimmed glasses, slicked back hair, and three-piece suit, Fremont reminded me of a detached MBA type. Yet, when I once overheard him speak to his wife, I detected a greater warmth. As the father of two teenage daughters, he was also a family man who purposely didn't work weekends in order to spend more time at home. Beyond that, Fremont remained something of a mystery to me. I never had any idea whether he genuinely loved art or even liked it. Although he did let it slip that he cherished the small *Mao* painting that Andy once gave him as a gift.

After a preliminary handshake, I looked up at the viewing wall and my eyes connected with the Warhol lobster for the first time. The painting itself was striking. Then I looked at the crab, which was equally attractive. But there was a problem. Pointing at the pumpkin-colored crab, I said to Fremont, "Nice painting. Too bad it's upside down."

"No it's not," said Fremont, as his eyebrows furrowed. "It's hung exactly as it should be—with the claws below the body."

"What are you talking about? I'm familiar with the series and they've always been displayed with the claws above the body. That was Andy's intention."

Fremont started to turn red and glare at me. It was obvious that he wasn't used to having someone challenge him. As the omnipotent distributor of the Warhol estate, he expected total obedience from interested parties. Even Larry Gagosian—the estate's biggest customer—was rumored to acquiesce to Fremont's wishes. Yet, I knew I was right.

The airless atmosphere at Crozier's began to close in on me. Another glance at Fremont's face seemed to say, "Contradict me one more time and you can kiss both pictures goodbye." But I wasn't ready to back

down. Maybe it was my pent-up anger over all the unreturned phone calls or the frustration over the lack of response from the Fisherman's Wharf lobster. Whatever it was, I refused to give in. I had just opened my mouth to speak when Fremont unwittingly rescued me from myself.

"Look, if you buy it, you can hang it anyway you want."

I felt like a spooked cat whose puffed-up body began to slowly deflate. Extracting a prewritten check from my wallet, I handed it to him and said, "O.K. We have a deal."

At that point, Fremont pulled out a rubber stamp and affixed the seal of the Andy Warhol Estate to the back of both paintings. They were also assigned numbers which were recorded in the estate's archives.

About a week later the paintings arrived at my apartment. When I went to hang the crab, I looked at its back to examine the estate's seal. What I saw somehow didn't surprise me. It was stamped upside down.

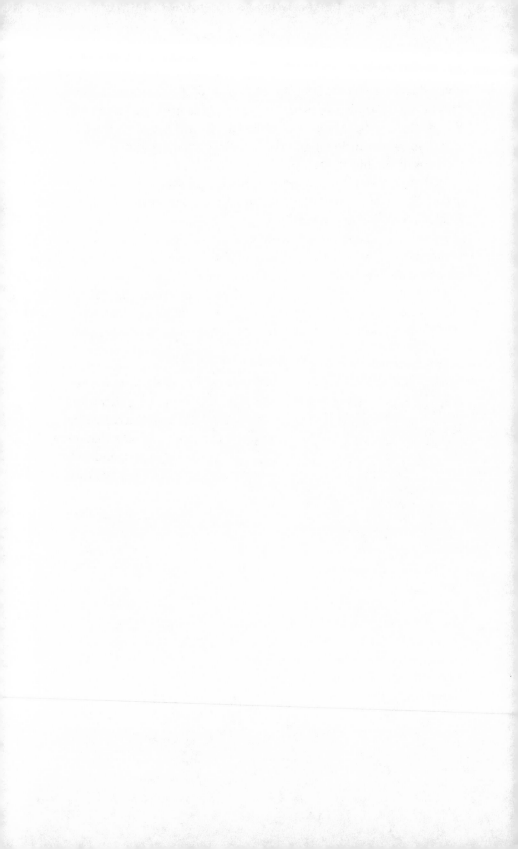

2

DOLLAR SIGNS

ALTHOUGH I DIDN'T KNOW it at the time, my search for an Andy Warhol for my own collection got under way in December 1986 with a visit to the artist's studio. Back then, the perception of Warhol's work was very different than it is now. His reputation was on the upswing after a long period of slow decline. The reasons were complex. It is an accepted fact that Warhol's strongest work was done between 1962 and 1967; that was *the era of the historic *Soup Cans, Celebrities, Disasters,* and *Self-Portraits.* Even Robert Hughes, Warhol's fiercest critic, described these works as "something akin to genius."

Sadly, in 1968, a deranged groupie of the Factory named Valerie Solanis inexplicably tried to kill Warhol. Without warning or provocation, she stormed into his studio and shot him with a Saturday night special. As Warhol hovered near death the police asked her why she had done it. Solanis cryptically replied, "Because he had too much control over my life." Apparently, she had repeatedly pestered Warhol to produce her screenplay and he had put her off one time too many.

Although Warhol eventually recovered from his near-fatal wounds, he temporarily seemed to lose his edge as an artist. There were brief moments, such as the 1973 paintings of Mao, where his work approached its 1960s acme but, by and large, the 1970s came and went without much significant work to show for it. During this period, Warhol focused on developing *Interview* magazine and building his financial empire, fueled

by an unending flow of commissioned portraits. However, once the 1980s rolled around, Warhol embarked on an increasingly productive period of art making.

1986 was shaping up to be Warhol's best creative year of the decade. For openers, he produced the provocative *Last Supper* paintings, based on the original by Leonardo da Vinci. There were also paintings of the Statue of Liberty, the abstract *Camouflage* series, and portraits of Lenin. Finally, at the urging of the London dealer Anthony d'Offay, Warhol completed a group of *Self-Portraits*, known as the "Fright Wigs." In these haunting works, Warhol appears with his wig standing straight up, as if he had stuck his finger in a light socket. Most critics thought they were his finest self-portraits since the so-called "mum voyeurs" of 1967.

Warhol's influence and likeness seemed to be everywhere. Around this time, he decided to exploit his famous face by signing up with a modeling agency. They quickly snared a deal with Drexel Burnham for Warhol to pose for a magazine ad. In the art world itself, Warhol had become a role model to a younger generation of artists and a mentor to Jean-Michel Basquiat. After years of indifference, the art market was also starting to pay attention. Charles Saatchi, the famed London collector, was quietly buying up major examples of Warhol's early work. Thomas Ammann, the respected Swiss dealer, was publicly pushing Warhol's prices up at auction. By the time of my visit to his studio, he was clearly on a roll.

I had flown to New York with my wife, Lia, specifically to buy a painting for an upcoming exhibition at our gallery, Acme Art. Our Warhol show was scheduled to open only three months later, in February 1987, and would include some paintings we owned, some we had on consignment, and some we borrowed from other dealers. In the history of San Francisco, there had been only one other show devoted to Warhol's work. In 1983, Martin Muller, the dapper owner of Modernism Gallery, had mounted a tightly focused exhibition of Warhol's *Myths* paintings. The gallery was ringed with images of Superman in flight and a smiling Mickey Mouse. Sales were tepid, but at least a beachhead had been established. I decided that our show would offer a more general overview by displaying an assortment of small paintings created over the last twenty years.

Although Warhol's stock was on the rise, the talk of the town was the young painter Julian Schnabel. He was a talented artist with a well-developed ego, whose signature style was to cover canvases with broken plates and then paint on the fractured surface with expressionistic bravado. At the ripe old age of thirty-five, Schnabel had just written a pretentious autobiography, titled *CVJ*. While the book left most of the art press panting with praise, it also had its share of detractors. In an issue of *The New Republic*, Robert Hughes reviewed *CVJ* and wrote, "The unexamined life, said Socrates, is not worth living. The memoirs of Julian Schnabel, such as they are, remind one that the converse is also true."

Schnabel may have been hot, but it was Warhol we were after. The home of his final studio at 22 East 33rd Street was a rather nondescript former power plant. It was a far cry from the original work space of the 1960s and its "anything goes" atmosphere. Those were the days of Lou Reed and the Velvet Underground, Viva, Ultra Violet, Nico, and other Factory superstars. The dealer Ivan Karp had also been a studio fixture. Initially, he spoke about the scene with a great sense of wonder and approval. But as time went on, he watched the positive energy of the Factory degenerate into an orgy of drugs and unsavory characters. Karp was quoted telling Warhol, "I know a lot of people think it's glamorous over there at your studio, but to me it's just—gloomy." Now the mood at his headquarters was corporate and professional. But still, this *was* Andy Warhol's studio—with much of its social cachet still intact.

Our appointment was with Fred Hughes, Warhol's charismatic business manager. According to Bob Colacello's *Holy Terror*, "Fred Hughes engineered the rise of Andy Warhol and set him on the road to riches. He launched the commissioned-portraits goldmine, drove up the sales and prices of the sixties paintings, expanded the limited-edition print business, and cultivated important new collectors and dealers, especially in Europe."

Hughes believed unconditionally in Andy Warhol. He was astute enough to remain in the background, and he carefully manipulated the media into giving Andy full credit for everything. Hughes knew that, despite Warhol's shy ways, he craved the spotlight. Despite the triumphant nature of the partnership, over time, Hughes's relationship

with Warhol evolved into the equivalent of an old marriage—filled with plenty of bickering, but also with true fidelity.

One thing on which Warhol never wavered was his empowerment of Hughes with complete discretion to sell his work. Even though Warhol was, technically, represented in New York by Leo Castelli, you could still buy directly from the studio—with a little effort and the right introduction. Although Castelli pretended to look the other way and not let these indiscretions bother him, they did, nonetheless. The flip side of the coin was that Warhol accurately claimed the gallery ignored him in favor of their biggest-selling artists: Jasper Johns and Roy Lichtenstein. From Warhol's first Castelli show in 1964 to his last in 1985, there was reportedly a palpable tension between the two of them.

That day, when we walked into the studio's lobby, I was startled by a Great Dane that was guarding the receptionist. Upon further observation, I realized it wasn't moving—it was stuffed! A few moments later, a young man ushered us into Hughes's office. The walls were painted a bright lipstick red and decorated with a single Warhol painting—a silver *Liz*. In this particular example, Elizabeth Taylor's face was dominated by her turquoise eye shadow. Not the color of the cheap turquoise you buy from roadside souvenir stands outside of Santa Fe, but the rich sky-blue stone prized by the ancient Navajos.

As my eyes met Liz's, she silently communicated her star quality. Although she had been seductive in *Giant* and ravishing in *Cleopatra*, she never looked better than the day that Andy Warhol painted her. My concentration was interrupted by the creaking of a door that opened to reveal Hughes in all his splendor. He was an Anglophile, and he wore what I was told were Savile Row suits and handcrafted Lobb shoes. But the real kicker was how he wore his wristwatch *over* the cuff of his shirt. I was dying to see its logo, but couldn't get close enough.

My first impression of Hughes was that he might have a "problem"— Warhol's code word for being gay. Although Warhol was obviously a homosexual, Hughes's sexual preference was less clear. He was typical of the art world's sexual ambiguity where one is never sure of *anyone's* true appetites.

He greeted us with surprising warmth. Some small talk was made, a few names of San Francisco socialites were dropped, and then we got down to business.

Hughes controlled the conversation, "So, tell me about the Warhol show that you are planning to mount."

I had anticipated the question. "Basically, we want to do a show that is a minisurvey of his small-scale paintings. We've already secured loans of a few *Flowers*, a *Mao*, and a *Skull*. I was hoping you would consider selling us a *Dollar Sign* to help round out the show. I was also wondering what it would take to get Andy to attend our opening reception."

Hughes looked me over carefully, as if he were summing up whether I could deliver the goods. I realized that the likelihood of getting Warhol to fly to San Francisco was slim. But nothing ventured....

"Andy's a busy man and his time is valuable. For him to come to San Francisco, it would take three days out of his life—a day just to get there, another day to attend the opening, and a third day to fly back to New York."

I was expecting this sort of posturing. Hughes was nothing if not astute and he wasn't about to waste his client's time. But he still hadn't answered the question—what would it take?

As if on cue, he said, "If you really want Andy to schlep all the way across the country and back, you're looking at a minimum of two portrait commissions."

I responded, "Approximately $50,000?"

"Bingo."

I thought for a moment and quickly decided that I wasn't interested in hustling portrait commissions in San Francisco.

It was time to change the subject, "So, are there any medium-size *Dollar Signs* available?"

In 1981, Warhol completed a series of paintings known as the *Dollar Signs*, whose imagery is just that—the universal symbol of money. While some viewed these paintings as crass, others appreciated how they updated Warhol's *Dollar Bill* canvases from 1962. When the *Dollar Signs* were originally unveiled at Castelli, business was anything but brisk. For all practical purposes collectors boycotted the show, once again proving how great artists are always a step ahead of their audience. For that reason, I knew there was a good chance not only that some *Dollar Signs* would be available, but that I might have my pick of the litter.

Hughes smiled graciously and said, "I think we can accommodate you."

With that, he picked up a phone and said with a flourish, "Would you please bring in three *Dollar Signs.*"

About a minute later, an assistant appeared with three glassine-wrapped paintings. Each canvas measured 20 by 16 inches. The assistant went through great pains to unwrap each picture, as if he were removing King Tut's delicate treasure from its tomb. The excavation must have gone on for a full ten minutes. I thought to myself, "For crying out loud, just take the damn paintings out of their wrappers."

Once the three works were finally visible, they were propped up on a ledge adjacent to Hughes's desk. Two of the paintings were rather ordinary, but the third possessed star quality. It's important to remember that paintings are, in many ways, like people. They have distinct personalities. Some are fun to be around, a few bore you to tears, and others you simply can't stand. An exceptional few are charming. Obviously, those are the relationships and pictures that you pursue.

I pointed at the one that caught my eye and asked, "How much do you want for it?"

"I can sell you that painting for $4,500."

I quickly calculated that I could retail the picture for $6,500. Not much of a profit margin. However, I knew that I wanted it, if only for an excuse to buy something directly from Warhol. I started wondering how many other dealers bought works through the studio for exactly the same reason. I knew that if Hughes forced my hand, I would pay his price, but decided to see if I could convince him to give us a better discount. Hughes had the reputation of being a master negotiator and I wanted to try my luck.

"Tell you what: I'll offer you $4,000, immediate payment."

Fred Hughes hesitated for a moment, then smiled and said, "I have to ask Andy. Let me call him."

I thought, "He needs to ask Andy to approve a $500 discount?"

Hughes picked up a phone, carefully exposing his black onyx and gold Art Deco cufflinks, and said, "The Polskys are here from San Francisco and are planning to do a show of your work. They've made me an offer of $4,000 for a *Dollar Sign.*"

The funny thing was that I sensed he wasn't really talking to Warhol. After some obligatory hems and haws, Hughes hung up and said, "Sorry, the price is $4,500."

I couldn't say I was surprised. While $4,500 was chump change to Warhol, Hughes wisely realized that it was more important that he protect his market. After all, if I received a further discount, there was no telling who I would brag to in the art world. He would rather maintain his price structure and risk losing the minor sale.

I paused for a moment, still unsure whether there had been anyone on the other end of the phone. Then I began to speak, planning to negotiate a bit further. But all that came out was, "Sold."

I picked up the painting with both hands and shifted it from side to side, watching its overlays of copper dollar signs shimmy like a dancer. When I turned it around, I noticed that it wasn't signed. Hughes explained that early in Warhol's career he established a policy of signing nothing until it was sold. Due to all the junkies and lost souls who hung out at the Factory, there used to be a high incidence of theft. This was Warhol's attempt at creating a painless form of security.

"I'll have Andy sign the painting a little later. I don't want to disturb him now—he's downstairs painting," said Hughes.

I couldn't hide my enthusiasm and said, "We'd love to meet him. Would it be alright if we stopped back later?"

"That would be fine. Why don't you return at, say, five o'clock?"

I shook hands, trying to sneak a peek at Hughes's watch, but he quickly withdrew his hand and I was thwarted again. Still, we left his office delighted that we were going to meet a living piece of history. As I strolled past the receptionist, I could have sworn that the Great Dane blinked. I informed the man at the desk that we would be back a little later to meet Warhol since we knew he was busy painting in his studio. The receptionist looked at me quizzically and said, "Andy hasn't come in yet." I just smiled.

Since we had a few hours to kill, Lia went shopping and I decided to hit some of the uptown galleries. The Pace Gallery (now called PaceWildenstein) was showing one of my favorite artists, Joseph Cornell. At the time, Pace was considered the top gallery not only in New York, but in the world. Owned by Arne Glimcher, who had built a

stable of artists that was the envy of everyone in the business, Pace represented such luminaries as Chuck Close, Claes Oldenburg, and the cash cow Jim Dine. They also handled the prestigious Mark Rothko estate and now they had just snagged Joseph Cornell's.

When he was alive, Cornell was a mysterious presence in the art world. His artistic reputation was based on originating the use of shoe box–size wooden containers, covered with glass, which contained miniature nostalgic environments. Cornell scavenged his materials from the used bookstores and penny arcades that once populated Times Square. Cornell himself was an eccentric loner who haunted New York's old Automats and seemed to exist entirely on sweets and pastries. He lived most of his adult life with his mother and his invalid brother in Queens. Ever the dreamer, Cornell seemed predestined to live on Utopia Parkway. But regardless of his odd personal life, Cornell was a highly respected American original—as one of his former dealers, Allan Stone, described him, "Cornell was part poet, part shaman, and part Yankee trader."

I took the elevator up to the Pace Gallery and was treated to a beautiful installation of Cornell boxes. The gallery's walls were painted midnight blue and each box was displayed on its own perch, its interior illuminated by a piercing spotlight. The effect was so dramatic that the gallery itself felt like a giant Cornell. Before viewing the individual works, I decided to just stand there for a minute and savor the experience. I guess I was standing too close to the receptionist's desk because my concentration was broken by, "Can I help you?"

I looked over and there she was, the well-worn stereotype of a gallery receptionist. The woman was young, perhaps in her mid-twenties, well groomed, with her blond hair severely pulled back, and her cream-colored sweater offset by a lone strand of pearls. Her expression exuded a cool disdain. I just rolled my eyes.

If there's a universal pet peeve in the art world, it's the receptionists in New York galleries. Generally, galleries tend to hire young women, fresh out of art school or perhaps Columbia's art history program. More often than not, the woman is the daughter of one of the gallery's biggest collectors. Usually, this is her inaugural job in the art world, and at first blush she's thrilled to have the position. After approximately two days

on the job she realizes there's essentially nothing to do. After a few weeks, she finds herself reading art magazines from cover to cover to avoid going crazy. At this point she has mastered the art of being rude to any artist who walks in and meekly asks about the gallery's policy of reviewing slides. Art classes and groups of older blue-haired women are also generally treated like vermin.

In fairness to the galleries, there is a reason why they take this semi-hostile approach. When I had a gallery, I quickly realized that if I met with every artist who wanted to show me his work, I would never get anything done. It takes approximately twenty minutes to look at someone's slides and give them some honest feedback. It's not only the time, but the emotional energy that goes into each viewing. Imagine an artist coming to you with a body of work that's taken him several years to put together. Then, over the course of a few short minutes, you end up picking it apart and turning him down for a show. After a few months of doing this it can get to be pretty demoralizing.

As far as visiting groups are concerned, my experience has been that they're more about socializing than looking at art. Usually, it's just a matter of time before an owner becomes cynical. I'll never forget a group that stopped by during Acme Art's Joseph Cornell show and asked "intelligent" questions such as, "Is this new work by the artist?" (*He's been dead for over twenty years*) and "What sort of person buys these boxes?" (*Obviously not someone like you*).

That particular day, the Pace receptionist asked if she could be of service only because I was wearing a coat and tie—a clear sign I wasn't one of those dreaded artists. Since I had her attention, I asked, "Do you have a price list handy?"

She studied me for a moment and then said with a monotonous relish, "They're all sold."

"I'm *sure* they are," I said. "But I'd like to know their price range for future reference."

"I'm not allowed to give out that information."

It's important to point out that this conversation took place in the days when galleries were allowed to hide their price lists. A code of secrecy existed around pricing, reinforcing the illusion of exclusivity and scarcity. Apparently, the city received a number of complaints about

this practice and, a few years later, a New York assemblyman helped pass a law that cracked down on secretive pricing. As a result, galleries must now display their price lists.

Since price information wasn't forthcoming, I asked to view the exhibition's catalogue. Pace Gallery had developed a well-deserved reputation for producing the finest exhibition catalogues in the business. This was the case until 1989, when the Mary Boone Gallery upped the ante by publishing a hardcover Lichtenstein catalogue that reputedly cost $100,000, just for the silver-leaf endpapers alone. Currently, the Gagosian Gallery owns bragging rights for doing the most elaborate catalogues. Not only are their exhibition catalogues a joy to read through, they serve as valuable historical documentation of the show.

As I turned the Cornell catalogue's pages, I asked, "How much is it?"

"Twenty-five dollars."

"Well, I'm a dealer who's shown Cornell's work and I do business with your gallery."

"So?"

Now here was an art dealer's dilemma. Even though it would have been a simple matter to write her a check, it went against my principles. Although many dealers are generous, when it comes to buying a rival gallery's catalogue they suddenly become quite frugal—and I was no exception. It is considered a professional courtesy to give a fellow dealer one of your catalogues. Not only does it assure you of receiving treatment in kind, it is also a way of making a statement about your success. While many think that catalogues are done as a marketing tool to promote an artist, they are also published to burnish a dealer's image.

Rather than respond with a check or explain the rules of the game, I decided to take another route. "Is Peter Boris in today?"

The receptionist looked at me as if she had just caught a whiff of broccoli cooking on the stove, "Just a minute, please."

A few moments later, Boris bounded out of the elevator. "Richard, good to see you! How do you like the show?"

"It's terrific. You know what a Cornell fan I am."

Then the moment of truth. "Here," said Boris. "Let me give you a catalogue."

Mission accomplished.

When I arrived a few hours later for our meeting with Warhol, Lia was already there, wearing a new bowler hat she had just bought at Morgane Le Fay. I gave the Great Dane a dirty look and we walked down to Hughes's office. As we entered, Hughes was on the intercom. A few seconds later, Andy Warhol silently appeared.

After seeing countless photographs of him, it was hard to fathom that he was now standing in front of me. He had a supernatural presence, almost like a fictional character come to life. At first, I found it difficult to make eye contact because I was distracted by his silvery wig. It was so blatantly fake—that it worked. If Warhol had settled for a more natural toupee, he would have looked ridiculous. Instead, he looked dignified. Even his blue-jelly oversized glasses suited him. He was wearing a black turtleneck and tight black jeans, making him look even thinner than he was. After staring at Warhol for a moment, I realized that his other-worldly looks were in large part responsible for his fame.

Back when he was an eight-year-old boy growing up in Pittsburgh, the former Andrew Warhola contracted Saint Vitus' dance—a disorder marked by uncontrollable muscle spasms. For a reason that may or may not have been connected to his illness, his skin underwent a permanent loss of pigmentation—which accounted for his ghostly complexion. While it must have been disheartening to grow up with such odd looks, in later years it worked to his advantage. Once you saw Andy Warhol, he remained etched in your mind forever.

As I pondered his appearance, Warhol quickly whipped out a black Sharpie felt-tip pen. He then signed and dated the *Dollar Sign*. He was also kind enough to pose with us for a couple of snapshots. Hughes acted as photographer and carefully positioned Warhol next to my wife and me. He then composed the shot and included a nice visual touch—a pot of white narcissus flowers on a desk in front of us.

I desperately wanted to communicate with Warhol, but couldn't think of an opening gambit. The problem with meeting someone truly famous is that virtually anything you say to them comes off as either ridiculous or overly sincere. Finally, I just played it straight by saying, "We're really looking forward to showing your work. I'll try to send you a few installation shots of the show."

"Gee, thanks," was all he could manage.

After a few more moments of small talk, Warhol waved to us and quietly slipped out of the room. In retrospect, the whole meeting lasted about ten minutes and was rather unremarkable. Although I was hoping for something more, objectively I was sympathetic to the fact that he spent every day being on display, granting interviews, and lunching with prospective portrait subjects. We weren't exactly friends of his nor were we big spenders. What did I expect?

As I shook hands with Hughes, he said, "Come back and see us again."

This time, his hand lingered long enough for me to finally identify his timepiece—it was a simple black Swatch.

TRIPLE ALL THE PRICES!

I LEFT HUGHES'S OFFICE THINKING that it might have been premature of me to dismiss trying to line up a few portrait commissions. After all, it would have been great to bring Warhol to San Francisco, not to mention the 10 percent commission that was routinely offered as a finder's fee. Part of my hesitancy was that I was well aware that many art critics had labeled these works crass and commercial—Warhol at his worst. But with the advantage of hindsight, I came to recognize how he brilliantly gave his sitters what they secretly loved the most—not fancy cars, homes, or jewelry—but idealized versions of themselves.

Over the years, much has been written about Warhol's commissioned portraits of the 1970s and how they represent a "Who's Who" of the era's social scene. By the end of the decade, the Whitney Museum of American Art mounted a high-profile show of these stylish paintings. From what I understand, the show's opening cocktail party was a bit surreal because most of the paintings' subjects were in attendance. Can you envision walking around a major American museum, surrounded by larger-than-life images of yourself and your friends? Can you imagine the backbiting? There was probably less than you think because Warhol went out of his way to flatter his sitters by disguising their double chins and large noses. As he once said, "If everybody's not a beauty, then nobody is."

Among the faces on the walls that night were art world heavy hitters, socialites, and even Warhol's mother, Julia. That evening, one could

have communed with portraits of the dealer who discovered Warhol (Ivan Karp), the dealer who gave him his first show (Irving Blum), and the dealer he would ultimately be associated with (Leo Castelli). There were portraits of fellow artists (David Hockney), rock stars (Mick Jagger), politicians (Golda Meir), authors (Truman Capote), actors (Dennis Hopper), and divas (Liza Minnelli).

In the show catalogue's introduction, the Whitney's director, Thomas Armstrong, lobbed a few surprises at the reader. Not only did he offer a glowing discourse on Warhol's importance, but he ended his essay with a statement that is still remembered in curatorial circles to this day: "When the last lifeboat is launched, I want old Blondie at the oars." His strong praise was considered controversial because museum directors were not supposed to proselytize. Many years later, Armstrong was rewarded for his loyalty by being named the first director of the Andy Warhol Museum.

The commissioned portraits originated in 1963 when Ethel Scull asked Warhol to paint her likeness. After a deal was struck, Warhol gathered her and a few rolls of quarters and headed to the nearest photo booth. The camera snapped away while Mrs. Scull hid behind her sunglasses, smiled, laughed, frowned, and occasionally struck a Garboesque pose. She once described the experience as one of the most enjoyable of her life. Warhol then took the strips of black-and-white photos to a processing lab, had photosensitized silkscreens made of the images, and eventually transferred them to thirty-six individual canvases, each painted with a different background color. He completed the work by combining all thirty-six panels into one painting, now jointly owned by the Whitney Museum and the Metropolitan Museum of Art.

But Warhol would find that working that way took too long. Keeping to his philosophy of wanting to be a "machine," he developed an assembly-line approach for creating portraits. The first step in the process was lining up the commissions. To that end, he encouraged his entire staff to solicit deals whenever the opportunity presented itself. Whether it was a dinner party or a gallery opening, Bob Colacello (the editor of *Interview*) and Fred Hughes were always prospecting. In fact, if either of them didn't go for the kill quickly enough, Warhol would take them aside and ask, "When are you going to pop the question?"

Once a potential client agreed to be painted, Warhol's modus operandi was to invite her to the studio for lunch. He was always careful to orchestrate these gourmet affairs by spicing them up with a celebrity or two. He created true synergy by cross-pollinating a portrait client with a star featured on the cover of that month's *Interview*. At lunch, a client might be seated with John McEnroe, Rudolph Nureyev, or perhaps Lee Radziwill. Often, Colacello or the equally witty Hughes was included to keep the conversation rolling. Meanwhile, Warhol had his tape recorder running to preserve everything for posterity. The result was that everyone at the table felt special—like they were experiencing the rewards of the "real" art world—and in a way, they were.

Still on a high, the client was then ushered into the studio for a photo session. Warhol got out his Polaroid Big Shot camera and went to work. He took the process seriously and often went through ten packs of film. When he was done, he spread out the photos and selected a winner. A silkscreen was made and once Warhol got it back he often performed a bit of cosmetic surgery by removing assorted jowls, wrinkles, and blemishes. He then painted two (or more) 40-by-40-inch canvases. Depending on his perception of the client, he used colors that suited her personality. He also applied the paint in an appropriate style—sometimes using a brush, sometimes enhancing the surface with finger painting.

When it was time for the grand unveiling, the client, along with her (often) wealthy husband, was invited back to the studio. Since Warhol was the consummate professional, all of the portraits were of a high quality, leaving the couple with the difficult task of choosing a single canvas. At that point, a member of Warhol's staff would discreetly suggest they consider purchasing more than one. According to Bob Colacello, in his essay for *Andy Warhol Headshots*, the standard sales pitch was: "Repetition is a very important element of Andy's aesthetic." Warhol's fee for a single canvas was $25,000, but a second one could be acquired for an additional $15,000. Any savvy businessman would say to himself: "That averages out to just $20,000 per canvas." More often than not, he bought both.

Warhol completed approximately 1,000 portraits during the course of his career. By the 1980s, he averaged a $40,000 sale per week of these

portraits, using the money to fuel his more experimental projects. The commissioned portraits were also valuable as trade bait and were used to swap with other artists for their work. Encouraged by Hughes, Warhol was able to amass art for his own collection by John Chamberlain, Roy Lichtenstein, Arman, and others. From Warhol's viewpoint, ending up with a blue-chip work of art was as good as a sale—and was also tax free.

In talking to various people who had their portraits painted, I was struck by their fond, if distant, memories of the experience. Art dealer Jason McCoy, the nephew of Jackson Pollock, had his portrait done in 1975. In a brief conversation, I asked him, "How did you come to commission Warhol?"

"Well, at the time, I was working with Stephen Mazoh as a private dealer. One day, we saw a portrait Warhol had done of Jan Cowles (married at the time to Gardner Cowles, publisher of *Look*). We spontaneously decided that it would be great to have our portraits done too," said McCoy.

"What sort of deal did you make?"

"That was a long time ago, so I don't remember all of the details. But I think Stephen and I traded a small Pollock and some cash for the two portraits and a silver *Elvis*."

"What was the process like?"

"I remember that I posed wearing a black Yves St. Laurent velvet jacket which I used to wear every day. The photo session was intense—Andy was very focused when he worked. On the other hand, he didn't care if I moved around. It was certainly different than when David Hockney did my portrait. He insisted that I remain absolutely still."

"Were you happy with the finished results?"

"I liked it, but I didn't look like Marlon Brando!" he said with a laugh.

There were also those people who commissioned portraits not of themselves, but of others. This was the case when Richard Weisman, son of the famed Los Angeles collectors Fred and Marcia Weisman, came up with a business proposition to commission Warhol to do a series of ten portraits of famous athletes. Participants included the baseball player Tom Seaver, basketball player Kareem Abdul-Jabbar, and the most famous athlete of all, Muhammad Ali. The now-disgraced football player O. J. Simpson was also part of the project. Many years later, not long

after his trial for murdering his wife Nicole Brown Simpson, one of his portraits came up to auction and sold for *less* than the owner paid for it—one of the rare instances of a Warhol going down in value. Many years later, in 2002, Neiman Marcus' annual Christmas catalogue offered a complete group of all ten athlete portraits for $3 million. An individual work from this series never exceeded $75,000 at auction. Which just goes to show you that in the art market it's always possible to pay hyper-retail.

While I was in New York I continued to ponder the possibility of pursuing portrait commissions, but by the time I flew back to San Francisco, I had decided to pass on the opportunity. A few months later, in February 1987, Lia and I opened our gallery's Warhol show. The exhibition was officially titled: "Andy Warhol, Small Paintings, 1962–1982." We took out a few ads, made a bunch of invitational phone calls to key local collectors, and hoped for the best.

At the time, the Bay Area art scene was stuck in neutral. For all its wealth and charm, San Francisco had been slow to blossom into a city that supported the fine arts. The San Francisco Museum of Modern Art didn't even have its own building and was forced to share a space with another institution. The museum's collection was weak—typically, it didn't own a single Warhol. The gallery scene was also sleepy. About the only time it sprang to life was when the dealer Diana Fuller went braless and wore a see-through blouse with a business card strategically placed in each breast pocket. It wasn't that San Francisco collectors didn't buy art, they just didn't buy locally. When they did, they tended to play it safe. That usually meant works on paper by Richard Diebenkorn and Wayne Thiebaud, two West Coast favorites.

Three days after the show was hung but before it opened, we drove to Sacramento to look at a tiny green Warhol *Self-Portrait* from 1967. A dealer had heard about our show and offered it to us for the quaint sum of $3,000. The painting depicted Warhol in profile and was from a series of portraits of his Castelli Gallery stablemates. We decided it would make a fine last-minute addition to our show and agreed to buy it. The painting was carefully bubble wrapped and then we headed back to San Francisco, quite pleased with our latest acquisition. Although we didn't have high expectations for the show, we were still confident of making a few sales. After all, if you couldn't sell Andy Warhol, who could you sell?

When we arrived home that night, our answering machine was blinking wildly. As I fumbled to turn on a lamp, all I could see in the darkness was a flashing red light—like an oncoming ambulance. I walked over to the machine and the message counter revealed over a dozen calls. I hit the playback button and voice after voice repeated the unthinkable—Andy Warhol was dead.

The press reported that Warhol had gone into the hospital for a routine operation to remove his gallbladder. The surgery itself had been a success. In fact, once the anesthesia had worn off, Warhol sat up in bed and had a brief conversation. He was given a painkiller and went to sleep, only to awaken a few hours later. By then he was feeling stronger and even made a few phone calls. He then dozed off—and never woke up. Officially, he died of "complications" following the surgery. What those complications were was never revealed in the successful wrongful death suit brought against the hospital. But at that point, what did it matter? The sad fact was that Andy Warhol didn't have to die at the relatively young age of fifty-eight.

I played back the messages a second time. Virtually all of them pertained to Warhol's market. Would his paintings go up in value? Would they go down? What did we have for sale? One of the lenders to our show, New York dealer Charlie Cowles, proved to be prescient with his frantic message, "Triple all the prices!" There was even one sick message from a private dealer who, assuming a windfall, wanted to "congratulate" us.

Still shocked by the news, I went over to the stereo and put on the David Bowie song "Andy Warhol." Somehow, it seemed appropriate. The chameleon of rock stars sang, "He'll think about paint and he'll think about glue, what a jolly boring thing to do." As I listened to Bowie pay homage to his friend, I tried to formulate a plan. Potentially, we were sitting on a small treasure trove of work. While I hated to profit from someone else's misfortune, I still had to play the cards I was dealt.

Our Warhol show began taking on a life of its own. The gallery posted its highest attendance ever. Kenneth Baker, a local critic, gave the show a strong review. Yet there was so much uncertainty over Warhol's market that relatively little sold. Because of his photo-silkscreen technique, which allowed him to produce work in quantity, the suspicion

was that there were far more paintings available than actually existed. As a result, right after his death, collectors were initially reluctant to reach for their checkbooks. Shrewd buyers were also aware that when a famous artist dies, his paintings often go *down* in value. The artist's market may become flooded with work by collectors and dealers anxious to cash in. Occasionally, the artist's family may also dump work to help pay estate taxes. But in keeping with an artist who broke all the rules, Warhol's market went up—and has continued to do so.

During our show, we were visited by Harry Anderson, one of the most respected collectors in the country. Anderson, known as "Hunk" to his friends (his wife went by "Moo" and his daughter "Putter"), had made his fortune in the food service industry. His collection had the strongest concentration of Abstract Expressionism in private hands. The highlight of the collection was the Jackson Pollock "drip" painting *Lucifer*—for which Anderson once turned down a reputed $30 million offer.

Anderson noticed a medium-size *Mao* hanging in the center of the show which we had on consignment. With a price list in hand, he studied the painting for quite a while. Then he walked over to me and said, "A few years ago, I looked at a similar painting for $5,000. Now, you're asking $25,000. I think you have a great painting here, but somehow I just can't justify paying *so much* for it." By 1999, the same painting would sell for approximately ten times that amount—if you could get someone to part with it.

Fortunately, we weren't only concerned with sales. Exhibitions can also function as magnets that attract works from collectors willing to sell. That scenario was played out when one day, near closing time, a sloppily dressed man wandered into Acme Art and said, "Hi, I'm Joe Prigmore. You know, I own a Warhol painting."

I was initially skeptical because Prigmore looked like a refugee from the city's seedy Haight-Ashbury district. I said, "Are you sure it's not a print?"

"It's a painting—of Troy Donahue," said Prigmore matter-of-factly.

I was stunned. In 1962, Troy Donahue was the subject of Warhol's first celebrity portrait. During the early 1960s, Donahue was a movie star and a legitimate box office draw. His blond hair and good looks

obviously appealed to a starstruck young Warhol. This led to a small series of *Troy* paintings that became a springboard for the *Liz* and *Marilyn* paintings.

Prigmore, our new "best friend," began to describe his painting. Usually when collectors showed up at our gallery and began bragging about all the fabulous things they owned, they backed down the minute you asked for specific details. Their stories always had a kernel of truth, but were usually exaggerated. But not Prigmore—his description rang true.

I then asked him, "Any labels on the back?"

I was referring to the descriptive labels that galleries affix to the back of a work. These labels become part of the painting's provenance (history of ownership). Even though it's what's on the front of a canvas that counts, a few labels from prestigious galleries can add extra value to a painting.

"I bought the Warhol when I lived in Florida from a private dealer named Marvin Ross Friedman. I think his label is on the back," said Prigmore.

Now here was a revelation that brought a grin to my face and Lia's. We were smiling because we had recently visited this man for the first time. Friedman was a prominent Miami personal injury attorney who had made his money on a couple of large class action suits. He lived in Coral Gables with his two children and his wife, Sheila Natasha—a wonderful woman with an exceptional flare for designing clothing. While he continued to practice law, Friedman's fascination with the art world gradually led him to move into private dealing. Essentially, a private dealer works from his home, rather than a gallery, and generally avoids representing artists in order to concentrate on the resale of blue-chip art.

Friedman's claim to fame was that he owned a number of major Roy Lichtenstein paintings. His "Roys" were world class and always in demand for loan to museum shows. Eventually, Friedman's identity in the art world became synonymous with his Lichtensteins. As a result, he could never really sell them. If he did, he would no longer be pursued by the art world hoping that he would either lend, donate, or auction his paintings. If Friedman ever did part with them, you could rest assured

that his invitations to art fair openings, museum cocktail parties, and gallery dinners would no longer be forthcoming.

Besides owning some prime Lichtensteins, Friedman also developed a personal relationship with the artist. They were friends and he made sure that any visitor to his home knew it.

When Friedman heard that Lia and I were coming to Miami, he was kind enough to invite us over for cocktails. I readily accepted, anxious to see his collection. When we arrived, I got directions from Friedman and was told the drive would take us an hour. We took the local roads that he suggested, rather than the freeway. As we got closer to his home, we found ourselves driving a rather circuitous course. We also noticed the surrounding houses were becoming more substantial. A mile from his residence, they became palatial. It soon became obvious that Friedman had wanted us to know he lived in an expensive area.

Once we found the Friedmans' home, I rang the bell and Marvin greeted us with enthusiasm. He yelled to his wife, "Sheila, the Polskys are here. Bring in the champagne!"

Not only did she bring in a bottle of bubbly, but Sheila also arrived with a silver-covered crystal bowl of fine caviar. She chatted for a few minutes and then went back to the kitchen. Before showing us his paintings, Friedman offered to give us a quick tour of the grounds. Champagne flutes in hand, we inspected the backyard's lush landscaping and noticed a swimming pool with steam coming off of it. Even though it was winter, I was surprised to see a heated pool in Florida.

Pointing to the evaporating vapor, Friedman said, "Do you know what you call that? Money!"

It was a great comment and we got a good laugh from it. We then returned to his house and I finally got a chance to see the Lichtensteins— they really were magnificent. The artist's masterful adaptations of comic strip art brilliantly combined the high and low of popular culture. Just then, I heard Sheila's voice from the kitchen, "Marvin? I forgot to tell you that Roy called earlier. He and Dorothy are going to be in town next week and he was wondering if they could stay with us?"

"*Again?*" said Friedman, with a pained expression.

Lia and I made eye contact and tried to suppress a smile.

Friedman turned to us, pursing his lips and shaking his head in mock disbelief, "Last month it was Leo Castelli, now it's Roy Lichtenstein. What am I supposed to do?"

We played our role to the hilt, commiserating with Friedman while expressing our admiration for his connections. Regardless, the Friedmans were gracious hosts and it was a pleasure spending time with them.

So we went along enthusiastically when Joe Prigmore invited us to his apartment to inspect his Warhol. Sure enough, he lived in the heart of hippie heaven—the Haight-Ashbury. His *Troy Donahue* painting was as good as advertised, so we cut a deal, handing him a check for $2,500. Foolishly, we resold it for $5,000—doubling our investment, but missing out on the big money down the road.

By the Warhol show's conclusion, our only sales had been to out-of-town collectors. Not a single painting was bought by a San Franciscan, although five were sold all together. Sadly, I also passed on the picture that Anderson rejected. Not long after, once I had made a commitment to buy a Warhol for myself, it was too late—the *Mao* had already been sold.

Slowly, the word got out that I was in the market for a Warhol canvas. When the informal dealer network learns that someone's buying, it's just a matter of time before the offerings start rolling in. I began to receive numerous solicitations from various galleries and private dealers. Most were a complete waste of time. I was shown everything from an actual Campbell's soup can signed by Warhol, to a musty wig (resembling a silver tarantula) that the seller swore was worn by Warhol. However, there was one offer that stood out. It was from Jim Corcoran, one of the West Coast's most powerful dealers—and definitely its most enigmatic.

4

I SURE HOPE
YOU HAVE INSURANCE

HOW DOES ONE BEGIN to describe James Corcoran? Physically he was intimidating, standing six-foot three, with the build of someone who worked out on a regular basis. He was an avid surfer—a hobby that frustrated many visitors to his gallery who, unable to find him, were told: "Sorry, surf's up." You might say Jim was handsome, with a balding head and warm blue eyes. You might also say his face would have been even more attractive had he not consistently missed a few patches of whiskers when he shaved. He was one of those people you'd look at and swear he reminded you of someone famous. Occasionally, he was mistaken for Senator Bill Bradley. However, Jim was the least political person I knew. All he wanted to do was surf, play golf, chase Asian women, and occasionally deal a great picture.

It was impossible to get a handle on Jim because he was a mess of contradictions. He could be charming one moment and remote as Antarctica the next. One day, he would be spotted at his gallery wearing the latest from Comme des Garcons, the next, he would be at his desk in a Body Glove T-shirt, Jimmy'Z shorts, and no shoes. He was a member of the exclusive Riviera Country Club, but prided himself on hanging out with some of the biggest bums in the city. Jim projected a youthful image, but then spoiled it by driving a Cadillac. His intelligence was beyond dispute, but half the time you didn't know what he was talking about because his stories and explanations were so fantastic.

Despite all of his quirks, Jim was highly respected by his colleagues. He was probably the most connected dealer in California and was often a fellow dealer's first call when he was looking for a painting. Jim had worked hard at developing his network of contacts, and as a result could get virtually any major collector, dealer, or artist on the phone. In the art world, that was considered power. Basically, he had a reputation as someone who could get things done.

Somehow, I had developed a tenuous friendship with Jim that was largely based on our mutual interest in Joseph Cornell. When Jim had heard that I was willing to spend a fair amount of money on a Warhol painting, he pounced. Since he had a good eye, I knew that anything he offered me would be of high quality. Unfortunately, I also knew that negotiating with him would be a long, drawn-out process.

In the art world, a dealer can't just offer a collector a painting, quote a price, and get a yes or no response. Things are much more complicated than that. A dealer like Jim would test you a bit and make you earn the painting. Humiliation is a standard practice, especially when dealers do business with each other. Collectors with deep pockets are generally spared. The only difference is that they are disparaged behind their backs rather than to their faces.

Jim wound up offering me a Warhol *Jackie*. Back in 1964, Warhol screened, at random, one of eight different images of Jackie Kennedy onto a large number of 20-by-16-inch canvases. Each canvas had either a blue, white, or gold background. The poses ranged from Jackie with President Kennedy standing behind her, to an image of her in mourning with her face covered by a veil. In 1987, the going rate for *Jackies* was approximately $35,000—a little more for a gold one with JFK, a little less for some of the other variants.

Over the phone, Jim described his *Jackie* in exquisite detail. It sounded great. Unfortunately, there was one small catch. Jim had only twenty-four hours left on his option to offer the picture. If he didn't make a deal to buy or sell it, he had to return it to the owner, who ostensibly had another buyer for it. Normally, when a dealer uses high-pressure tactics on me, I don't take him seriously. But the contemporary art market was beginning to take on some heat. The urgency behind Jim's offer was real, so I asked him to FedEx me a transparency.

The next day, I waited at home until half past ten in the morning for the FedEx truck to arrive. By eleven o'clock, it hadn't shown up. I remained unconcerned because I figured he probably checked the "Standard Overnight" box rather than "Priority Overnight" in order to save a few bucks. I knew never to underestimate an art dealer's aversion to spending money. By five o'clock, the envelope still hadn't appeared, and I started to get worried. Something had gone wrong. I tried reaching Jim that evening but he was nowhere to be found. I went to sleep that night wondering what lame excuse he would come up with.

I finally heard from Jim the following morning. When he called, he sheepishly confessed, "Let me tell you what happened. I was on the golf course and it was already four in the afternoon. I was playing a friend of mine and I was up $6,000. If I had left in the middle of the match, I would have forfeited my winnings. So I figured the $6,000 was more than I stood to earn on the *Jackie* and decided to hell with FedEx."

I was amazed. Not by the fact that he didn't send the transparency, but by the creativity behind the excuse.

Jim continued, "Look, I really feel bad about this and I'm going to make it up to you. I happen to own an incredible small *Mao*. I wasn't planning on selling it, but it's yours if you want it."

"So send me a transparency."

"Nope," he said. "If you want to see it, you have to come down to L.A. this weekend. I'm throwing a party to celebrate the opening of my new space. Why don't you join us for dinner?"

I hadn't been to Los Angeles in six months and figured it might be fun.

"Can I ask you something?" I said.

"You already did," said Jim, using one of his favorite lines.

"How should I dress?"

"I don't give a shit *what* you wear. Good-bye."

Just like that, he hung up on me. Social convention was not Jim's strong point.

A few days after our conversation I found myself in Santa Monica cruising down Colorado Avenue toward the Corcoran Gallery. The warm Santa Ana winds were blowing and the streets were littered with palm tree fronds. It was one of those typical Los Angeles days where the

hazy white light made it feel like it was eternally three in the after-
noon—too late in the day to start something new and too early to call
it quits.

Visiting Jim's gallery always made me uncomfortable. In an odd way,
it was comparable to going to the neighboring La Brea Tar Pits—the pre-
historic petroleum swamp that trapped mastodons and saber-toothed
tigers in its sticky tar. Just as the tar pits' water-covered surface was allur-
ing, so was the view peering into Jim's gallery. But like the suffocating
tar, you certainly didn't want to get stuck in there. Part of the problem
was that Jim had a taste for the bizarre and hired his staff accordingly.
Some of his employees resembled fugitives from a carnival freak show
and, as a result, the gallery's ambiance bordered on the surreal.

That day, things were more chaotic than usual. A team of caterers
were scurrying around making preparations for the dinner party. I
heard a crash as a tray of glasses shattered on the gallery's shiny concrete
floor. The loud noise set off a chain reaction, rousing Jim's dog Chico, a
boxer with crazed yellow eyes. Like Dennis Hopper's character in *Blue
Velvet*, he began trying to hump anything that moved.

Within seconds I had fallen victim to Chico's amorous advances.
Extracting myself, I tried to get the attention of Jim's assistant, Barbara
Little. She was responsible for the gallery's general operation, as well as
screening Jim from the day's usual annoyances. Little was attractive in
the way a Homecoming Queen nominee is—not the actual Queen, but
one of the runners-up. Unfortunately, she was preoccupied with a high-
ly personal art project. She had become obsessed with making imagina-
tive drawings of the gallery artists' penises. Each artist's unit resembled
his work in some clever way. For instance, the artist Chuck Arnoldi,
whose early constructions were made out of tree branches, was given a
penis shaped like a skinny twig. I just shook my head, amazed at the
freedom Jim gave his staff.

Most gallery owners are control fanatics. Mary Boone actually made
her staff use specific green, blue, or red pens to perform certain tasks—
and woe to the employee who used the wrong pen. Rumor had it that
she once slapped one of her assistants across the face for mislabeling a
slide. Imagine what would have happened if he had *lost* the slide.

Adding to the general tension at the Corcoran Gallery was a drama
involving money. The day before Jim had sold a de Kooning canvas for

$800,000. What should have been cause for celebration quickly turned
to despair—Jim had lost the check. Now his staff was on a frantic scav-
enger hunt for the missing funds. It was the only time I had ever seen
Jim panicked.

In theory, he could have called the client and asked him to stop pay-
ment on the check and simply send a new one. But as with most large
art deals, you didn't want to rock the boat. Why give a client an excuse
to suffer buyer's remorse and cancel the sale? Not that a rich collector
needed an excuse. Anyone wealthy enough to write a check of that mag-
nitude didn't need a reason for what they did.

Little, the penile chronicler, had been kind enough to warn me about
Jim's poor state of mind. Fully briefed, I made my way back to Jim's
office. Walking down the hall, I passed an open bathroom and noticed
someone was scrubbing the toilet bowl—it was Squid (no one knew her
real name)—a twenty-something Asian woman who was a mysterious
presence in Jim's life. Rumor had it that she was Jim's lover. People who
were familiar with Squid spoke of her dark side. Supposedly, she had a
tattoo on the bottom of her left sole that said, "Made in Japan." That day,
she was sporting a short punk haircut and a revealing low-slung halter.
Not wanting to get distracted, I simply waved to her and continued
down to Jim's office.

I opened the door gingerly and found him slumped in his black
leather Corbusier chair with a telephone glued to his ear. His face was
red and he was obviously upset about something. When Jim saw me, he
quickly terminated the call with an emphatic slam of the receiver.

"Well, well, if it isn't the Polecat. *What are you doing here?*"

"You invited me."

"I did?"

This was a typical Jim ploy—immediately putting you on the defen-
sive. Sidestepping his opening remarks, I cut to the chase.

"I'm here to see the *Mao*."

As Jim stared at me, I remained standing. He was trying to determine
how interested I really was. He continued to stare, watching my discom-
fort grow as the seconds ticked away. I felt like an insect being fried by a
sadistic child holding a magnifying glass. Maybe I had acted too inter-
ested on the phone or, then again, maybe I hadn't acted interested
enough. It was impossible to determine where Jim was coming from.

Finally, he broke the silence by saying, "Do you think the Dodgers are going to win tonight?"

That was it. Nothing about the painting. It was one of the oldest bargaining strategies in the book—talk about everything *but* the painting. Meeting him halfway, I responded with idle talk about baseball. It was as if whoever mentioned the *Mao* first would lose. This mindless banter went on for five or six minutes until, mercifully, the tedium was broken by a knock on the door. In walked a tall, thirtyish man dressed in a Club Med sweatshirt, khakis, and topsiders with no socks. It was Ryan Collier.

Here was the proverbial accident waiting to happen. Collier was a young collector with a sweet disposition and a substantial trust fund. Despite Collier's habit of spending a big portion of his monthly stipend at the gallery, Jim gave him a hard time and found little ways to torment him. He probably resented Collier, but still wanted his business. Just the other night, there had been an incident at the movies. When Collier went out for popcorn, Jim purposely switched seats so that Collier had to stumble around in the dark to try and find him. But that was nothing.

Two months earlier, their relationship had reached a new low when Collier asked Jim for a job. It wasn't that he needed the money, he was simply curious about the art business. Reluctantly, Jim hired him. Within a week, Collier made his first sale, only to be fired for accidentally selling a painting for $4,000 less than Jim paid for it. Jim yelled at him and shamed him so badly that Collier reportedly left the gallery in tears. A few days later, the two of them were seen lunching at The Ivy. Only in the art world could you humiliate one of your best clients and have him return to you as if nothing had happened.

Now Collier was back at the gallery for his daily share of abuse. Ignoring the unpleasant look on Jim's face, he said, "Hi guys. Where's the *Mao* painting I'm supposed to look at?"

My jaw dropped slightly. Here was a development I hadn't counted on. Was Collier genuinely interested in buying a *Mao*, or was he just a shill?

Quickly, I scanned the room, trying to locate the painting. Maybe it wasn't even worth fighting over. Finally, I spotted it on the wall, peeking out from behind the door. My eyes locked on to it like radar—the painting was the real deal. Mao's gaze was both beatific and malevolent. Here

was the communist leader of the most populous nation on earth, whose ruthless politics cost the lives of millions, smiling like the Buddha. It was this irony that gave the painting its strength. Even though its colors resembled Pepto Bismol and a rotting orange, they enhanced the work's emotional content.

The *Mao* paintings, created in 1972–73, were Warhol's first significant work since he was shot five years earlier. Critics praised their painterly surfaces and their edgy subject matter. Collectors flocked to the work, buying up both the paintings and a series of prints that followed.

Finally, I said, "Okay Jim, what do you want for it?"

Rather than name a figure, Jim threw me a curve. In his deep baritone he said, "Hey, let's not get too serious, Richard. What I could really use right now is some comic relief." Pausing for effect, he went on, "Just this once, I'm going to let the two of you ask me a single question—and I promise to answer it truthfully."

Jim looked at his watch, "You have exactly one minute to come up with the question." With that, he left the room.

Collier and I were speechless. What an opportunity! The grains of sand slid through the hourglass as Collier and I volleyed possibilities back and forth.

"Why don't we ask him how much money he made last year?" I suggested.

"No. I have a better idea," said Collier. "Let's ask him about the biggest single profit he ever made off a collector."

Just then it hit me. Here I was in the office of one of the most highly regarded dealers in the world, an accomplice to utter nonsense. Rather than closing a deal on the *Mao*, I was seriously pondering what sort of probing question I should be asking this joker. In just about any other industry this would *never* happen. Imagine Jack Welch, the former chairman of General Electric, having this same conversation with two of *his* better clients.

Exactly sixty seconds later, Jim walked back in.

"Time's up. What's your question?"

Before I could say anything, Collier blurted out, "Have you ever had a homosexual experience?"

If there was one thing the art world liked talking about, it was homosexuality. Jim grinned and said, "No. But I can see what's on *your* mind."

So much for great revelations of the art world.

At that point, Jim sat down and started fidgeting in his chair. It was obvious that he was too distracted to consummate any sort of transaction. Rather than have him withdraw the painting, which he had been known to do in the past, I suggested that we talk later that night. He nodded, relieved by not having to make a commitment. With that, Collier and I took off.

After we left the building, I watched Collier casually slip into a sleek black Ferrari convertible. Money is meaningless in the art world—everyone has it. What *really* matters is the quality of your art collection. Anyone can buy an exotic car, but only one person can own Jim's *Mao*. Therein lay one of the golden lures of collecting art. Some publications refer to art as the last great luxury. They are right. By hanging your home with works by leading artists, you announce to all visitors that you are above the fray. Not only do you have money, but you possess something even more valuable—taste and sophistication.

Thanks to surprisingly light traffic, I arrived within a few minutes at the Shangri-La Hotel. Since the city's gallery scene had migrated to Santa Monica, the former Art Deco apartment building had become the hotel of choice. After checking in, I took a quick nap, trying to clear my head of all the Corcoran Gallery insanity. Before I knew it, the hours had slipped away and it was time to head back to the gallery for dinner.

I pulled up to Jim's art emporium and handed my car keys to the valet. The party was in full swing and the martinis were flowing. Remarkably, every aspect of the affair was first-rate—from the high-quality vodka to the well-groomed waiters. Despite the elitist nature of the art world, most galleries throw terrible parties. The bottom line is that they are reluctant to open their wallets. Gallery openings are notorious for serving the cheapest wine possible. While there is always an understandable fear of freeloaders, it seems counterproductive to risk alienating legitimate buyers with jug wine. But Jim believed in the best.

The dress code at an art event is less straightforward than the wine selection. It is always one extreme or another. At that time, either the guests wore the latest from Maxfield's—the L.A. clothing store of the moment—or they appeared as if they had gotten dressed in the dark. But that night, most of the revelers were wearing what I call "art world black." I never knew there were so many shades of black: blue black,

charcoal black, jet black, just plain black. Although the expression "terminally hip" hadn't been introduced yet into popular jargon, that evening's gathering may have provided the inspiration for the term.

I noticed that the artist delegation had already started breaking up into small cliques. Generally, the established artists would form one group and the emerging artists another. There was a reason for this. It is a truism in the creative world that a young artist has to pay his dues. You pay them by working your ass off to find representation at a top gallery. Until that happens, you just don't deserve to hang out with the artists at the top of the food chain.

Looking around, I saw one artist standing off by himself. An aura of superiority seemed to envelop him. He was wearing an Armani blazer, pressed jeans, and Belgian Shoes. He was of medium height with broad, sloping shoulders from too many workouts at Gold's Gym. He had an angular head with closely cropped dark hair. I sensed that, rather than join the crowd, he was waiting for people to seek *him* out. Sure enough, a few seconds later, one of Los Angeles's most important collectors strolled over and embraced him.

Chuck Arnoldi may not have been a household name in New York, but in Los Angeles he was a certified art star. He was also the Corcoran Gallery's biggest-selling artist. For a period of time you couldn't walk into a prominent local home and *not* see an Arnoldi on the wall. Knowing a good thing when I saw it, I once pitched him to show at Acme Art. Over lunch, I used every compliment I could muster to convince him to join my stable. Chuck just soaked up the praise like a thirsty cactus after a desert downpour. When we finished our meal, he reached over and handed me a flat knife.

"What's that for?" I asked.

"That's in case you want to butter me up some more."

Chuck Arnoldi never joined my gallery, but that was a few years ago. Times had changed and that night I found him approaching *me*.

"So Richard, I hear you're in the market for a serious Warhol. That's a gutsy call. Why don't you go after a sure thing and buy one of *my* paintings?"

Some things never change.

I had to explain to him that while I was a fan of his work, I had my reasons for buying a Warhol. I didn't have the heart to tell him that I was

concerned about liquidity. If push came to shove there was a far greater audience for Warhol than Arnoldi. It was much easier to get a collector in New York or London on the phone to offer him a work by an international artist who was in every museum and art history book than an artist who was a star only in Southern California.

Adjusting his lapel, Chuck turned to me and asked, "So, have you found a Warhol yet?"

"Possibly. Jim has a terrific *Mao* in his office. Want to see it?"

Chuck's eyes lit up and we discreetly left the party and walked into Jim's office. The room was perfectly lit with a lone spotlight illuminating the painting. Even someone as jaded as Chuck had to be impressed. For a moment he was speechless. When he finally spoke, I wished he hadn't.

"That's quite a painting," he said, taking a step toward the picture. "I've always wanted a Warhol. *Maybe I'll buy it.*"

I was shocked because I knew he was serious. That's all I needed— more competition. If this turned into a bidding war, I knew Chuck's bankroll was fatter than mine, and Collier had more money than both of us put together.

Trying to change the subject, I said, "So Chuck, tell me about the new series of paintings you're working on." That seemed to do the trick. We wandered back to the party where we noticed Jim standing alone in a corner, looking a bit melancholy.

Chuck said to me, "Corcoran looks like he's at a funeral."

"Yeah, he's mourning the loss of $800,000," I said, trying to keep a straight face.

As we continued talking, a tuxedoed waiter ushered us into the main space for dinner. My dining companions were a microcosm of the art world: a dealer, a critic, a pair of collectors, a curator, and a couple of artists. As the appetizer was served, the usual art world gossip began: which artist was leaving which dealer (old news), a controversy over a show at a museum that included paintings owned by its trustees (a serious conflict of interest, but every museum was doing it), and who had recently come out of the closet (also old news).

As the meal gathered momentum, I noticed our overly solicitous waiters were filling our glasses with wine at every opportunity. I couldn't have taken more than two sips of my Edna Valley chardonnay before a

tiny cascade of liquid seemed to come from nowhere and top off the contents of my glass. By the time the main course was set before us, most of us were inebriated.

Scanning the other tables, I noticed the guests were getting a bit rowdy. Jim Corcoran's table was particularly boisterous. I heard Squid loudly arguing with his current girlfriend, Cherise Chen. At another table, two of Jim's cronies, affectionately known as Z and Pokey, were also well on their way to oblivion. Even the normally dignified curator Henry Hopkins appeared tipsy, a toothy grin flashing under his gray moustache.

I turned to nobody in particular and slurred, "This is starting to get ugly."

The words had just left my mouth when a chicken wing flew across the room like a greasy missile. It failed to do any damage and slid harm-lessly across the floor. The next salvo proved more deadly: a chicken wing scored a direct hit on Marcia Weisman's blond bouffant. The indig-nant doyenne of L.A. collectors spun around and hurled an uniden-tified piece of food in retaliation. That was it—pandemonium erupted in the Corcoran Gallery. Guests intent on self-preservation began hoist-ing up sections of white tablecloth to protect themselves from the crossfire.

As it happened, the carnage occurred while Jim was out of the room, but the audible commotion brought him rushing in. By the surprised expression on his face, I couldn't tell if he was going to put a quick stop to the riot or join in. While he was making up his mind, a whole chick-en breast took flight and just missed hitting Chuck Arnoldi. Never one to back down from a fight, Chuck grabbed a drumstick and hurled it at the perceived marauder. His intended target ducked and the drumstick kept going until it splattered on an Ed Ruscha silhouette painting of a Joshua tree—leaving a grease spot the size of a silver dollar.

Just like that, the dinner party's hostilities came to a screeching halt. A $65,000 painting had been damaged, perhaps irrevocably. The artist himself was at the party and came rushing over to inspect the injury. A look of anger slowly crossed Ruscha's face as he said to Jim, "I sure hope you have insurance."

That was it. The party was over. No one even bothered with dessert. One by one, the guests hastily gathered up their belongings and went up

to Jim to thank him for dinner. But I didn't care about such social amenities—all I could think about was buying the Warhol. Knowing I had nothing to lose, I waited until everyone had left and said to Jim, "Great party! Let's go into your office and take another look at the *Mao*."

Jim stared at me for a moment, glanced at a chicken wing on the floor, then shrugged. "Sure," he said. "What the hell." When we were inside his office, he sat down wearily and said, "That's the last party you'll ever see at *this* gallery. If I find the asshole who hit the Ruscha...."

I nodded sympathetically. I considered fingering Arnoldi, but resisted. "So how much do you want for the Warhol?"

"You know, Richard, the more I look at this painting the more I like it. Why should I sell it? I don't need the money. I think I'm just going to hang on to it," said Jim, with a tone of finality.

I was crushed. All that for nothing.

"What I do *need* right now is something to settle me down," said Jim. "You want a shot of vodka?"

With that, he went into a small Eames wooden cabinet behind his desk. As he carefully opened a hidden compartment, a wide grin crossed his face. He reached in, extracted a piece of light blue paper, and held it aloft triumphantly. It was the missing $800,000 check.

5

THE KING KONG
OF GALLERIES

IN THE MONTHS FOLLOWING WARHOL'S death, the market for contemporary art began to explode. But in October 1987, the stock market crashed and suddenly there was a great deal of apprehension. The November auctions at Sotheby's and Christie's were only a few weeks away and no one knew if collectors would panic and stop buying. Watching your stock portfolio plunge can be a very sobering experience. Surprisingly, not only did the auctions find willing buyers, but works of art began to sell for record prices. Leading the charge was Andy Warhol.

Collectors took money out of the stock market and began pouring it into tangible assets—real estate, antiques, and art. Traditionally, money goes where it's treated best and there was something in the air that indicated the art market would treat it like a queen. Collectors began to snap up the Pop artists who had been undervalued for years. Auction houses break art down into selling categories: Impressionism (post-1870: Monet, Renoir, etc.); Modern art (post-1900: Picasso, Matisse, etc.); and Contemporary art (post-1945: Pollock, Warhol, etc.). Traditionally, Impressionism had always attracted the big money, closely followed by Modern art. But suddenly Contemporary art caught fire. Collectors began to see a real opportunity there and the boom was on.

With the death of Warhol, collectors and dealers realized that the Pop artists were mortal and weren't going to be around forever. While he was alive, the record for one of his paintings was set in 1986 when *200 One*

Dollar Bills sold for $385,000. Compared to other major figures, this was a rather anemic high-water mark. Warhol had always been taken for granted by the art market.

In a way, Warhol was partly to blame if he thought his prices were too low. The art market has always had a hard time with any artist who wears more than one hat. Not only did Warhol make paintings but, during the early 1960s, he was also a committed filmmaker. Although many of these films are tedious to watch—*Sleep*, a six-hour marathon of a nude man sleeping is a prime example—they've still found a niche in the history of avant-garde cinema. Eventually, Warhol realized that he was better off sticking to his painting. Or, as he confessed in an interview with art-world journalist Paul Taylor, "My films are better talked about than seen."

Later, in the mid-1960s, Warhol got involved in producing and promoting the rock band the Velvet Underground. Led by Lou Reed, the group boasted a German singer of questionable talent (but unquestionable good looks) who went by the single name Nico. Warhol designed the cover of their first album: a bright yellow banana with a removable peel. Warhol was quite taken with the rock scene and once contemplated trying to put on the world's biggest rock concert—at the Taj Mahal.

Then came the 1970s and *Interview* magazine, and with it the accusation that Warhol was spending too much time socializing and not enough time in the studio. Like everything he attempted, the magazine was fresh, quirky, and original. But since its contents helped fuel the rapidly emerging celebrity culture, it reinforced the art market's perception of Warhol as a Salvador Dalí–type artist—more interested in publicity and money than painting.

In the mid-1980s, people talked more about Warhol's cameo appearance on the television show *The Love Boat* than about his latest silkscreens. The show, produced by noted art collector Douglas Cramer, called for Warhol to play himself. According to *The Andy Warhol Diaries*, he enjoyed the experience but resented being asked to speak the line "Art is crass commercialism." His *Love Boat* episode proved popular with viewers but, once again, reinforced the bias of the art market against an artist involved in more than one creative endeavor.

There was also the issue surrounding the perceived availability of Warhol paintings. Since he was extremely prolific, collectors wrongly

assumed that there would always be plenty of work for sale. If you wanted a Jasper Johns (who painted perhaps twelve canvases a year) you had to earn it by pursuing a relationship with Leo Castelli. The same rules applied to buying a Roy Lichtenstein, even though he may have produced three dozen paintings a year. Since Warhol's average yearly output numbered in the hundreds, collectors felt no sense of urgency and tended to put off filling the Warhol gap in their collections.

But times had changed. Now that Warhol was gone, the fact that there were a large number of paintings worked in his market's favor. It allowed more people to own work, which increased his visibility, which, in turn, ratcheted up interest and demand. That demand was evident with the prices he and his fellow Pop artists achieved at the November 1987 auctions. Once these sales ended, the art market took a deep breath and wondered what was next. By the following round of auctions, in May 1988, it found out—prices for Contemporary art shot up even higher.

While the death of Warhol and America's stock market crash played a part in triggering the art market's rise, an additional crucial factor was the Japanese. Toward the end of the 1980s, Japan began to experience a dramatic rise in real estate prices. Suddenly, property owners had become extremely rich, at least on paper. By using their inflated real estate as collateral, they were able to borrow large amounts of money at rates far lower than those Americans and Europeans were paying. Some of these borrowers leveraged this money to invest in art, often preferring to buy at auction.

Although many Japanese continued their traditional pattern of buying Impressionism, a younger, new wave of dealers and collectors sprung up and became hooked on Contemporary art. Studies show that during this time period, the Japanese were fully responsible for about one-third of the buying at auction, with the other two-thirds spilt between Americans and Europeans. What's more, buyers from Japan tended to be less discriminating in what they bought and had a tendency to overpay—which helped to artificially boost prices. But, then again, when you're using "play money," what did it matter?

During the May 1988 sales at Christie's, five Warhol paintings came up for sale and each of them sold for more than their presale estimates and, in some cases, for *much* more. For example, *Four Marilyns*, which

was put up for sale by Andy's brother, Paul Warhola, came on the auction block with an estimate of $60,000–$80,000. It sold for $484,000. At the same sale, *Elvis IV*, once given as a gift from Warhol to Bob Dylan, came up with an estimate of $250,000–$350,000. It soared to a final selling price of $880,000. Even a minor painting of a butterfly from the *Endangered Species* series more than doubled the low end of its $40,000–$60,000 estimate to sell for $110,000.

By November 1988, Warhol prices were headed to the stratosphere. At Sotheby's, the multiimage *Marilyn Monroe (Twenty Times)* roughly tripled its estimate of $1.25–$1.75 million to sell for $3.9 million—a new record for the artist. The decade's prices for Warhol finally peaked a year later, in May 1989, when the infamous *Shot Red Marilyn* sold for $4 million.

Shot Red Marilyn has a fascinating history. In 1964, an acquaintance of Warhol's showed up at the Factory, jokingly asked Andy if she could shoot one of the 40-by-40-inch *Marilyns*, and then shocked Warhol by pulling out a pistol and blowing a hole through Marilyn's forehead. The painting was leaning against the wall with several additional *Marilyns* stacked behind it. The slug made a neat little hole that penetrated all of the paintings. The works were skillfully restored, and rather than reduce the value of the paintings, the shooting incident gave the pictures a mystique that actually *increased* their worth.

By the end of 1988, with auction fever fueling demand, my search for a Warhol was on the verge of becoming prohibitively expensive. I remained hopeful, but the market was getting away from me. And although I was still being sent transparencies, the paintings were either ridiculously priced or of inferior quality. I was beginning to think that I might have to wait things out on the sidelines when I got a call from Jack Glenn, a private dealer who I spoke with on a regular basis.

Originally from Kansas City, Glenn had gotten his first taste of the art world as a collector of Pop art. His collection once boasted a Lichtenstein, a Rosenquist, and a significant Warhol canvas, *Red Elvis*. Eventually, the collection took on enough prominence to appear in several national magazines. During the seventies, Glenn sold his paintings and moved to a suburb of Los Angeles where he opened an eponymous gallery. His reputation for having a strong eye and being a genuine enthusiast was offset by mixed appraisals of his business dealings.

I can safely say that he was the most upbeat person I ever met. One day, I couldn't resist asking him how he always managed to stay so positive. He replied, "The way I see it, I'm 59 years old, which means, since the average male life span is 76, I have approximately 6,200 days left to live—doesn't sound like much, right? Well, if you approach life on those terms, it sort of puts things into perspective. When a friend of mine broke my life down like that it really turned my head around and convinced me to enjoy each day."

Everyone seemed to have an opinion of Glenn. According to the realist painter Dan Douke, who once showed with his gallery, "Jack was a lot of fun. He was successful selling my work, but it was always an adventure to get paid. Even if he owed you money, he was so charming that you'd leave his gallery feeling as if you were the one who owed *him*. He was also a stylish guy who paid attention to fashion and used to wear red snakeskin cowboy boots. I remember that his gallery was an old converted bank building which he decorated with fine antique furniture. He used to sit behind a carved rosewood desk with his feet up, proudly showing off his boots."

Douke went on, "Jack was also a bit of a maverick when it came to taking out ads in art magazines. For instance, he once ran this ad that looked like a green freeway sign, which read, '3,000 miles to New York, 6,000 miles to Paris, 20 miles to the Jack Glenn Gallery.' I'm not sure how much sense the ad made, but it was definitely eye catching. He also once did an ad with a picture of King Kong. Right below the gorilla, the text read, 'Jack Glenn, the King Kong of Galleries.'" Although the gallery-going public loved the ads, the art magazines were less than thrilled because, allegedly, Glenn didn't always get around to paying for them.

Many years later, just before Glenn went private, he owned a gallery called Glenn-Dash. His young partner, the late Philip Dash, was a real piece of work. With Glenn's gleeful encouragement, Dash used to cut up gay male porno magazines and use the penises to make collages—which were then faxed to fellow dealers of a similar persuasion. I've often wondered, what is it about people who work at galleries and their desire to make art from penises?

Glenn was a big fan of Ivan Karp. He once paid Karp good money to fly to Los Angeles to do a lecture at his gallery. In order to insure a

decent turnout, Glenn mailed invitations advertising that Karp would be speaking on the inner workings of the New York art scene. I attended the lecture and sat mesmerized as Karp spoke at length about the current Cajun food craze and his love of blackened redfish—not a single word about art. When Karp concluded his talk, Glenn was absolutely ecstatic, and the audience, taking a cue from him, applauded wildly— thinking they had experienced something profound.

When I called Glenn to see what he had for resale, I expressed my frustration at not being able to acquire a Warhol. Earlier that week I had been offered a sensational small painting, *Lavender Marilyn*, that unfortunately far exceeded my $100,000 budget. Glenn commiserated with me and then, with awesome timing, announced that *he* had a *Marilyn* for sale that I could afford. In fact, not only did he have a *Marilyn*, but he also had an *Electric Chair*, a *Car Crash*, a *Marlon Brando*, and about a dozen other Warhol canvases—all from the sixties and all within my price range!

I was dumbfounded. On the surface, Glenn's pronouncement made no sense. Had he mentioned only the *Marilyn*, I would have been amazed. Now I was suspicious. There was no way a dealer could have had a stash of Warhols of that magnitude and kept it a secret. Then there was the question of the low price. To allay my suspicions, I asked him about the provenance of the paintings.

Glenn replied, "Rather than discuss it over the phone, why don't you just come to L.A. and see them in person. I promise you won't be disappointed."

Even if the paintings proved to be bogus, there were always other deals that I could pursue in Southern California. A few days later, I flew into LAX. It was remarkably clear and the Los Angeles basin had been swept clean of smog by a steady wind. I could even see the distinctive Hollywood sign in the distance. After driving in an endless centipede of traffic, I finally wound up at Glenn's apartment.

At this stage of his career, Glenn had become a bit reclusive. Yet, when I rang the doorbell, Glenn greeted me effusively and poured me the L.A. drink of choice (ice tea). I looked around, but was not impressed by what I saw on his walls. Curiously, there wasn't a single Warhol in sight. Rather than immediately ask to see the paintings, I let him determine the agenda.

Glenn insisted that I have a seat. He settled back on a fifties-style sofa and began to regale me with tales of his days as a young collector. Although the stories were entertaining, I wasn't in the mood. I just wanted to see the Warhols. Near the point of exasperation, or maybe it was exhaustion, I said, "Those are great stories, but what about all the Warhol paintings. I don't see any of them hanging. Where are they?"

"I thought you'd never ask," he laughed. "Coming right up!"

Glenn disappeared into his bedroom and emerged with a tremendous cardboard shipping tube. It was filled with rolled canvases. He carefully pulled the paintings out of their narrow home and slowly laid them out on the bleached hardwood floor. I couldn't believe my eyes as he casually unveiled an incredible double-portrait of Marlon Brando. Marlon was dressed in leather and sitting confidently astride his motorcycle in a still from *The Wild One*. After the *Brando* was unrolled, the parade of iconic Warhols continued with a pink *Electric Chair*, followed by a couple of gold *Jackies*, a multicolor *Flowers* painting, and then a lime green *Car Crash*. I felt as if I had hit the aesthetic mother lode.

Then Glenn cheerfully said, "I have the rest in another tube, I'll be right back."

"Jack," I said. "Wait a minute! Let's just look at what you have here."

He chuckled and said, "Not bad, huh? I'll bet you've never seen this many great vintage Warhols in your life."

"Of course I haven't—no one has," I said. "Do you mind if I take a closer look at them?"

"Be my guest," said Glenn.

I examined the *Marlon* first. It was a nice-sized picture, perhaps 3 by 4 feet. Knowing a little about the *Marlons*, I remembered that Warhol screened them onto raw brown linen rather than canvas. Sure enough, Glenn's painting was on *raw brown linen*. I also looked carefully at the other paintings, but could find nothing wrong with them. I kept thinking, "This just can't be." Next, I flipped over the paintings and saw that none of them bore signatures—finally, a problem.

I said to Glenn, "They look good, but they're not signed. Where did you get them?"

Glenn beamed and said, "They come from one of Warhol's old studio assistants who received them in lieu of a salary. He's had them rolled up and stored in his attic since the sixties."

In the art business, there are two standard stories that you never buy into: "I found the painting in an attic," and "The painting came from my grandmother." But what you *really* don't want to hear is, "I found the painting in my grandmother's attic."

"That still doesn't explain why they're not signed," I said.

"I have no explanation for that. The owner of the paintings died and I got them from his lover. He really wasn't able to tell me much about them."

I then asked the next logical question, "Have you shown them to the Warhol Foundation for authentication?"

"I really don't want to do that since the owner's relationship with Andy was highly personal."

At that point, I knew there was a major problem. If the authentication committee inspected a painting and thought it was of dubious origin, they would place a rubber stamp on the back denying its approval. Obviously, the owner didn't want to risk that.

"So how much do you want for them?" I asked.

"Depends on the painting. I think the *Marlon's* the most valuable, so I want $7,500 for it. I'll sell you the *Electric Chair* for only $2,500."

That clinched it. I said, "Come on Jack, I've known you a long time. The paintings that you've just shown me are worth hundreds of thousands of dollars. What's going on here?"

"Richard, all I can tell you is they're real," he said, with a slight confrontational tremor in his voice. "If you want to take a chance with the authentication committee, it might be a good gamble. But I admit, without a signature, an authentication stamp, or a plausible provenance, they would be very difficult to resell. But you have to agree, they look terrific."

I stood there for a few minutes, debating the right course of action. It was an art dealer's worst nightmare. At first glance, the paintings looked right as rain. But as I stared at the *Electric Chair*, I noticed the sign in back of the chair—the one that admonished "Silence"—was completely obscured with heavy black ink. Then I noticed the image had a funny quality to it, as if it had been screened in haste. Still, it was hard to say if the painting was right. Maybe my imagination was playing tricks on me because I *wanted* to find fault.

While there wasn't an obvious red flag, something was clearly off. I reluctantly decided to pass and promised Glenn that I wouldn't tell anyone about the paintings. I thanked him for his time and drove off. Midway down Wilshire Boulevard, it hit me. The paintings were definitely from Warhol's screens, but had probably been run off by an assistant after hours, when no one was looking. The *Electric Chair's* shaky screening could be attributed to nervous hands working in a hurry. While no one could ever prove it, this was probably what happened.

Over the years, I never heard again about those paintings. I also never did see the *Marilyn* that lured me in the first place.

6

TUNAFISH DISASTER

LEAVE IT TO JIM CORCORAN to sum up the prevailing attitude among deal-
ers. As he put it, "Many people in the world suffer from low self-esteem.
But art dealers suffer from self-esteem that's too *high*." Jim was right, of
course. Most art dealers acted as if they painted the works themselves.

Not that I was immune from being a little haughty myself. I started to
believe that San Francisco was too small a town for my ambitions. Lia
and I decided that the time was right for a move to a bigger city with a
more dynamic art scene—Los Angeles. By the late 1980s, Los Angeles
was making a strong claim to overtake Chicago as the nation's number
two art market. Change was in the air. The city had just opened MOCA,
a new museum dedicated to contemporary art. Galleries were springing
up like mushrooms and the city was about to host its first contemporary
art fair.

By early 1989, we had closed Acme Art, moved to Santa Monica, and
became private dealers. Freed from the constraints of having to run a
gallery, we envisioned a life of pleasure and travel in the pursuit of art
deals. Without the overhead of a gallery we also saw the potential for
greater profits. However, there was a tradeoff. By giving up our space, we
knew there would be fewer opportunities for meeting new clients. There
was also the issue of no longer having access to consigned inventory
from the artists whom we represented.

Yet it seemed like a logical progression in my art-dealing career. After
all, the greatest part of our income had come increasingly from our back

room dealings. The reality of the industry is that galleries rarely make a living from their monthly exhibitions. They often rely on selling material that they've kept stashed in a room behind their main exhibition space, hence the expression "back room."

Basically, there are two approaches to the secondary market business. You can take works on consignment, but that usually results in small commissions. Or, if you have the financial wherewithal and ice water in your veins, you can borrow money, buy a few paintings, and speculate on them. This is the equivalent of trading your own account in the stock market.

To become a successful stock trader you have to be adept at research, focus on a specific industry, be extremely disciplined, remain unemotional, and then place gutsy bets. You're taught to buy industry leaders that are well managed and then hang on to them. Conventional wisdom is that you make money in the stock market by being a long-term player. To that end, brokerage houses hire analysts to determine which companies have the best future prospects. At the end of the day, however, it often comes down to plain dumb luck.

When it comes to dealing art there's a surprising amount of overlap with trading securities. In the art market, you can substitute major artists for industry leaders and upper-echelon galleries for well-managed companies. Focusing on a specific industry is the equivalent of trading in artists from a distinct movement, such as Minimalism or Photorealism. Research comes down to studying a decade's worth of auction catalogues and memorizing the results. As for staying disciplined and remaining unemotional, that depends on one's personality. Ultimately, you have to believe in yourself and the position you've taken.

Both the stock market and the art market use the term "blue-chip" to describe high-end commodities. In most scenarios, buying a blue-chip company like Wal-Mart is a relatively safe move. While the stock market is cyclical, the odds are in your favor that this corporation will survive periodic shakeouts. You could draw a similar analogy to buying blue-chip artists such as Picasso and Matisse. The art market also has its ups and downs but, even in a recession, chances are that Picasso and Matisse will go down less than most other artists. However, the art market's comparison with the stock market ends there. The major difference is

liquidity. It takes only a phone call to your broker to buy or sell 1,000 shares of AOL Time Warner. If you want to buy or sell a Picasso, it's infinitely more complicated.

For the sake of argument, let's say you're a dealer with $500,000 to spend and you want to purchase a Picasso. Where do you begin? Your first decision is to determine which period of the artist's career has the most potential for appreciation. If you decide Picasso's Cubist works have the most upside, you're out of luck—you can't buy a Cubist painting for $500,000. A good one starts at $5 million. So, you're forced to consider buying a late work from the 1960s, for instance. But, even here, your vision is likely to be stymied because you would have to settle for an extremely small canvas. And while late Picassos have been increasing in value, this has been more a function of the scarcity of the early work than the quality of the late work. This means you're going to have to buy a painting that you might not necessarily believe in or want to live with.

Let's say that you've reconciled in your mind that although it's not your first choice, you'll take the plunge and buy a late Picasso. Your next move is to find a painting that's undervalued. The easiest course of action is to buy one from another dealer or at auction, but each of these options has its drawbacks. If you buy from a dealer, you may be buying a painting that's less than fresh to the market. Chances are that, despite the dealer's furious denials, it's been shopped around—which reduces its desirability. If you buy at auction, the amount of money that you paid for the painting becomes public record. As a result, you usually have to warehouse the picture for at least two years, until collectors have forgotten about the painting and what you paid for it.

The best-case scenario would be if you already knew of a late Picasso in a private collection. Assuming you had a good relationship with its owners, you would still need to summon the courage to place an exploratory phone call. You call them up and yes, as a matter of fact, they might consider selling for the right price. Now you've opened Pandora's box.

Initially, the collectors are going to rely on you to give them an honest appraisal of the painting's value. If you quote too high a price just to hype them into selling, you're going to have a problem down the road when you fail to deliver on your promise. Conversely, if the numbers pencil out too low, you may scare them out of selling. If the owners are

particularly savvy, they're going to ask you difficult questions about current market conditions as well as past results for similar Picassos at auction. Ditto for gallery prices.

Now you're in a no-win situation. Like being in a deposition, your best strategy is to answer the questions but not volunteer too much information. You want to allow yourself as much room as possible to maneuver. It's unfortunate, but you can't be totally forthright with the owners and still make money. For example, if you give them an honest evaluation of their picture and tell them it's worth $500,000, they'll say, "Fine, give us $500,000." Although they expect you to make a profit, even if you offer them $450,000 and explain that a 10 percent profit is extremely reasonable, chances are they'll be appalled by your greed. All the collectors see is that *you're* going to make $50,000.

What collectors don't understand is that you're taking an incredible gamble if you buy the painting. They have no idea what you're up against. For openers, chances are you borrowed the money and have to pay carrying costs. Let's say your cost for the use of $500,000 is 10 percent. That means for each *month* you hold on to the painting, your account is debited $4,166, or $50,000 a year. If you can't position the painting within a year, you may have to try and dump the work at auction just to recoup your losses.

Then, there are a multitude of expenses that you're likely to incur by selling the Picasso. You have to insure the painting, you may have to hire a conservator to have it cleaned, and you'll probably need to put an expensive gold leaf frame on it. There may also be crating and shipping costs. To market the painting you have to employ a professional photographer to shoot costly transparencies. While all of this is being done, the meter continues to run.

Your investment is also vulnerable to the vacillations of both the American and international economies. When economic conditions go south, one of the first things the wealthy quit buying is art. Aside from that, there are also fluctuations within the art market. Let's say that a major Picasso collection comes on the market and winds up at auction. Such a sale could go either way. If the sale is a disaster, you have a serious problem on your hands.

But, for the sake of argument, let's say that the stars are perfectly aligned and luck is with you. A group of late Picassos come up to

auction and all of them sell over estimate. The ensuing publicity from the sale gives you some positive momentum. After only three months you find a buyer. However, the buyer turns out to be another dealer, which means you're not going to make as much of a profit as if you sold it to a collector. A dealer will only buy if he foresees a chance to make money, which translates into giving a discount. What's more, many dealers are notoriously slow about paying their bills. With some reluctance, you agree to a deal, ship off the painting, and pray you'll be paid in a timely fashion. But even then you're not home free.

The painting could arrive damaged from shipping. Or the dealer's commitment may be a ruse. He may have agreed to buy it just to get you to send him the painting. Meanwhile, he was really planning all along to show it to a collector. The collector sees the painting and turns it down. The dealer then calls you with the absurd excuse that the painting has a "condition" problem or says the provenance you gave him was inaccurate. Believe it or not, a well-known Madison Avenue dealer has a reputation for periodically pulling this scam.

It's been said many times before, but the only time you have a firm deal is when you deposit the check—and it clears. Such risks explain why a dealer is often forced into misleading a collector on the value of his property. Realistically, you can't buy inventory and make only 10 percent. On a $500,000 investment, you're looking to make $150,000 to $250,000, or more.

The other approach to dealing out of the back room is taking works on consignment. Here, it's completely logical to broker deals for 10 percent. After all, you're not risking your own capital. Unfortunately, when you receive a blue-chip work on consignment, it's usually not first-rate. If collectors have something outstanding to sell, they know they can find a buyer on their own or put it up to auction. There are exceptions to the rule. If the collector originally bought the work from you, as a courtesy he might let you handle its resale. For that reason, whenever possible, you want to sell to a collector rather than a rival dealer. That way, you're building a bank of potential inventory.

If you're fortunate enough to secure a great consignment, it's still not time to celebrate. If you don't move fast enough, the collector can (and will) withdraw the work on a whim. Sometimes a rival dealer will see a picture in your gallery, know the collection it comes from, and call the

owner to make a deal—cutting you out of the loop. The point is that whenever possible you want to control the art object. To succeed on the secondary market, you generally have to be a well-capitalized dealer. The catch-22 is that if you're a well-capitalized dealer, you probably wouldn't be dealing art—you'd be collecting it.

At any rate, we settled into Santa Monica and began life as private dealers. While searching for a Warhol was still very much of a priority, so was making a living. To that end, I called Jim Corcoran to see what was at the top of his wish list. Dealers often call each other on what I refer to as "fishing expeditions." In other words, you may not be calling about a specific painting, but you hope your discussion leads to hooking a big one.

My conversation with Jim went something like this, "Hi, what are you looking for these days?"

"Well, I could use a Diebenkorn figurative drawing," said Jim.

"Really? I actually know of one. Want me to send you a photo of it?"

"That would be great. Anything I can do for you?"

"I have a firm buyer for a Hockney colored pencil drawing."

"I've got one—I'll have Barbara send you a picture of it today."

Two days later, our mail crossed and I received a call from Jim.

"Hi, Richard. I just took a look at your Diebenkorn."

"What do you think of it?"

"I think it's a piece of shit—I'd be ashamed to offer it to one of my clients. What do you think of the Hockney?"

"Well, your drawing is no great shakes either."

"Fine," said Jim, hanging up without saying good-bye. Fortunately, most of my conversations with him were more productive.

Besides having a close working relationship with the Corcoran Gallery, I also had ongoing dealings with Jonathan Novak, a private dealer. Typical of the art business, Jonathan became an art dealer through an unusual set of circumstances. Originally, he was a trial attorney with a San Francisco law firm, on the fast track to becoming a partner. But he had also taken a Sotheby's course in London and developed an interest in the art market. Jonathan began dealing contemporary prints, as a side venture, and slowly developed a clientele.

During the late 1970s, his firm represented the few survivors of the Jim Jones People's Temple tragedy in Guyana (they survived because

they remained in California). Evidently, there were a few million dollars in the cult's bank account that needed to be divided up and distributed. Once the case was settled, Jonathan had to fly to Watts, the notorious Los Angeles ghetto, to hand-deliver checks to some of the survivors. The experience was so unnerving that Jonathan soon stopped practicing law and turned his attention to dealing art on a full-time basis.

As he became more established, he moved his operation to his hometown, Los Angeles. Once he made the move, he quickly fell into the city's hedonistic lifestyle and his business began to flourish. He bought a deluxe mid-Wilshire high-rise apartment and, in a matter of a few years, was probably the city's top-grossing private dealer. With his success came an overwhelming need for personal services. The desire to have as much help as possible goes with the territory of being an art dealer. The business abounds with stories about the helplessness of dealers and their need for support services. Perhaps my favorite is the one about the New York dealer who decided to reposition a bench in his gallery—and hired an architect.

At one point, Jonathan's ever-expanding "staff" included two full-time secretaries, a preparator, a time-management consultant, a nutritionist, a maid, an accountant, a chiropractor, a wardrobe consultant who advised him on what colors to wear (he was a "winter"), a dry cleaner who came to his house (charge: $7.50 to launder a single shirt), and a woman named Sunday who diligently showed up once a week to water and fertilize his orchids.

One afternoon soon after arriving in L.A., I decided to drop by Jonathan's apartment to see if we could work on some deals together. I pulled into his driveway and was met by a valet who instantly whisked my car away. I took the elevator to the eighteenth floor and walked into a spacious sun-filled apartment. With one glance, it was easy to see why Jonathan's business was flourishing. His walls were covered with highly salable works from his inventory by Sam Francis and Jean Dubuffet.

As my eyes continued their lap around the room, I spotted some magnificent white Phalaenopsis orchids. My eyes then came to rest on Jonathan's beleaguered assistant, Julie Zdenahlik, a former employee of the Glenn-Dash Gallery. She appeared to be cleaning a gold leaf frame—with a Q-tip. I quietly strode a few feet closer to her. Julie must have felt my presence as she spun around and immediately turned red.

"Hi Julie, what on earth are you doing?" I asked.

"What does it *look* like I'm doing?"

"It looks like you're dusting a picture frame. But with a Q-tip?"

"Look, Richard, it's part of my job description—you know what Jonathan's like. You should have seen what I was doing a few minutes ago. I just cleaned out the refrigerator and threw away fourteen different jars of old mustard. Tomorrow, I'll start on the jellies."

I shook my head, "So, where's Jonathan?"

"He's with his personal trainer."

That's perfect, I thought.

I began to wander around the apartment and noticed an appropriation of an Andy Warhol *Tunafish Disaster* by the conceptual artist Lee Kaplan. His art centered around making color reproductions of well-known art historical images, scaling them down, and then subtly altering their appearance to change their content.

I heard the phone ring. Julie yelled out in a high-pitched voice, "Richard! It's for you. It's Jim Corcoran."

"What's happening, Jim?"

"Would you and Jonathan like to stop by for drinks and dinner later tonight?"

"Sounds good."

"How's the Jonestown lawyer?" asked Jim, with a touch of sarcasm.

"He's been doing a lot of business. I think he just made a killing at the Chicago Art Fair. Did you know he commissioned Lee Kaplan to do a Warhol *Tunafish Disaster*?"

"Of all paintings, why would he want to live with that?"

"Probably because Jonathan's two favorite foods are chicken and tuna. You might want to take that into account when you select tonight's menu."

There was a short pause in our conversation.

"Well," said Jim ominously, "he's about to have a tuna fish disaster of his own."

When Jonathan finally showed up, I told him about our dinner invitation. At first, he wanted to decline, given that he never felt totally comfortable around Jim. But when I suggested this was a golden opportunity to get to know him better and perhaps do some business, he relented.

Jonathan and I then began discussing potential deals, but I was distracted by his "Warhol" painting. The *Disasters* series, of which the *Tunafish Disaster* was a prime example, remains one of Warhol's most compelling and historically important bodies of work. Begun in 1962, the series focused primarily on horrific car crashes, but also included atomic bombs, suicides, race riots, and electric chairs. The majority of the paintings contained repetitive imagery. To see a group of mangled bodies sprawled on the ground was disturbing. To view the scene of carnage over and over again was numbing and unforgettable.

Among the finest *Disaster* paintings were the diptychs. For example, in the left-hand panel of *Blue Electric Chair*, Warhol staggered fifteen electric chairs in five rows of three images. In the corresponding right-hand panel, he intentionally left the blue canvas blank. At first glance, the viewer is confronted with a graphic indictment of capital punishment. The electric chair, a fraught image in American society, is illustrated over and over again until you feel sensory overload. But then, you look at the empty canvas next to all those cruel instruments of death, and your eyes and mind are given a much-needed rest. In purely aesthetic terms, the device of juxtaposing a canvas clogged with imagery next to one completely devoid of it is a visual stunner.

As for the *Tunafish Disaster* paintings, back in 1963 Warhol screened the newspaper headline "Mrs. Brown and Mrs. McCarthy Die of Tainted Tuna." On the same canvas, he also included images of two middle-class housewives who resembled pathetic contestants from the old television show *Queen for a Day*. Below that were multiple cans of A&P chunk light tuna, apparently poisoned with botulism as reported in the article. The ordinary appearance of the victims and the random nature of the accident is chilling. These paintings are everyone's worst nightmare—if it could happen to Mrs. Brown and Mrs. McCarthy, it could happen to you. Normally, a trip to the market to purchase a few cans of tuna is such a mundane activity that it's not worthy of discussion. But given Warhol's obsession with death, he was able to uncover a one-in-a-million event and use it to unnerve the viewer about future visits to the supermarket. While his *Campbell's Soup Cans* and *Brillo Boxes* are a meditation on the joys and visual stimulation of shopping, the *Tunafish Disasters* are a dark reflection on our consumerist society.

Despite the grim message of the *Tunafish Disasters*, each painting's black ink and metallic silver color carry such a strong visual punch that those confident in their taste would have no trouble hanging one of these paintings in their living room. Like all of the *Disasters*, once you get beyond the shock of the subject matter, you're left with paintings of incredible virtuosity.

Soon it was time to drive over to Jim's Santa Monica residence, which overlooked the Pacific. As he once put it, "Life can be pretty depressing without a view." The house itself was striking and decorated in an eclectic Californian-Mediterranean style. As we approached Jim's front door, Jonathan reached for a comb. He had just gotten a haircut at the trendy salon Juan-Juan, in the close-cropped style that was popular at the time. Jonathan had borderline movie-star looks and was a sharp dresser, but that night he wore a tacky Hawaiian shirt.

Jim welcomed us in and offered us martinis. Jonathan, who didn't really drink, uncharacteristically accepted Jim's hospitality. He rapidly drained his first cocktail and then asked for an encore. It was as if he sensed something was going to happen and whatever that something was, it would be better to face it while under the influence. The evening was being cohosted by Jim's girlfriend, Grace Yamamoto, an exotic Japanese woman who wore her hair in long dreadlocks. Other guests included Pokey (John Pochna), the owner of the new-wave Zero One Gallery, Squid, and a couple whose names I don't remember.

While I was getting reacquainted with Pokey, Jonathan discovered a skateboard and began to test it out on the living room's slick linoleum-tiled floor. Jim noticed, but didn't seem to mind. He then invited me into his den and pointed to a display case that was actually more of a curio cabinet. Inside the case was a handsome group of Indian artifacts. There were several beautifully carved arrowheads along with an ancient Clovis point. Another shelf revealed a tiny Mimbres bowl from New Mexico. The Mimbres culture was known for producing the finest American prehistoric pottery. Jim's bowl featured an interior pictorial of an indigenous turtle. I was impressed by its spiritual quality and the fact that its creator had painted it more than nine hundred years ago.

Jim was pleased by my response and said, "Look what's on the bottom shelf."

I looked down and saw a tremendous foot-long tooth from a woolly mammoth. I grinned because the tooth had originally belonged to me; I had swapped it with Jim for a rare Joseph Cornell catalogue. The catalogue was actually more of an elaborate portfolio and was desirable because it contained candid photos of the reclusive artist, additional photos of his box constructions, and a few essays, including one written by the actor and Cornell collector Tony Curtis. When I traded with Jim, we engaged in an epic battle to come to an agreement. After all, how do you put a value on a mammoth tooth?

We left his study just in time to witness Jonathan fall off his skateboard and crash into a coffee table. Fortunately, he wasn't hurt—which was more than I could say for the delicate ceramic sculpture that had been on the table. Having never seen this side of Jonathan before, Jim was totally amused by the incident.

Jim motioned us over to the dining room and we stumbled to the table in various states of coherence. I got there first and was impressed by the handsome arrangement of fresh cala lilies, bright Fiestaware, carefully folded linen napkins, and tasteful utensils. There were even place tags with everyone's first names carefully printed on them. Everything seemed *too* normal. My disappointment was short-lived once I saw what was placed in front of Jonathan's name. There, before my eyes, was a carefully stacked pyramid of a dozen cans of Chicken of the Sea albacore tuna, packed in water (not oil)—just the way Jonathan liked it.

Grace emerged from the kitchen carrying a steaming large bowl of linguini with roasted red peppers and grilled prawns. As the other diners found their places, she began dishing up the pasta. As luck would have it, Jonathan was the last to sit down. When he saw the small mountain of distinctive circular cans, his eyes grew wide and he yelled out, "Tuna!"

However, once he saw everyone eating and realized nothing else was forthcoming for him, he started to look a little worried. Finally, he said, "How am I supposed to eat this?"

"Oh, sorry Jonathan," said Grace, as she made a beeline to the kitchen. Seconds later, she emerged with a can opener and handed it to him.

That was it. Everyone else at the table ignored Jonathan's misery and happily consumed their pasta. Eventually, Jonathan had no choice but to employ the can opener and create his own dinner. I figured the least Grace could have done was give him a jar of mayonnaise.

As the evening came to its conclusion, I said goodnight and thanked Jim for a memorable dinner. He responded, "Glad you guys could make it. Jonathan—you're always welcome here."

Jonathan managed a weak smile, but said nothing. However, once we got into the car, I got an earful. All I could say to him was, "Well, look at the bright side—at least it wasn't A&P chunk light!"

7

BELGIAN SHOES

IT'S OFTEN BEEN SAID THAT the late 1980s art market was about auction fever. If that was the case, then I failed to get inoculated. Speculation ran rampant and I was certainly not immune from wanting to try my luck. At the time, a trip to Sotheby's or Christie's was like entering Monte Carlo. Just like that fabled gambling kingdom and its two-tiered casinos—one for the international jet set and one for the riffraff—the auction houses had their high-profile evening sales and less glamorous day sales. Unlike the casinos, the auction houses never comped hotel rooms or meals—just admission to one of the greatest visual spectacles in the art world.

The big money was made by buying a blue-chip work of art and paying whatever you had to—knowing it would sell for much more only a few months later. Then all you had to do was place a call to each auction house and let them slug it out for who would offer you the highest estimate. Once you selected one of the two houses, you'd sign a contract. Then your painting would be reproduced in an auction catalogue, collectors would lust after it, bid it up to the stratosphere, and you would walk away a few hundred thousand dollars richer. It sounded easy and, for a while, it was.

Obviously, the anatomy of an auction score is a little more complicated than that. The following story, which typifies a late 1980s deal, was told to me by a private dealer who is no longer in the business. The

details have been slightly changed to protect his privacy but are otherwise accurate. While this story illustrates the lucrative nature of doing business during that era, it is by no means indicative of a major deal. Instead, it was more of a mid-sized deal—just the sort of transaction that I would have gotten involved with at the time.

In 1989, a dealer whom we'll call Roger did some market research to determine if there were any historically important artists who were undervalued. At the time, the most alluring artists to speculate on were Andy Warhol, Cy Twombly, Roy Lichtenstein, Willem de Kooning, and Jasper Johns. Naturally, to trade in significant works by those art gods required millions of dollars of working capital. To put things in perspective, the Jasper Johns painting *False Start* sold for $17 million in 1988.

At the time, Roger identified the West Coast artist Edward Ruscha (pronounced Roo-shay) as someone who was grossly underpriced. Ruscha had a lot going for him. His work matured in 1962, just as Pop art was coming to the forefront. His pictorial niche was the Los Angeles urban landscape and he quickly gained recognition for his paintings of Standard gasoline stations, the 20th Century Fox trademark, and the city's giant Hollywood sign. He was also the first artist to use language as his primary subject matter; a signature Ruscha painting might be a 6-foot square canvas painted dark blue, with the word "Boss" superimposed on it in large orange letters. In 1973, he became the first and only West Coast artist to be represented by Leo Castelli—giving his work the imprimatur that should have catapulted him into superstardom. But it didn't.

The reasons why some artists make it and some don't are complex. In Ruscha's case, his reputation was probably held back by New York's prejudice against California—it was simply not considered a place to make serious art. But Ruscha persevered, and during the late 1980s, after almost twenty years of innovative work, his career took off. He had created a gutsy new group of paintings that were a radical departure from his Word imagery. The new work depicted quintessentially American images such as wagon trains, buffaloes, and tract homes that were airbrushed in black silhouettes.

Although critics were perplexed by the new work, a handful of visionary art dealers felt their antennae quiver. Something was in the air

that told them to reevaluate the earlier Word pictures, which were plentiful and affordable. In 1985, you could buy a high quality Ruscha Word drawing for only $3,500. A major painting would have cost approximately $45,000. While these prices weren't exactly pocket money, they were still highly attractive for most dealers.

A few of these prescient dealers, including Roger, began to quietly buy up Ruschas. As he began prospecting, his divining rod led him to a highly unlikely source—a gallery located in Los Angeles's Pacific Design Center, also known as the "Blue Whale" for its mammoth size and blue glass-clad exterior. The gallery, which shall remain nameless, was known primarily for exhibiting corporate art. Corporate art is essentially innocuous decorative works that won't make waves in the executive suites. Somehow, this gallery ended up with a better-than-average Ed Ruscha painting. The work was titled *The Past* and its words were painted to resemble the Hollywood sign.

Roger inquired as to its price and was quoted $35,000. In the current speculative market he thought it might be worth as much as three times that. Negotiations began, but the gallery held firm. Realizing *The Past* was a bargain even at full retail, Roger capitulated and agreed to pay their asking price. A deal was struck over the phone and Roger said he would stop by the next day with a check. Typical of art world dealings, that night he received an unsettling phone call from the gallery. Apparently, they had gotten wind that Ruscha was "in play" and suddenly they wanted more money for it.

Roger was seething inside but didn't want to blow the deal, so he calmly asked, "How much more?" The smooth female voice at the other end of the receiver said, "Another 10 percent: $3,500." Relieved that the final price wasn't twice what they had previously wanted, Roger agreed to the adjusted figure.

The next day he arrived at the gallery with a check and spirited the painting away before they changed their mind again. Knowing that he would be selling himself short by offering the Ruscha to a client at its current price, Roger decided to go for broke and put *The Past* up to auction—hoping the price he paid for the painting would be a thing of "the past." His suspicions as to the painting's true financial potential were confirmed by Sotheby's when they quoted him an estimate of $80,000–$100,000. But Roger wasn't satisfied. The estimate was fine, but

what he really wanted was an assurance that the painting would be placed in the prestigious evening sale.

During the art market's boom years in the late 1980s, the evening sales at Sotheby's and Christie's resembled high-powered cocktail parties, minus the alcohol. Instead, something far more intoxicating lubricated the night's social interaction—money. The audience was a heady mix of financiers like Saul Steinberg and entertainers like Sylvester Stallone. It seemed as if everyone was collecting Contemporary art. Since these high-profile art enthusiasts were there to be seen as much as anything else, there were always arguments over tickets for seats, even though they were free. Where you were seated said a lot about your status in the art world. The best seats, generally those closest to the auctioneer's podium, were reserved for the biggest players. I once wound up with one of those choice seats when a collector I knew couldn't make it. I'll never forget the pained expression on several prominent dealers' faces when they watched me stroll past them to sit near the likes of David Geffen.

Roger was able to convince Sotheby's to put his painting in the evening sale, which exponentially increased his chances of getting a high price. Part of the reason Sotheby's consented to Roger's request was because they hadn't been offered any other Ruschas. A great sale contains a harmonious balance of important artists, periods, and styles. The head of a department tries to orchestrate a sale so that it plays like a symphony. The auctioneer acts as the conductor and tries to build the bidding to a crescendo. If he's successful, collectors applaud with their wallets.

It is a known fact that art auctions operate on momentum. Experience has proven that it's often wise to open an auction with a small flashy work, conservatively estimated, that's almost guaranteed to sell over estimate. If the first few lots sell well, they tend to draw additional bidding on the lots that follow. Even though most collectors and dealers have set bidding limits before the sale, their strategies often fly out the window during a strong auction.

High prices breed confidence. Witnessing painting after painting exceed estimate convinces even the most insecure bidder that it's a safe time to be investing in art. Those who choose to swim in the deep end do so because they believe that they are making a fundamentally sound

investment. While they may pay lip service to their love of art, the reality is they care more than they let on about the works' potential for appreciation. Anyone who says otherwise is lying.

The auction market gives art prices validity. Dealers may brag how they sold a David Hockney for an even higher price than the one achieved recently at auction. But who can prove it? Are they going to show you the canceled check for what they paid for the work and the check for what they sold it for? Of course not. At least the prices realized at auction are a matter of public record. As a successful buyer, you know there was at least one other "fool" willing to pay one bid below what you paid.

Auction prices also create a meaningful secondary market. Without the auctions, if a collector ever wanted to resell a painting, he would be at the mercy of a dealer. In the long out-of-print book *The Art Crowd*, by Sophie Burnham, there's an account of a collector approaching a dealer to resell a Miró portfolio that he originally bought from him. The tale begins with the collector jauntily setting out for the gallery, convinced that after making multiple purchases from that dealer, he would be delighted to help him out. When the collector arrives, the receptionist discreetly informs the dealer as to the reason for his visit. The collector is kept waiting for forty-five minutes. When the dealer finally emerges from his office, the collector is given a plethora of excuses as to why the dealer can't buy the work back or resell it: "The market for Miró is soft right now," "Who would I sell such a portfolio to?" and so on. The collector left the gallery ashen-faced.

Roger waited patiently until November (the major American sales are held in May and November). When the sale catalogue arrived, Roger, like all dealers, opened it with great trepidation. A dealer lives in fear of turning the pages and coming across a painting that he once owned—now with a much greater estimate than what he'd sold it for. There's no worse feeling in the world than knowing that you should have held on to a particular painting. Unfortunately, most dealers have an acute blind spot when it comes to bemoaning the painting that "got away." They forget that they either made a reasonable profit on it or needed the money at the time. But Roger managed to avoid a swig of Mylanta—other than the Ruscha, there was not a single picture in the catalogue that once graced his walls.

A few days later, he flew to New York to attend the auction preview—an opportunity for the public to examine the works of art to be offered. The previews are serious business. Department specialists labor to install the works as if they are mounting a museum exhibition. The most valuable works are featured in the main room and are hung with plenty of breathing room around them. In fact, the more space around the work, the more important it is perceived to be. A serious buyer will use the preview to check the condition of a work, examine the provenance labels on its verso, and ask any relevant questions. If you have a good relationship with the head of the department, he'll inform you about the level of interest in a particular picture—thus helping you prepare your bidding strategy.

On the night of the sale, Roger arrived, was greeted by his colleagues, and took his assigned seat. As he looked up at the giant currency board, which resembles an electronic scoreboard at a basketball game, he began fantasizing about his painting. With each raise of a paddle, the amount of the bid is instantaneously converted into yen, deutsche marks, francs, and other major international currencies. With each conversion, the board makes a noise that resembles a hoard of locusts devouring a field of wheat.

In addition to the cacophony of sounds at an auction, there are the accompanying sights. One of the more remarkable displays is the rows of people with their auction catalogues on their laps, all open to the same page. For a minute or so you see dozens of images of, say, a Frank Stella "Black" painting. The overall effect resembles a room-sized multi-image Andy Warhol painting. When the work sells and the crowd flips the page in unison to a Wayne Thiebaud painting of a row of cakes, the colors ripple like an undulating wave.

Before the sale, Roger told me that he had set the "reserve" for his painting. The reserve is the minimum price that the collector is willing to accept for his work of art. However, the reserve cannot exceed the low end of the estimate. In other words, since his Ruscha was given an estimate of $80,000–$100,000, his reserve could not go over $80,000—which was exactly the number he agreed to. As far as the estimate goes, the number is determined in a zenlike manner. Too high an estimate and you scare off bidders, too low and you devalue the work of art. The correct estimate is one that tempts the bidder but still maintains a

healthy respect for the work. Typically, a collector is supposed to pay the auction house a commission of 10 percent for selling his painting and a dealer's rate is 6 percent. But, like everything else in life, the rate is negotiable depending on the quality of your property. What is *not* negotiable is the premium that the buyer pays (10 percent, at the time).

That evening's sale consisted of fifty-five lots. Roger's Ruscha was lot number fifty. If you're a consignor, you would prefer that your painting come up earlier in a sale because of all the disruptions that occur as the sale wears on. Not only do people leave early for dinner, but a certain small group of women consistently leave the proceedings with nine or ten lots to go, just so the crowd can get a good look at them. Smirks break out in the audience as the ladies, clothed in the latest from whomever, traipse down the aisle with their embarrassed husbands trailing dutifully behind.

As the auction opened, John Marion, then considered the world's finest auctioneer, read the usual preliminary announcements. Then, it was off to the races. The sale got off to a bang as a confident Marion knocked down lot after lot, with most paintings selling above estimate. Roger recalled how he nervously fidgeted in his seat, knowing chances were that he'd do well—but you never know at auction. Finally, the moment of truth arrived. All the months of anxiety were finally coming to an end. The turning carousel, located center stage, spun to reveal the velvety cobalt blue surface of the Ruscha. The painting was a star. At that very moment, Jack's fears vanished—he knew he was in the money.

"Lot number 50, the Ruscha," said John Marion, with authority.

"Do I have $50,000 to open? I have 50. Fifty-five, sixty, sixty-five, seventy," he continued.

Once the bidding reached $80,000, Roger heaved a silent sigh of relief. By the time the bidding hit $100,000, Marion began raising the ante in $10,000 increments. As the bidding continued to go north, Roger remembered thinking how hard it was to make $10,000 on a deal. Now, in a matter of seconds, he was making it over and over again.

Finally, Marion's deep voice announced, "$190,000. Any more bids? I'm going to sell this painting for $190,000. Anyone else? Sold!—for $190,000."

And that was that. With the 10 percent buyer's premium, *The Past* had sold for $209,000—a new record for an Ed Ruscha painting. After

deducting the negotiated 4 percent sales commission that Roger owed Sotheby's, as well as his cost of $38,500 for the painting, he was looking at a profit of $143,900. Not bad for holding a painting only six months.

During the same round of sales I, too, sold a work of art and decided to reward myself by doing what any self-respecting art dealer would have done at the time—I headed over to the Belgian Shoes store. Back in 1989, if someone had asked me, "What does the art world *really* revolve around?" I would have had to answer, "Belgian Shoes." Not money or status, but a pair of hand-crafted butter-soft loafers. There was nothing in the realm of fashion like Belgian Shoes. Only one store in New York sold them. When you walked in to examine a pair they treated you with a subtle disdain, as if they were doing you a favor—and they were.

Owning a pair of Belgian Shoes announced that you belonged. Jim Corcoran had six pairs. When I informed Chuck Arnoldi about Jim's hoard of Belgians, he said, "Big deal. I have at least a dozen." I knew he was telling the truth because years later, when he moved on to the latest trend, he offered to give them to me. I remember rushing over to try on a pair of cognac ostrich shoes and then cursing out loud when they did not fit. Alas, Chuck wore a size 10 and I wore a 10½.

Part of the shoes' mystique was that they were fairly expensive— $235 for what was essentially a pair of slippers. In fact, because the leather soles were so thin, you immediately had to take a new pair to a shoe repair shop so they could affix a protective rubber sole over them. Additional cost: $45. Combined with New York's hefty sales tax bite, the shoes wound up costing about $300. If you really wanted to make a statement, you wore them without the rubber soles. That way, when they wore out after two months of pounding Manhattan's pavement, you simply threw them away—and then made sure you told everyone. As much as I craved Belgians, I once promised myself that I wasn't going to succumb to peer pressure and waste my money. There was simply no way I was going to follow the herd.

However, after having some luck at auction, my willpower evaporated. As I strode down 56th Street, the store's low-key signage announced that I had arrived—in more ways than one. I rang the bell, walked in, and was scrutinized by an unsmiling salesman. As I scanned the rows of shoes, I was enthralled by a cornucopia of exotic leathers and imaginative colors. There was olive suede with maroon trim, menthol blue

lizard, a velvet shoe with a leopard pattern, and even a simple black shoe with room to sew on the family crest. There was only one basic style of shoe, each designed to resemble a simple pair of penny loafers. But, instead of a slit to hold Lincoln's copper likeness, there was a tiny leather bow. So elegant, so correct, and so very desirable.

After much agonizing, I finally settled on a wonderful pair of burgundy suedes with smooth black piping and a black bow. As I flashed my United mileage-plus Visa card, all I could think was that at long last, I was a serious art dealer—or as serious as you could be, given how absurd it all was.

While my Belgian Shoes purchase may have bordered on the ridiculous, it is impossible to overstate their symbolic importance. This is because so much of the art world is about appearances. For instance, when a dealer comes to New York to participate in the spring and fall auctions, it is imperative that he stay at a prestigious hotel. That way, he can give the "right" answer when a client asks, "Where can I reach you?" In the 1980s, the Carlyle and the Mark were *de rigueur*, the Regency was acceptable, and the Paramount was cutting it close (you may be cheap, but at least you're cool), while the Sheraton and the Marriott just didn't make it. Personally, I stayed at an obscure bed and breakfast on the Upper West Side—so obscure that no one could determine its status quotient.

Besides seeking approval on your hotel choice, there are restaurant conflicts to contend with. For instance, it used to be that if you left Christie's between the day sales to eat lunch, you had better not be seen at Kaplan's Delicatessen. That was a sure sign that you had little taste— both in your mouth and on the walls of your gallery. A far better choice was to skip lunch altogether or maybe sneak over to Lexington Avenue to grab a slice. However, during the day sales at Sotheby's, the restaurant choices were more compelling. A smart move was to be seen dining at Petaluma. But even then, if you were seated with a fellow dealer, you lost points. Far better to be seen with a recognizable big-name collector.

Then there was the issue of transportation. No one ever admits to taking the subway—but everyone does it on the sly, especially when journeying downtown to SoHo. Buses are too slow and cabs are better than nothing, but if you have business on Madison Avenue you are best off walking. That way you can show off your clothing and hope to run

into a client who might comment, "Nice shoes." However, if you are really intent on traveling in style, you hire a car and driver for the day. Imagine being chauffeured around town in a shiny black limousine, stepping out of it in front of the chic Mary Boone Gallery (she of the nasty temper and 200 pairs of designer shoes)—and being spotted by a rival dealer or impressionable collector. Life in the art world didn't get any sweeter than that.

But even if you had your wardrobe together, registered at an impressive hotel, reserved at fashionable restaurants, and employed a car and driver, your image was ultimately dependent upon the art you dealt. If you wanted to be in the "club" of upper-echelon dealers, you had to deal great art. The lowest form of animal was a print dealer; to deal multiples was an indication that you were either poorly financed or lacked enough confidence in your judgment to buy unique works. Lithographs and silkscreens were just downright unadventurous. Most print dealers were so desperate that they would undercut your price by a measly hundred dollars just to ace you out of a deal.

The real prestige was to deal superb paintings by major artists. The biggest players dealt works by the highly revered Abstract Expressionists; names like Rothko, Kline, and Pollock were the currency in which they traded. Buying and selling works by the next generation, especially the Pop artists, also carried heavy cachet. But nothing set a dealer's heart to flutter more than when you offered him an extraordinary Warhol that had been buried in a collection for twenty years. A rare early Warhol was one of the most sought-after trophies among dealers. To have one for sale reminded you of a famous line from the movie *The Apprenticeship of Duddy Kravitz*: "To own land is to be somebody." Well, in the art world, to own a significant Warhol was to be somebody. But to own a pair of Belgian Shoes was the next best thing.

8

AN ECCENTRIC COLLECTION

DESPITE THE UPWARD SPIRAL of prices for Contemporary art, my search for the right Warhol continued. Since I was living in Santa Monica, I began spending more time exploring the city's galleries in an effort to ferret out a Warhol.

To that end, I decided to visit Blum Helman. For gallery partner Irving Blum it was a homecoming of sorts. Ever since his Ferus Gallery days in the early 1960s, Blum had deeply missed California and was itching for an excuse to come back to his roots. The Los Angeles renaissance provided him with the perfect reason to return. Although Blum, along with his partner, Joseph Helman, was involved with representing his own stable of artists, the gallery was still a prime source of resale material. So, I decided to drop by and see Irving about the possibility of buying a Warhol.

On my way over, I couldn't help but think about the days when Blum exhibited the original *Campbell's Soup Cans*—probably the single most important gallery event of the last forty years. Back in 1962, the show met with such derision that a rival gallery across the street stacked some actual soup cans in their window and printed a sign: "We Have the Real Thing for 29 Cents."

According to Blum, Warhol sent him 32 *Soup Can* paintings, which were to comprise his very first gallery show. Each canvas bore the name of a different soup and was priced at $100 (net $50 each to Blum). Miraculously, he managed to find six takers, including Dennis Hopper.

When the show finally came to its ignominious close, he had an epiphany. He decided the set should remain together—it would be worth much more in the future if it stayed intact. He called Warhol and asked him how much he wanted for the entire group. Warhol thought for a moment and offered Blum the set for only $1,000. But, at the time, even that was too much money for him. The only way he could manage the deal was to ask for a series of ten monthly payments of $100. With visions of a sold-out show dancing in his head, Warhol readily agreed. Blum then quickly phoned the six buyers and they all agreed to relinquish their claims on the paintings. Blum had accomplished his goal. He managed to hang on to the paintings until 1995, when he sold them to the Museum of Modern Art for approximately $15 million. That transaction remains the single greatest deal in the history of contemporary art dealing.

This story is certainly remarkable, only it may not have been accurate—according to Joseph Helman. One day during the late 1970s, he had lunch with Blum and Andy Warhol at the Ginger Man on the Upper West Side of New York. At some point, the conversation veered toward the good old days. But according to Andy, they weren't so good. Warhol's version of the *Soup Can* story was that the only reason he consented to the exhibition was because Blum guaranteed to buy the entire show. Despite a few paintings being placed on reserve, the show developed no momentum and nothing sold. Even though Dennis Hopper came close to buying a painting, he never got it together (although eventually, he did buy a *Soup Can* from another series). At the end of the show, Warhol called Blum and told him that he still expected his $1,600, but would accept $1,500.

Allegedly, the conversation went something like this:

"I'm sorry, Andy, but I don't have any money," said Blum.

Warhol was quite upset and said, "I worked very hard on this show to hand-paint all 32 paintings. I really don't want to, but I'll take $1,000."

"You don't get it—I honestly don't have any money," pleaded Blum.

"Someday you will," said Warhol, and with that he hung up.

It took Blum two years to pay him off, but by then, the *Campbell's Soup Can* paintings were worth at least $1,000 *each*.

Back when Blum made his commitment to buy the *Soup Cans*, most collectors thought Warhol was a passing fad. Many people wondered

whether his paintings even qualified as art. Since Dennis Hopper was one of the few foresighted buyers from that era, it seemed preordained when I ran into him in the parking lot of the gallery complex where Blum Helman was located.

I had never met Hopper before, but felt comfortable going up to him to introduce myself because we knew someone in common—his stepson Jeffrey Thomas. Thomas was the son of Hopper's first wife, Brooke Hayward. Following his interest in art, Thomas opened a Contemporary art gallery in SoHo. He was an extremely outgoing person with a winning style of salesmanship. I had gotten to know Thomas and was always captivated by his stories of growing up with Dennis Hopper. If Thomas's memories were accurate, Hopper's depraved movie persona and real life personality bore remarkable similarities.

Hopper was still collecting art, but now he was also making it. His work was inspired by the gang graffiti prevalent in his Venice neighborhood. Hopper noticed how, over time, writers sprayed their tags on buildings but then maintenance crews repeatedly covered those sections of wall with a paint roller. The result was a surface covered with irregular geometric forms that stood out because the new sections of paint never quite matched the wall's original color. Hopper's paintings took their cue from these found street images. The work had integrity and was scheduled for a show at Jim Corcoran's gallery.

I went up to Dennis Hopper and greeted him with an outstretched hand, "Hi, I'm Richard Polsky—I'm a friend of Jeffrey's."

Hopper looked puzzled. He winced a little as he tried to recall if there was a Jeffrey in his life. He then replied, "Jeffrey?"

"Sure, Jeffrey. You know, the guy who has a gallery in New York," I said, trying to be respectful by giving him a clue so that he could recognize the name on his own.

But Hopper still looked confused. "Jeffrey, Jeffrey…" was all he could say, repeating the name like a mantra.

Finally, I couldn't take it any longer, "Jeffrey Thomas—you know, your stepson."

"Oh…that Jeffrey!" said Hopper, finally breaking into his trademark devilish grin, while squinting his eyes.

We talked for a few minutes about the shows that were on view around town. I was tempted to ask him about his early days as a Pop

collector, but decided to save it for another time. With that, I said good-bye and walked into Blum Helman. I was in luck because Blum was in town that day. As I greeted him, I thought about how he was frequently described as a Cary Grant look-alike. There was some resemblance, and he certainly carried himself like a film star. We talked for a bit and then I asked him if he had any Warhols on resale. The only thing he knew of was a *Liz*, but that was out of my price range. While we were on the subject, I couldn't resist asking him, "Weren't you the first dealer to show the *Lizes*?"

He responded, "Yes, I was the one. In fact, I showed them at the same time that I showed the *Elvises*."

He went on to explain how the image of Elvis Presley was taken from a publicity still from the movie *Flaming Star*. The shot features Elvis as a Western gunslinger who appears to be quick on the draw. The majority of the paintings were screened with black ink on metallic silver and many have multiple life-sized Elvises.

According to Blum, "When the paintings were first shown in 1963, people hated them because the images looked like they were torn out of the daily newspaper—which was precisely the point."

At the premier of the *Elvis* series, Blum filled a second room with portraits of Elizabeth Taylor. Most of the *Liz* paintings were done on forty-inch-square canvases in a variety of color combinations. All of the color schemes were quirky and unexpected, but somehow worked brilliantly—confirming that Warhol was underrated as a colorist.

Blum explained, "The *Elvises* were priced at $1,000 and the *Lizes* were a relative bargain at $800. None of the *Elvises* sold, but I somehow convinced a woman to buy a *Liz*. Unfortunately, two weeks later, she came back to the gallery and asked for a refund."

"Did she tell you why?"

"She complained that her husband and kids laughed at it," said Blum, while stifling a laugh of his own.

He went on, "If you really want to see the greatest *Liz* painting, you should probably give Ed Janss a call. Although, come to think of it, I'm not sure he still has it."

Blum was referring to the magnificent painting, *Blue Liz as Cleopatra*. The painting depicts Elizabeth Taylor portraying the beautiful Egyptian

seductress, adorned in a beaded headdress with her eyes outlined in dark kohl. Her likeness was screened fifteen times on a blue canvas that measured almost seven feet tall. Janss gave the painting as a gift to one of his relatives, who at some point decided to sell the painting at auction. Although it failed to find a buyer, it was later sold privately to the collector Robert Mnuchin, who eventually switched gears and became a prominent art dealer. From there, the painting changed hands a few more times and ultimately wound up in the Daros collection in Switzerland.

Although Janss no longer possessed the painting, his collection remained formidable. For years I had heard about its wonders from Jim Corcoran, who was for a time married to Janss's only child, Dagny. Although Jim and Dagny eventually parted ways, Jim remained close to his former father-in-law. Knowing this, I repeatedly asked Jim if I could meet Ed Janss and see his paintings. The fact that Janss's collection was off limits to most people made it even more tantalizing. There were certainly more high-profile collections in the city, such as the Weismans and the Gershes, but no collection was more cloaked in mystery and intrigue.

One day, out of the blue, I got a call from Jim inviting Lia and me to have supper with him at the Janss house. However, there was one caveat. "I'm inviting you because I told Ed you were interested in nudibranchs."

He was referring to a species of sea creature that resembles a garden slug, but that's where the similarities end. Like tropical butterflies, minerals, and sea shells, nudibranchs come in every color imaginable. They can only be seen by strapping on scuba gear, which gave Janss the excuse to combine his love of diving and underwater photography. He soon became obsessed with trying to document every variety in existence. It was just the kind of challenge that Janss seemed to thrive on.

Years later, after he passed away, his adventurous spirit was summed up in an essay written by Dagny that appeared in a Sotheby's catalogue offering her dad's treasures: "Some time ago, when the King Tut exhibition was in L.A., a woman asked my father if he'd seen it. 'Oh yes,' he replied, 'in the tomb in 1928.'"

Yet, like many extraordinary men, Janss was also a true eccentric. On the rare occasion that he sought advice, he turned to a fellow eccentric,

the museum curator Walter Hopps. One of their better collaborative efforts was the time Hopps (then a partner with Irving Blum in the Ferus Gallery) approached him about bringing the first Joseph Cornell show to Los Angeles. Hopps had met with the reclusive artist, who insisted that he guarantee the sale of at least three boxes. Hopps then turned to Janss, who agreed to purchase three Cornells for a few thousand dollars each in the event none sold—which was precisely how Janss wound up owning three Cornells. In 1989, during the dispersal of Janss's collection, one of the boxes sold for $209,000—a record for Cornell and a further testament to Janss's keen eye.

On the evening that we were supposed to have dinner with the Janss family, I called Jim for directions. By the tone of his voice, it was obvious he was annoyed about something.

"What's wrong, Jim?" I asked.

"Oh, one of our colleagues backed out of a deal on a *Medici* box [the most valuable of Cornell boxes]."

I paused and said, "That's a bummer. I hope you're not going to do business with him again."

"No, I'm sure I will," said Jim.

"What the hell for?"

"Well, it's like this. Let's say you owned a champion thoroughbred race horse and when you fed him a carrot he took a bite out of your hand. What would you do, destroy the horse?" I always remembered the wisdom behind that logic and often applied it in my future dealings. Given the nature of the art business, I applied it quite often.

The Janss residence was located in West Los Angeles—rather than Bel Air or Beverly Hills. Despite his wealth, Janss was a modest man who cared little for the opinions of society and took an independent approach to life. When he appeared at the door, I noticed that the tan craggy features of Janss's seventy-something face seemed to reveal experience more than age. Alongside Janss was his second wife, Ann, who looked more than a decade younger. She welcomed us in with a quick flourish of her hand.

Surprisingly, the first imagery that we were confronted with was not works by contemporary masters but Janss's color photographs of nudibranchs. There was a gallery displaying many of the sea creatures that

Janss had managed to document. After viewing them, I commented, "It looks like a pretty thorough collection."

"It is," Ed acknowledged solemnly. "But there is still one particularly elusive species that hasn't been checked off my list—but it won't elude me forever."

A year later, I would learn, Jim accompanied Janss on a diving trip to the Bahamas to search for the missing mollusk. Call it beginner's luck but, based on seeing a guidebook photo, Jim himself scooped up what appeared to be an example of the rare invertebrate and brought it back to the boat. He placed it in a cup of water and proudly walked over to show it to Janss, who casually looked up from the book he was reading, glanced into the cup, and said with little emotion, "Yeah, that's it, all right." He then told Jim, "O.K. You can toss it back now." After all those years of coming up empty handed, that was it. No ceremony, no champagne toast, no nothing.

But that was merely one side of Janss. The other side was expressed in the enthusiasm he displayed for his art collection. As we walked into his brown-carpeted living room, it was obvious that he couldn't wait to show us around. The first stop on the tour was *Diehard,* a Robert Rauschenberg painting from the early 1960s. Its 12-foot-long surface was clogged with some of the defining iconography of the times, including the splashdown of one of the Mercury space capsules. *Diehard* was flanked by a Surrealist work by René Magritte and a Sam Francis painting—both of museum quality. There was also an exceptional painting by David Hockney of an ancient Egyptian processional and a powerful Francis Bacon portrait of Vincent van Gogh striding down the road to Tarascon.

However, as I began to delve into the mysteries of each painting, I was distracted by an even greater enigma. Interspersed among the paintings were actual tropical insects, pinned to the wall as if they were mounted in a cotton-filled Riker box—a black-rimmed cardboard container used by science museums to house their collections. As I moved closer, I identified one of the specimens as a Spiny Devil from New Guinea, a fearsome eight-inch-long walking stick covered with thorns. There was an impressive Leaf insect from Malaysia, a five-inch-long bug that resembled a living section of green leaves. I also spotted a gigantic

Goliath Beetle from Cameroon the size of a child's toy airplane. To off-set the frightening beauty of these creepy crawlers, Janss added a num-ber of spectacular butterflies to the mix.

The insects were certainly an unexpected touch, but they did little to prepare me for what was to follow. As my eyes wandered around the perimeter of the room, I noticed a few taxidermied animals on the floor. I was used to seeing the occasional mounted head of a buffalo or deer hung incongruously near a painting. But upon closer inspection, I real-ized the animals were domestic dogs and house cats—someone's former pets. I remarked to Janss, as casually as I could, "Gee, I've never seen a stuffed cocker spaniel before." He told me that he picked it up on the cheap from a taxidermy shop down in Mexico. I wasn't sure what to make of the preserved animals or insects, but Janss's wild kingdom cer-tainly provided a provocative counterpoint to all of his wonderful paintings.

Right before we sat down to dinner, Ann called us into the kitchen to partake in a family ritual. She grabbed a giant steaming pot from the stove and poured dozens of large gulf prawns onto a long wooden coun-tertop. The pungent fragrance of spices from the boiled shrimp perme-ated the room, creating an atmosphere reminiscent of a Maryland crab shack. We then gathered around the counter, along with four other guests, and proceeded to peel away. The crustaceans were delicious, and eventually the mound of discarded shells began to exceed the pile of prawns. When we were done, Ann picked up a window squeegee and with a good shove, deposited the shells in a waiting trash can on the side of the counter. We then sat down to dinner, which was equally memo-rable—lots of great food and discussions about the art world.

When the meal ended and it was time to leave, I suddenly became possessed by a perverse idea. I quietly went over to the trash bin. Like a devious character from a television cartoon, I looked to my left and then to my right to make sure the coast was clear. I then plunged my hand into the brimming waste receptacle and gingerly fished out a discarded prawn shell. Then, while everyone was still engaged in conversation, I walked into the living room. Once I spied the Hockney, I carefully extracted a spare pin from a neighboring Hercules Beetle. As I looked at the three parading figures in the painting, I noticed one of them had an

extended hand. In a burst of inspiration, I pinned the prawn carcass just above the canvas, so that it appeared to be falling into a waiting open palm.

As I stood there admiring my handiwork, I began to wonder whether Janss would ever invite me back if he figured out that I was the perpetrator. Knowing his irreverent sense of humor, I felt sure of it.

9

THE $500 *MARILYN*

THERE'S AN OLD JOKE that goes like this: "What's the difference between a good accountant and a great accountant?"

"If you ask a good accountant, how much is fifty and fifty? He'll tell you that it's one hundred. If you ask a great accountant, how much is fifty and fifty? He'll tell you that *it's anything you want it to be.*"

Well, given the vagaries of the unregulated art business, such as the often disputed tax write-offs for donating art, and other potential IRS hassles, you definitely need a great accountant—and I was fortunate enough to find one in Steve Axelrod. Not that he was dishonest, quite the contrary. What makes Axelrod a great accountant is that he's completely in love with what he does. For instance, you can call Axelrod at eleven o'clock at night, and he'll cheerfully answer, "Oh, hi Rich. Let me get out your file." But that's nothing. One of Axelrod's claims to fame is that in his spare time he writes songs about accounting. While I can't imagine a topic less suited for being set to music, somehow Axelrod put to pen such autobiographical gems as "Accountin' on Him" and "The Time is Right: It's Always 1040." Rumor had it that Axelrod was also working on an "improved" version of the Beatles' "Tax Man." Some of his songs weren't half bad. But when Axelrod began exploring the possibility of going on the David Letterman show, I thought he was pushing the envelope.

Given Axelrod's unconventional approach to his profession, I began to worry about being audited, a common fate of art dealers. Luckily, my

worries about the IRS proved unfounded. However, I did have other legal concerns on my mind. Those worries centered around a new business venture whose genesis took place during a visit to Dan Douke's studio in Pasadena. Douke was an artist with a long exhibition history. At the time, Douke's work would have been classified as a form of "material illusionism." All that meant was that he produced paintings that bore an uncanny resemblance to real life objects—in this case sheets of irregularly weathered steel. Douke's paintings were so realistic that he included all of the rust stains, scratches, and weld marks from where the "metal" had been cut with a blowtorch.

We had once represented Dan Douke at Acme Art and he was one of our biggest sellers. He was also a consummate professional, which made him an endangered species among artists. I had never met an artist before who always honored his commitments, consistently delivered work on time, and was flexible when I needed to negotiate a discount. In other words, we had the dream artist/dealer relationship.

One day in 1990, I arrived at Douke's studio anticipating a look at his latest wizardry. But when I walked in, I was stunned by an image not of steel but of flesh and blood—an Andy Warhol *Marilyn*. There, before my eyes, was a 40-inch-square red *Marilyn*. Standing by the painting was Douke himself, with an uncharacteristically mischievous expression on his face that seemed to say, "I can't wait to tell you the story, but I'm going to enjoy keeping you in suspense for a few minutes."

From a distance, I looked at the red background, blond hair, and the unmistakable smile and concluded that Douke was the highly unlikely possessor of an extremely valuable *Marilyn*. But as I moved closer to the painting I smelled something funny—fresh paint. I looked at Douke who, all of a sudden, broke into a broad grin and began to laugh.

I said, "Come on Dan, what's the deal?"

Taking the painting off the wall, he said, "Why don't you turn it around and have a look for yourself."

I flipped the painting over, and there, on the bottom of the canvas, was the signature Dan Douke.

I just shook my head, "That's incredible! You almost had me fooled. I've seen a number of genuine *Marilyns* before and this is pretty convincing—the colors and image are almost perfect. How'd you do it?"

With a sense of pride, Douke told me how he had always wanted to own a major Warhol, but couldn't afford it. Then he realized that many of the magazine photos that Warhol derived his imagery from were in the public domain. One day at a flea market he came across the famous Marilyn photo that Warhol had converted to a silkscreen. The proverbial light bulb went off in his head when he realized that he could essentially create the same painting. So he bought the photo, went to a lab, and had a silkscreen made in the exact same dimensions as Warhol's original. Given Douke's considerable artistic skills, it was a relatively simple matter to look at a reproduction of the original and match the colors and paint application technique. Just like Warhol, Douke first outlined where the colors would go before painting them in—much like using a coloring book. For instance, he used a pencil to designate where he would paint in Marilyn's yellow hair. The final step was to screen an overlay of the image in black ink.

Once the painting was finished, Douke hung the masterwork in his living room. That weekend he had a party and invited a number of fellow artists. As expected, the *Marilyn* was the center of attention and sparked a feisty debate over whether or not it was real. When Douke confessed that he had made the painting for his own enjoyment, he was inundated with requests from his friends. Ever accommodating, he ended up making a few more and sold them to his admirers. But then his entrepreneurial spirit kicked in and he began to think about the possibilities of marketing them.

"What do you think I could get for one?" queried Douke.

I said, "I don't know, but if it were reasonable, I'd be a buyer."

That seemed to clinch it for Douke. If his own dealer was interested in buying an appropriated *Marilyn*, then he was definitely on to something. He lit up a La Gloria de Cubana cigar and we sat down to discuss the possibility of going into the Warhol reproduction business. After figuring our costs at less than $500 per canvas, we calculated that we could sell each painting for $1,500. We intuitively knew that at that price, the potential audience would be substantial. Not only could we sell *Marilyns*, but eventually we could expand into *Lizes*, *Jackies*, and *Elvises*. As we played off each other's enthusiasm, we began talking about how with the right marketing we might be able to earn enough to afford an actual *Marilyn*.

Then reality disrupted our discussion in the form of Douke's level-headed wife, Nadine, who asked the obvious question, "How are you guys going to get away with faking Warhol's artwork?"

It was a valid question. My initial thoughts were that if Douke signed each one with his own name and indicated it was not a genuine Warhol, the plan might work. After all, one of the lessons to come out of the conceptual art movement during the 1970s was that it was acceptable for an artist to appropriate another artist's image—provided he gave credit to the originator. During the 1980s, the artist Sherrie Levine made a career out of this strategy. Among the artists she plundered were Man Ray, Walker Evans, and none other than the king of the conceptualists, Marcel Duchamp.

I said to Douke, "If there were some way that you could declare these as your latest artworks, we'd be in business. On the other hand, it might mean giving up your 'metal' paintings to show you were sincere."

Ever cautious, Douke said, "Let me give it some thought—I mean, we're talking about my life's work. This may be a deal where we 'date before we get married.' Why don't you take a blue *Marilyn* home and live with it for a while. That way, you can decide whether the work holds up."

I responded, "I'll do that and as a gesture of good faith, I'd like to buy the painting from you. How much do you want for it?"

Douke thought for a moment, scratched his carefully manicured beard, and said, "How about $500?"

"Done."

With that, we wrapped the Douke/Warhol in plastic and placed it in my car. When I got home that night, I hung the painting in my living room, carefully lighting it as if it were the real thing. When the picture was in position, Lia and I marveled at its wall power. It felt like we were sitting in the Museum of Modern Art. As we sat sipping a glass of wine, I couldn't resist saying, "Let's have some fun with this—I've got to call Jonathan."

I was referring, of course, to my across-the-street neighbor, Jonathan Novak. I grabbed the phone, dialed, and listened to his phone ring at least five times. I was just about to give up when he finally answered, "This better be important."

"Hey, Jonathan, what are you doing right now?"

"I'm in the middle of watching a rerun of *Lifestyles of the Rich and Famous.* Did you know that if you buy a million-dollar condo on Fisher Island, they throw in a free electric golf cart to get around your property?"

"Listen, I don't have time for that right now. I finally found the Warhol of my dreams—a blue *Marilyn.*"

There was silence on Wilshire Boulevard. "Would you repeat that?"

"I'm serious. Wait till you see this painting! It certainly exceeded my budget, but somehow I got the money together. You've got to come right over."

"Fine. I'm on my way."

As I gazed at my *Marilyn*, I began to reflect on the history of the series. Back in August 1962, Warhol got his idea for the paintings right after reading about the former Norma Jean Mortenson's suicide. He immediately began searching various photo archives for the perfect head shot. When he found the right glossy, a publicity still from the film *Niagara*, he had some silkscreens made and got to work. Although *Gold Marilyn* remains the crown jewel of the series, there were also twelve small (20-by-16-inch) *Marilyns*. Warhol chose to give some of them titles associated with food: *Liquorice Marilyn, Mint Marilyn, Peach Marilyn, Cherry Marilyn, Grape Marilyn,* and *Lemon Marilyn.* At one time, Ivan Karp was the grateful recipient of one of the few paintings from the series not named after a flavor—*Red Marilyn.*

I once asked Ivan, "Why did Warhol give you that painting?"

"Why?" said a mildly indignant Karp, "My support, my charm, my spirit, my enthusiasm, and my eloquence. Polsky, you forget I was his first mentor. Right after my initial studio visit, he delivered to the gallery a 5-by-5-foot *Nancy* [the cartoon character] with a red bow wrapped around it. His gift would be worth $6–$8 million today."

Karp continued, "Warhol gave me paintings all the time. About twenty years ago, during the early 1970s, I sold *Red Marilyn* for around $18,000. It helped buy my loft in SoHo." Neither one of us had the heart to voice what the other knew—had he hung on to it, he could have bought almost half the block. It also wasn't lost on me that he wound up marrying a woman named Marilyn.

At the other end of the *Marilyns* spectrum is the largest painting from the series, *Marilyn x 100.* The painting's format features bifurcated imagery: the left side contains fifty images of Marilyn painted in

a combination of orange, yellow, pink, red, and turquoise; the right side is covered with fifty black-and-white portraits. Measuring approximately 7 by 19 feet, the painting was originally bought in 1984 by Charles Saatchi, directly from Warhol's studio. It had been rolled up for years and was so imposing that buyers had always shied away from it. But Saatchi, who was in the process of putting together a superior collection of early Warhols, was never intimidated by the size of the canvas nor its price—probably between $500,000 and $1 million. A deal was struck and the painting was sent back to London, where it remained until Saatchi fell into financial difficulty during the early 1990s.

Faced with mounting debts, Saatchi sold part of his collection at Sotheby's in November 1992, including *Marilyn x 100*. Sotheby's was so high on the painting that they devoted an entire catalogue to promoting its sale. In the catalogue's essay, they astutely pointed out how Marilyn Monroe had inspired other works of art by artists as diverse as Willem de Kooning, Richard Smith, and Joseph Cornell. Regardless of the hype, *Marilyn x 100* didn't live up to its presale expectations of $4–$6 million, mainly because it was sold in a recessionary market. Despite some spirited bidding, it brought only $3.7 million. The buyer remained a secret, but rumor had it that he shipped the painting to a warehouse, where it was safely ensconced until he was ready to resell it.

In 1997, the Cleveland Museum of Art put the word out that they were in the market for a major Warhol. They were soon offered *Marilyn x 100*. While the asking price exceeded the museum's budget, the trustees raised the money—a figure of $10 million had been tossed around by the press. While that might have seemed exorbitant, the museum's faith in Warhol proved to be a smart decision when, not long after, *Orange Marilyn* sold for a colossal $17.3 million.

Having seen Cleveland's Warhol painting, I can certainly confirm the work's overwhelming star quality. Thanks to all of the intentionally over-inked and under-inked screens, the work possesses a wonderful hand-made quality. No two images are exactly alike—some are crisp perfection and others are mere phantoms. There's even one painted image where Marilyn suffers from having "big hair." Ultimately, the painting echoes Warhol's philosophy that if one is good, one hundred are even better.

I was still thinking about the history of the *Marilyn* series when I heard the doorbell ring. In walked Jonathan. Once he entered our living room, he just stood there in a state of bewilderment. You didn't have to be a mind reader to know what he was thinking. I'm sure his thoughts raced between, "Where did they get the money?" to "Who did they buy it from?" to "How much do they want for it?" The problem was which question to ask first. In a moment of calculated troublemaking, I decided to keep silent and let him labor to draw the story out of me.

When he finally spoke, he took a tactic that put us on the defensive, "You obviously don't own this. Who consigned it to you?"

"Nope. We own it. I know it exceeds my $100,000 limit—by far—but it's been a good year. Besides, there comes a time in every man's life when he has to step up to the plate—and this is *that* time."

"Yeah, right. I still don't believe you own it, but how much do you want for it?"

"Sorry," I said, baiting him even further. "I have no interest in selling. I'd rather keep it for my private collection."

"You don't *have* a private collection," said Jonathan, with a note of disdain.

"I do now," I said, with a broad grin.

"Fine, be an asshole—I'm leaving." With that, Jonathan left our apartment.

A few minutes later, I called Douke, "Hey, guess what? Your *Marilyn* passed the acid test—my friendship with Jonathan may have ended because I refused to quote him a price on the painting."

"Really? That's amazing, but I still want to think about it. Remember, for you this is just another business deal, but for me—my entire career's on the line."

"I understand. Tell you what, just to be on the safe side, I'll give the Warhol Foundation a call tomorrow and see how they feel about our idea."

The next morning, I was on the phone to the Foundation, where my call was transferred to their legal counsel. I tactfully explained the concept, carefully emphasizing that Douke's paintings were not reproductions, but conceptual art of high integrity. The attorney listened patiently, asked if I was through talking, and then gave me his one word ruling: "No."

Although I was disappointed and Douke was relieved, I can't say I was surprised by the lawyer's decision. As he went on to explain, it would have been one thing if Douke did a single series of *Marilyns* and then exhibited them in a gallery. But if he decided to go into production, then we had a problem. Essentially, we needed to negotiate a product licensing agreement with the Foundation—and there was little chance that we would have been granted one. Even if we had come to an agreement, its cost would have torpedoed any chance of our selling the paintings for only $1,500. Once I understood the hard reality of the situation, I knew it was time to move on.

But, at least for a few days, I enjoyed the fantasy of imagined riches, not to mention an improved budget for buying a Warhol painting. With a little luck and the continued growth of the art market, I thought the whole thing could have worked out—Douke's paintings were *that* good.

10

GOLD

I HAD JUST GOTTEN OFF A plane in New York, en route to viewing the 1989 Andy Warhol retrospective at the Museum of Modern Art. The show was being touted as the finest and most comprehensive overview of Warhol's work ever held. I couldn't recall the last time I looked forward to seeing a show so much. As I made my way to the United luggage carousel, I noticed a familiar figure—it was the San Francisco dealer John Berggruen. I didn't remember seeing him on my flight, but figured he was probably in first class.

"Hi John, what are you doing here?"

"Oh, hi Richard. You want to know why I'm here? One of my hobbies is visiting airports to see who I run into. Listen, I have a car and driver waiting outside—do you want a lift into the city?"

"Sure, that's very nice of you. I really appreciate it," I said, with a look of surprise.

I was surprised because although I knew Berggruen, I certainly wasn't a close acquaintance of his. Yet he was always friendly to me because of my association with Jim Corcoran. While Jim was the most important dealer in Los Angeles, Berggruen was by far the biggest dealer in San Francisco. He had art dealing in his genes. He was the son of the legendary Parisian gallerist and collector Heinz Berggruen, a dealer so successful that he once donated *ninety* Paul Klee watercolors to the Metropolitan Museum of Art and barely missed them.

Thanks to Berggruen's fun-loving ways, he was always in demand on the local social circuit. Sometimes, however, his act would descend into buffoonery, as it did the time he stuck a green grape up each nostril at a dinner party. But he also had a serious side. While Berggruen was quoted as saying that when it came to discovering new artists he was not a "pathfinder," he certainly blazed a trail in the American resale market. He was also responsible for bringing exhibitions to the city by a number of established artists who would never have considered showing in San Francisco, if not for their respect for Berggruen.

Once, when I was invited to his house for drinks, I spied a Frida Kahlo painting hanging directly above the bar. Frida Kahlo was a mythical figure in the art world who produced fewer than three hundred paintings in her short, painful life. Most of her paintings are in museums, and almost all of the rest are in a private collection in Mexico. The rare mature work that makes it to market is a guaranteed million dollar–plus seller. Over the years, I had visited many homes filled with significant art, but had never seen a Kahlo. The bottom line was that *no one* had a Frida Kahlo painting. So when I saw Berggruen's, I felt compelled to ask about the painting's identity, just to reassure myself that it was actually by the Mexican master.

"Is that really a Kahlo?"

"Absolutely. You know my father knew her…in the biblical sense."

"Get out of here!"

"If you look at any biography on Frida Kahlo, you'll see for yourself," said Berggruen.

The very next day, I went to a bookstore and sure enough, early in her life, she had an affair with Heinz Berggruen. Reading that passage made me realize just how rarefied a background John came from. In retrospect, I was always more impressed by the Kahlo connection than by all of his wealth and blue-chip paintings.

That day at the airport, we walked outside, where the driver of Berggruen's Lincoln Town Car greeted him as if he were a regular, which he was. Once we were in the car and comfortably seated, Berggruen said to the driver, "Listen, I don't care what route you take as long as the car keeps moving. Under no circumstances do I want to sit in traffic."

The driver nodded and we embarked on an out-of-the-way path that led us through a section of Queens that was virgin territory to me. Berggruen and I chatted about our plans in New York, including galleries that we intended to visit. As we talked, I looked out the window and noticed that we were passing through a rather poor section of town—not decrepit but definitely low income.

I said to Berggruen, "Hey, check out this neighborhood."

Before Berggruen could say anything, the driver interjected, "Yeah, it's quite a place. In another two blocks, you'll see where they filmed *All in the Family*."

Knowing of Berggruen's imperial upbringing, I said, "Can you imagine growing up in a neighborhood like *this*?"

The minute the words left my mouth, I knew I would regret them. The next voice I heard was not Berggruen's but the driver's. "I live in this neighborhood," he said, with more than a touch of resentment.

I quickly tried to retract the insult and apologize, but it was no use. Berggruen just glared at me, as if to say, "Nice going." But I couldn't really tell if he was upset or just trying to give me a hard time. Regardless, the rest of the drive was pretty quiet. Once we arrived in Manhattan, Berggruen had the driver drop me off first at my hotel. As I left the car, I still felt a little funny about my rude remark, but decided to shrug it off and forget about it. My own background (growing up in Cleveland) hadn't been so fancy and I was by no means a snob.

The next morning, I received a call from Jim Corcoran in Los Angeles. I figured he was calling because he wanted me to go look at a painting with him when he arrived in New York. But instead he said, "I understand you insulted Berggruen's limo driver—how could you do such a thing?"

I was flabbergasted. Didn't these guys have anything better to talk about? I decided to head over to MoMA. Part of the art community's anticipation over the retrospective was that the museum had never honored Warhol with a show during his lifetime—an inexcusable oversight, considering Frank Stella had already been given *two* full-dress retrospectives. But all slights were quickly put aside once I walked into the exhibition. The show was such an embarrassment of riches that it rivaled the museum's great Picasso retrospective.

Suffice to say, all of Warhol's major bodies of work were well represented: the *Celebrities, Disasters, Soup Cans, Product Boxes, Self-Portraits, Flowers, Maos,* and so on. While all of these paintings and sculptures were wonderful to see, the show also had its share of surprises, including some rarely exhibited late works. There had been a lot written about the *Last Suppers* and *Lenins,* but little opportunity to examine them in person. Here, at last, was the chance to do so.

Another body of work that proved surprising was the series *Thirteen Most Wanted Men.* The origin of these paintings dates back to the 1964 New York World's Fair. At the time, the architect Philip Johnson held the prestigious appointment of Arts Commissioner for the New York State Pavilion. Among the select group of artists invited to participate was Andy Warhol.

Warhol's response was to go to a local post office and secure copies of their ubiquitous Most Wanted posters. He selected the top thirteen criminals who had eluded capture and had silkscreens made of their faces. Each fugitive's mug shot was depicted on two black-and-white canvases—a frontal view and a profile. They were then assembled as part of a multi-panel mural that measured 20 by 20 feet and hung on the outside of the pavilion. However, Robert Moses, the World's Fair director, uttered something about "legal issues" and demanded that the painting be removed. At first, Warhol was indignant and wanted to replace the canvases with portraits of Moses. But Johnson nixed the idea as being too disrespectful. So, in a typical Warholian response, Andy had the whole painting covered in silver paint—and that became his contribution to the 1964 New York World's Fair.

In addition to the retrospective, the accompanying catalogue proved to be a compendium of information about Warhol's career. Perhaps the most interesting part of the book was a section devoted to personal remembrances of Warhol by people who knew him well. Many of their quotes were heartfelt, but only Ed Ruscha's came close to summing up the Warhol psyche. As Ruscha put it, "Most artists are born to be opinionated, but he was like no artist I had ever met because he was for everything and nothing at the same time."

After I had walked through the show once, just to get an overview, I made a second pass to look more carefully and savor my favorite pictures. As I entered the room that grouped his various self-portraits, I

had a revelation. I was stunned by the depth and intensity of Warhol's last series of self-portraits, the so-called Fright Wigs. There was a group of six of these on the wall in a variety of vivid colors. The look on Warhol's face seemed to anticipate his death, yet was somehow upbeat, full of energy, and life-affirming. I instantly wanted one.

Since I was already in New York, it would be the perfect opportunity to investigate their availability and price. For the first time since I had begun my Warhol search, I would be pursuing a specific image, rather than considering whatever came my way. I was starting to get pumped up—there was nothing more thrilling than to be in New York with a tightly focused art agenda.

I fortified myself with lunch before going to Ursus Books to buy some Warhol catalogues and do a little research. I was in the vicinity of Kaplan's Delicatessen and, despite having sworn that I would never eat there again, I couldn't resist giving it one more chance. When I arrived, the place smelled strongly of cooked brisket. The elderly waitress certainly didn't aim to please, cracking her gum as she took my order—a lean hot pastrami sandwich on rye, side of cole slaw, and a chocolate phosphate. She hadn't been gone for more than thirty seconds when I saw something scoot under my chair—it was a rat!

Stunned, I called over the manager and protested, "Did you know that you have rats in this restaurant?"

Looking hurt, the manager retorted, "There's no way. We have an exterminator here weekly—there's just no way."

Then, as if on cue, we both saw the rodent dash under the kitchen door. "What do you call that?!" I asked, feeling fully vindicated.

"Oh, that. That's a mouse!" he said, appearing vastly relieved.

"What the hell's the difference? Rat? Mouse? You've got a serious problem here as far as I'm concerned."

"Look, you're in New York. What do you want from my life?"

Before I could say anything else, the manager walked away. He didn't even have the decency to offer to pick up the check. I thought to myself, that settles it—no more Kaplan's, ever again. I left without eating and hurried over to Lexington Avenue for some pizza. I spotted one of the city's many Original Ray's, bought a plain slice, and ate it greedily as I walked uptown to Ursus. Although I was a loyal customer of Arcana Books in Santa Monica, I knew I didn't have time to wait until I

returned home to buy research material. Call it an art dealer's intuition, but I sensed that I had only a brief window of opportunity to find a *Self-Portrait*. In the heat of the chase, I actually broke out in a sweat.

Once I arrived at the city's largest art book store, I glanced at a few Warhol catalogues and discovered that not only did the late *Self-Portraits* come in a variety of poses, but they also came in a multitude of dimensions: 22 by 22 inches, 40 by 40 inches, 80 by 80 inches, and a monstrous 108 by 108 inches. Despite some being of similar color and pose, each was unique because of the variations in screening. Knowing that Warhol's earlier *Self-Portraits* were already bringing big money, I had a sneaking suspicion that even the smallest paintings would cost in excess of $100,000. Still, it was worth a shot.

I set out to contact all of the public and private dealers in Manhattan who I thought might be helpful. One of my first inquiries was to the now-late Judith Goldberg. She was a semi-private dealer located off Madison Avenue. Her specialty was limited-edition prints by the Pop artists, with an emphasis on Warhol. Goldberg was also known for inventorying small, choice Warhol canvases. However, perhaps her greatest attribute was that she seemed to be universally liked—a distinction completely unheard of in the art world.

I walked into her space, and was treated to a show of *Marilyn* prints. In fact, Goldberg had the whole portfolio of ten on display, and their Day-Glo colors made for an invigorating environment. When they were first released in 1967, they were priced at $500 a set. By the end of the 1980s, they had risen to more than $500,000.

We hugged and then she said, "What brings you to town?"

Managing to conceal a grin, I said, "To quote the Blues Brothers, 'I'm on a mission from God.' Would you happen to know of any late Warhol *Self-Portraits*?"

"Do you mean the 'Fright Wigs'?"

"Exactly. I'm interested in buying the smallest size painting—a 22 by 22."

"Hmm. Did you know there are even smaller ones?" said Goldberg, twirling a brown curl.

"You're kidding. How small?"

"I know of one that's 12 inches square."

Betraying my enthusiasm, I said, "Wow. I'd love to see it. Any idea what color it is?"

Then Goldberg's lips formed the one word that every true Warhol connoisseur salivates over: "Gold."

"Gold? You know of a 12-inch *gold* 'Fright Wig'? What do you think they want for it?"

"I don't know. It's in a private collection. I believe the owner got it as a Christmas present from Andy. But I'm sure she needs money, so you could probably make her an offer."

I blurted out, "Tell you what—I'll pay her $40,000 for it and give you an additional $5,000 as a finder's fee."

Normally, I wouldn't have made such a quick offer without pondering it carefully and looking into past auction results. But I detected a genuine opportunity. I was also a subscriber to the "He who hesitates" theory. Goldberg considered my offer for about five seconds and said, "That sounds fair. I'll give her a call a little later and let you know."

Recovering my equilibrium, I said, "I probably should ask you, have you seen it? What kind of condition is it in?"

"As far as I know, it's perfect."

That was good enough for me. I trusted her judgment. Goldberg reached me later that day with good news—the painting was mine, provided I could write a check for it upon delivery. I agreed to buy the painting once I had inspected it in person. The next morning, Goldberg and I met for breakfast at Three Guys on Madison Avenue, then stopped by her space to examine the work. She carefully extracted it from its bubble-wrap cocoon and hung it on the wall. In her haste, she hung it slightly crooked, but no matter—the painting was magnificent. Warhol's face glowed as if it were illuminated from within while his scraggly hair stood on end. The overall effect was that of a holy icon—not meant to be worshipped, but rather a symbol that absorbed the viewer's energy and returned it threefold.

"I'll take it. I really owe you one!"

Goldberg seemed genuinely pleased by my appreciative response. Naturally, all art dealers are delighted any time they make a sale. But, despite most dealers' self interested ways, there's still a degree of satisfaction when you know you made a client happy. I reached for my wallet,

took out two checks, and made one out to the collector and another to the Judith Goldberg Gallery. Once the painting was wrapped, I was on my way, fully convinced that after only two years I had succeeded in discovering the perfect Warhol. I couldn't believe my good fortune. I felt like celebrating, so I decided to leave my bed and breakfast and check into the understatedly elegant Mark Hotel.

As I strolled down Madison Avenue with the Warhol tucked under my arm, something strange began to happen. My heady intoxication over this great triumph began to slip away. Having been well-versed in the history of important art collections, I started to recall how the greatest prizes were often the hardest to keep. Somehow, I had a funny feeling that the gold "Fright Wig" might not be mine for long.

Once I had registered at the Mark and dropped off the painting, I called the neighboring Carlyle to see if Jim Corcoran had arrived yet. I knew he was planning to be in New York the day after I got into town. I was able to reach Jim and we made plans to get together an hour later. Still glowing over my Warhol deal, I decided to hang out in the Mark's bar, one of the more civilized places in Manhattan to have a drink. As I nursed a Heineken, I debated whether to share with Jim the news of my momentous purchase. I decided against it. Although I knew it was a firm deal, I had witnessed too many "done deals" unravel in the past—I was still superstitious. Before I knew it the hour had flown by, so I paid my tab and walked across the street to the Carlyle.

"Hello Richard, welcome to New York. Do you want to go running tomorrow morning?" asked Jim.

"Sure, but what do you want to do now?"

"How would you like to see where I grew up? Why don't we go to Greenwich?" said Jim, striking a nostalgic tone.

Before I answered, I thought about how valuable my time was when I came to New York—I was here to do business. Then again, the thought of going down to the Village to see where Jim spent his youth was irresistible.

"Fine. Sounds like fun."

We flagged down a cab and headed downtown. Jim spoke first, "You're not going to believe this, but earlier today I saw Idi Amin in a Madison Avenue gallery."

Idi Amin? In an uptown art gallery? By the look on Jim's face, I could see that he was dead serious. For some unknown reason, I had always been fascinated by stories about the former Ugandan dictator. Here was a cannibalistic thug masquerading as a national leader who on a regular basis issued completely absurd directives that were, in turn, reported by his country's press. Probably my favorite story about Amin was that he had once warned his subjects that there was a talking tortoise padding around the countryside, spreading false rumors about the government, and that if they ran into the tortoise they should not listen to him.

Once Amin was overthrown, he found sanctuary in Saudi Arabia, where he lived in comfortable exile. Now, Jim claimed an Idi Amin sighting in a contemporary art gallery in the heart of New York. This time, Corcoran had gone too far. I was just beginning to argue with him over his ludicrous remark when I heard the cab driver yell out, "Grand Central Station."

I went to pay the driver, but realized I must have left my wallet in my room. Jim smirked at my absentmindedness and paid the driver. Feeling a surge of panic, I said to him, "Thanks. I sure hope I left my wallet back at the hotel."

"What are you worried about—there's never anything in it," said Jim with a cruel laugh.

"Very funny. What I'd like to know is what are we doing at Grand Central Station?"

"Don't worry about it, just follow me," said Jim, clearly irritated.

He was still offended that I had the audacity to question his Idi Amin story, and now I was compounding his aggravation by taking him to task over the best way to get to the Village. Sensing it might be better to simply go with the flow, I followed him into the chaotic terminal and kept silent. Looking up at the ceiling, I was thrilled by how it was covered with an array of constellations rendered in blue and gold. Yet the building and ceiling were in such a poor state of repair that the city's neglect of this overlooked Beaux Arts treasure made me angry. The next thing I knew, we were standing in line waiting to buy Metro North train tickets.

"Uh, Jim," I said. "Not to be difficult, but what are we doing standing in line to buy train tickets?"

"Well, would you prefer to walk to Greenwich? Connecticut's a long way from here."

With a look of exasperation, I said, "What do you mean? I thought we were going to Greenwich Village."

"I grew up in Greenwich, Connecticut. I assumed you knew that," said Jim.

"I suppose we could go there. But I had no idea you were planning a long excursion."

We were now at the front of the line and the ticket seller looked at us with anticipation. I could tell that Jim was deep in thought. Finally, he said, "Tell you what—why don't *you* go to Greenwich. See you later."

Just like that, Jim walked away and melted into the crowd, leaving me standing in line. "Hey mister," said the ticket seller. "Where do you want to go?" I shook my head and stepped out of line, wondering what had just happened. As I left the building, it occurred to me that I had just wasted the better part of an hour following Corcoran around like the village idiot. But, trying to look at the bright side, at least I had increased my repertoire of Idi Amin stories.

IVAN KARP

THE PLAY *Six Degrees of Separation* hypothesizes that every person on the planet is only six people removed from any other person. Similarly, every person involved in the art world is probably *less* than six people removed from Andy Warhol. Basically, every participant has at one time or another either bought a Warhol, sold a Warhol, written about Warhol, curated a Warhol show, read a book about Warhol, watched a Warhol film, viewed a Warhol in a museum, or met Warhol at Studio 54. In theory, Andy Warhol is the unifying element in the world of Contemporary art.

As far as artists go, other than Picasso, Warhol's name carries the greatest recognition among the general public. What's more, his is the most democratic of all markets. Warhol's paintings are the most widely collected and traded works of art in the world. His range of subjects may even surpass that of Picasso. In many ways, his work is the last great consensus of twentieth-century art. Not liking at least some aspect of Warhol's work is as perverse as not liking the sun.

Nowhere is the Warhol connection more pronounced than in the links between contemporary art dealers. A look at the individuals who have exhibited Warhol's work would form an art dealer hall of fame. They include many of the biggest international players, such as Bruno Bischofberger, Thomas Ammann, and Ernst Beyeler. But they also include many midlevel dealers such as Jason McCoy, as well as numerous obscure private dealers like James Phillips. The birth of the Warhol

market goes all the way back to 1961, when Ivan Karp took a chance on a peculiar-looking young man who, during Karp's initial studio visit, played "I Saw Linda Yesterday" over and over again on his phonograph. What did Karp's radar detect that fateful day?

In search of answers, I decided to head down to SoHo to hear from the man himself. I was flush with a sense of victory from having acquired the gold "Fright Wig." The trip to New York had been an unqualified success. Having discovered the holy grail, it seemed appropriate to visit Karp, the man who was the first to recognize Warhol's genius. I headed to the nearest subway and descended into New York's subterranean universe, feeling like a mole man. While cabs were classier and buses cleaner, when it came to getting downtown in the most expedient manner, there was nothing like the Number 1 train. That particular stop at 59th Street was ringed with a series of handsome Grueby tiles depicting clipper ships, glazed in deep blues, burnt umbers, and vegetal greens. Grueby was considered the finest art pottery during America's glorious Arts and Crafts movement (1890–1920). The Grueby Faience Company of Boston started out as a producer of ceramic tiles, and apparently the city of New York was a major customer. Even though most of the city's subway stations had long since been remodeled, two stations were still decorated with valuable Grueby tiles—the other being Astor Place, which was covered with foot-long colorful tiles of beavers with unusually pronounced flat tails in honor of John Jacob Astor's beginnings as a fur trader. If these particular tiles could be removed without being damaged and sold legally on the open market, they could fetch $20,000 each.

As the subway pulled away from the station, the car twisted violently from side-to-side like an amoeba trying to separate. Doing my best to ignore the diverse sea of humanity that enveloped me, I began to reflect on the origins of dealing Warhols and the symbiotic relationship between Leo Castelli and Ivan Karp. Even though every novice in the art world has heard of Castelli, only relative veterans of the scene are familiar with Karp. This may sound like blasphemy to some, but in my opinion, Karp was every bit as important a dealer as Castelli.

During the early 1950s, when Castelli first appeared on the scene, the New York art world was almost nonexistent, with only a handful of

serious contemporary galleries. Charles Egan, Peggy Guggenheim, and Betty Parsons were the pioneering dealers who took huge risks to show the likes of Jackson Pollock. By today's standards, their operations were more like club houses than galleries—making a profit took a back seat to showing new art that mattered. By the late 1950s, enough of a foundation was in place for Sidney Janis and eventually Leo Castelli to take the American art scene to the next level.

Janis pirated away Pollock and others from the struggling Betty Parsons Gallery and succeeded in developing more profitable marketing strategies for them. He treated his gallery like a business, and a business was expected to make money. One of his strategies included reevaluating the price structure of all of his artists. According to *The Art Dealers,* when abstract painter Franz Kline came to Janis from another dealer, Janis lowered his prices. Instead of having Kline's pictures remain unsold at the previous asking price of $3,000, Janis was able to sell many of them at $1,500. Only then were the prices raised back to $3,000, eventually going way beyond that level.

It's crucial to point out that Janis, unlike Parsons, had more than just a good eye going for him—he also had serious wealth. Janis had made his fortune in shirt manufacturing and used some of his profits to collect art. After some time, the lure of the art scene proved irresistible and Janis sold his company and opened a gallery. In Castelli's case, he relied on the largess of his wife's (Ileana Sonnabend) family to get started.

At the urging of de Kooning and other artists, Castelli opened his own gallery. His first space was located in an Upper East Side townhouse that was also his residence. His initial plan was to show a combination of older Europeans such as Dubuffet and Mondrian and younger Americans like de Kooning, Pollock, and David Smith. But all of that changed one day in 1957.

It began when Castelli went to visit the studio of Robert Rauschenberg, ostensibly to offer him a show. At the time, Jasper Johns was the name being tossed around as the next "new thing." Once Castelli was seated in Rauschenberg's studio, the artist let it slip that Johns's studio was just downstairs. Then the inevitable happened, a moment of destiny that would galvanize Castelli and create a domino effect still felt to this day: Castelli ran down to Johns's loft, saw what he correctly

perceived to be the future of art, and promptly offered him a show. Robert Rauschenberg's show was put on the back burner.

A peeved Rauschenberg never forgave Castelli for his snub, although eventually, the two came to an uneasy understanding and Rauschenberg joined Castelli's stable. Had Castelli done nothing more than promote these two artists—the artists who bridged the gap between the Abstract Expressionists and the Pop artists—he would still be considered a major historical figure among art dealers.

But discovering and exhibiting Johns and Rauschenberg was not Castelli's only achievement. Among his other accomplishments, he was also responsible for helping Rauschenberg become the first American to win the grand prize at the 1964 Venice Biennale—a very big deal at the time because it signaled the beginning of American dominance in contemporary art. Castelli also came up with the business innovation of sharing his blue-chip artists with a consortium of galleries around the country, increasing the exposure of their work.

In contrast to Castelli's privileged and worldly European upbringing, Karp grew up in modest circumstances in Brooklyn and was a high school dropout—a fact that he was actually proud of. Through an innate sense of curiosity and a voracious appetite for reading, he educated himself and developed a sophistication that far exceeded that of most Ivy League graduates. As a young man, he began doing some writing and eventually landed a position at the *Village Voice*, where he was assigned the job of reviewing theater, dance, and art.

Soon word got out around town that Karp wrote with passion and spoke with great conviction about the arts. Eventually, he was asked to codirect the Hansa Gallery, at virtually minimum wage, along with Richard Bellamy, and then hired by the high-end Martha Jackson Gallery, where he was offered a salary plus commission. As Karp joked, "I was so impressed that I went to Brooks Brothers and bought a new suit." He used his stint at Jackson to further hone his visual perceptions and soon found himself being wined and dined by Castelli. During a lunch at the Carlyle, Castelli asked Karp to become his gallery director. "I was offered $100 a week, which was a substantial salary, so I bought another suit," said Karp. The year was 1959, and Karp went on to become Castelli's point man for the next ten years.

Castelli and Karp formed the perfect complementary art-dealing duo, confirming the old "opposites attract" adage. Castelli provided the exhibition space and used his smooth Old World manners to charm and develop an urbane clientele. Karp's fast-paced sales pitches attracted a different breed of buyer who preferred more of a razzle-dazzle approach. When it came to artist relations, Castelli's enlightened policy of paying monthly stipends assured loyalty (most of the time) among his high-powered stable. Karp's street-wise intelligence also made him a favorite with the gallery artists who enjoyed hanging out and philosophizing with him. Although Castelli had a great eye and certainly recognized innovation and quality when he saw it, in most cases, Karp was really the Geiger counter.

Karp's main role was in the trenches. He spent much of his time exploring artists' studios, always on the prowl for work of consequence. When he came across something wonderful, he would bring Castelli back for a visit, hoping for confirmation of his own taste. Through hard work and clarity of vision, the two dealers were able to assemble a remarkable list of artists who would go on to alter the course of art history. By 1966, their roster read like an all-star team: Jasper Johns, Robert Rauschenberg, Cy Twombly, John Chamberlain, Frank Stella, Roy Lichtenstein, James Rosenquist, and Andy Warhol. Never again would a single gallery control so many great artists.

When the subway finally arrived in SoHo, I made my way to Karp's O. K. Harris Gallery on West Broadway. The gallery debuted in 1969—the same year Karp resigned from the Castelli Gallery. The name O. K. Harris is fictitious. Karp chose it because it sounded like an all-American name for an old riverboat gambler. Using a fabricated name had its advantages. When someone approached Karp with a complaint, he would say, "I'm only the caretaker. You'll have to take that up with Mr. Harris, who isn't in today."

Part carnival barker and part pitchman, Karp is nothing if not entertaining. Anyone who meets him is in for a treat. Unlike most dealers who hide in their offices (the better to avoid artists trying to show their slides), Karp boldly sits out front, often wearing a watermelon-seed necklace and sporting a New York Mets baseball cap. A dedicated cigar smoker, he'll immediately offer one of his prize Romeo y Julietas to a

fellow enthusiast. If you're lucky, he'll discuss his long-out-of-print novel, *Doobie Doo*. The book concerns itself with the currents of contemporary life but, for some unknown reason, fixates on why a Nez Percé Indian could never become president. Karp's style of speech is transfixing; he spews words like an Uzi.

The real humor begins when you watch him reject an artist looking for representation by imploring him to "seek another path." Or: "You must be the disciple of a certain cubist. We're really more concerned with work that makes no reference to the art of the past." Another favorite quip: "These works are qualified to be shown in a prominent gallery—but this is not the one."

Although Karp was prosperous and represented a number of established artists, including Duane Hanson and Ralph Goings, life was a far cry from his Castelli Gallery salad days from 1959 to 1969. Realistically, how could Karp ever top what he had accomplished with Castelli?

When I walked in, the gallery's cavernous space was filled with three highly professional exhibitions of work by emerging artists and one unexpected visual revelation—a room full of antique hand-carved wooden washboards. By being taken out of their utilitarian context and mounted on the walls of a gallery, the washboards were transformed into poetic objects of contemplation. Every now and then, Karp liked to shake up his audience's preconceived notions of art by exhibiting everything from old game boards to nineteenth-century salt-glaze stoneware crocks.

In a story on Karp's loft in *Architectural Digest*, he commented on his love of collecting: "I have a flirtatious eye for objects, and these objects seduce me. They put me in a condition of unreasonableness. When I see one, I need it. How can I leave it in melancholy isolation in someone's shop?"

I made my way back to Karp's command center, which he sometimes referred to as "world headquarters." While I was waiting to catch his eye, I looked up at his wall clock to see what time it was. Typical of Karp's warped humor, the clock's numerals had been altered so that time ran backwards. I looked at him and smiled. He was approximately my father's age, having been born in 1926. I noticed his receding hairline, which was accentuated by the way he combed his wavy hair back—also

just like my father—no doubt a grooming trait of men from that generation. Karp's face had an angelic quality that resembled the faces of old cherubic Manhattan building ornaments, which was fitting because he pioneered the collection and preservation of these overlooked art forms.

Before Karp could fire off a wisecrack, I said, "I'm here to once and for all set the record straight about who should be credited with discovering all of those Castelli artists."

"That's very noble of you, Polsky, and a task well worth undertaking. However, 'discovering' is such a misleading word. The artists discover themselves. I prefer to use the word 'identify.'"

"Fine. Let me throw out a few names and you tell me what role you played in *identifying* them."

"Proceed—this is certainly a subject that causes me no pain."

"How about Dan Flavin?" (An artist who assembled colored fluorescent light tubes and then plugged them in, allowing their glow to bathe the wall in color.)

Karp started laughing. "I played a signature role in his career. When I met him, he was unsure of his destiny as a human being. He honestly couldn't decide whether to become an artist or a priest. I pointed him in the right direction."

"Cy Twombly?" (A painter whose sophisticated scribbles and graffiti-like marks sometimes resemble used chalkboards.)

"Twombly was recommended to Castelli by Johns and Rauschenberg. His work was considered incomprehensible and impossible to sell, but Leo and I thought he was the greatest. In fact, I had a magazine reproduction of one of his paintings glued on my phone book so that I could constantly look at it. You might say I was a leading spokesperson for his work."

"John Chamberlain?" (A sculptor who welds together colorful crushed automobile sheet metal, moving steel around the way de Kooning moves paint.)

"One of my heroes—I was involved with him from the start. I showed him with Richard Bellamy at Hansa, then I took him with me to Martha Jackson, and then finally I recommended him to Castelli."

"Frank Stella?" (A painter whose most notable contributions were early all-black canvases that helped usher in Minimalism.)

"I was there with Castelli during his first studio visit to see the *Black* paintings. Stella used to paint in this tiny 300-or-400-square-foot studio in Lower Manhattan. I encouraged Castelli to show him, but certainly didn't need to encourage Stella in any way—he was brimming with confidence."

"James Rosenquist?" (A former billboard painter known for his large-scale fractured realist imagery that combines subjects as disparate as spaghetti and fighter jets.)

"I came across Rosenquist, Wesselmann, Lichtenstein, and Warhol during an astounding three-month period [in 1961]. They had a unity of purpose that caught my eye. Along with Bellamy, I was an encouraging force and helped him find his way to Castelli."

"Roy Lichtenstein?" (A painter who converted comic book images into fine art by using their graphic format and Ben-day dots—the tiny dots of color that make up magazine and newspaper images—to transform a wide range of subjects.)

"The story's been told many times about Lichtenstein driving to Castelli with his canvases strapped to the top of his station wagon, since he didn't have any slides. There was something brash and straightforward about his paintings—the work was simultaneously smart and dumb. I was quite taken with them and convinced Leo to take him on."

"Tom Wesselmann?" (A painter of still lifes that incorporate found objects, as well as the creator of an important body of work known as the *Great American Nude* series.)

"I identified him as a prime mover in Pop art but he ended up spending his career at Sidney Janis."

"Here's another name—Richard Artschwager." (A painter/sculptor who pioneered working with the industrial materials Celotex and Formica.)

That brought a quick laugh. "I found Artschwager, and during the first *three years* that we showed him, Castelli never once recognized him when he walked into the gallery. He never knew who that tall guy was!"

"What about other artists like Mel Ramos [a realist painter of cheesecake nudes] and Claes Oldenburg [a sculptor who takes common objects and greatly enlarges their scale, sometimes fabricating them out of soft materials] who had brief associations with Castelli?"

"Ramos showed under my goodwill at Castelli. As for Oldenburg, he was really only a Castelli artist for a few years. I did get him into a 1961 exhibition, along with Jim Dine, in Provincetown. You might also want to add that I was a main factor in the identification and development of Lee Bontecou."

"So here's the last question, what about Castelli himself? Who does he owe his success to?"

"Leo Castelli deserves all of the credit he's gotten, especially when it comes to his role in handling artists. He displayed a self-victimizing generosity that was more fraternal than paternal."

But, of course, Karp's greatest discovery was Andy Warhol. He met Warhol in 1961 when the artist wandered into the Castelli gallery with a friend. Karp recalled how he was immediately struck by Warhol's outstanding physical presence. Warhol wound up buying a small Jasper Johns drawing of a light bulb. The drawing was priced at $350, and Karp sold it to him for $280 (the drawing brought $242,000 at Sotheby's in 1988 during the dispersal of Warhol's personal collection). He also showed Warhol a Roy Lichtenstein painting of a girl with a beach ball. Warhol experienced a shock when he saw it. When he recovered he told Karp that he was doing paintings in the same style. This led to Karp's first visit to Warhol's studio.

Karp was quite taken with Warhol's paintings and worked hard to champion his work. Warhol was appreciative of Karp's enthusiasm and once said to him, "You are the guide to my career." Yet, despite Karp's efforts to expose collectors to Warhol—which would sometimes result in a small sale—he was unable to convince Castelli to give him a show. This, of course, was Warhol's ultimate goal. He desperately wanted to show with the artists that he admired the most—Johns and Rauschenberg.

When asked about Castelli's initial rejection of Warhol, Karp explained, "It was a combination of having just taken on Lichtenstein along with how Warhol made Leo uncomfortable."

It's hard to fault Castelli's early dismissal of Warhol's art. One has to remember that in the works that Castelli first viewed, Warhol was using an illustrator's touch to portray such common subjects as household appliances (refrigerators, etc.) and comic strips (Superman,

etc.)—which was similar to what Lichtenstein was doing. Warhol was still hand-painting his works; he was a year away from embarking on his silkscreens. However, once Castelli saw Warhol's first New York show in 1962 at Eleanor Ward's Stable Gallery which included many of the great *Marilyn* paintings, he moved to rectify the situation.

By 1964, Warhol was a Castelli artist.

12

SURVIVAL
OF THE FITTEST

AS SOON AS I GOT HOME TO Los Angeles, I unwrapped my Warhol and hung it over the fireplace. I immediately felt a sense of pride in ownership. I was stunned that I had been able to pull it off—I honestly thought the search to find the right picture would be much tougher and take a lot longer. Still, it all felt too easy.

I checked my messages and there was a call from Chuck Arnoldi, reminding me that we were still "on" for the next morning. There was also a message from Jim Corcoran inviting me to have lunch. Finally, Judy Goldberg left an inquiry wondering whether I'd be interested in flipping my Warhol for a quick profit.

The next day, after barely sleeping, I hurried to my 10:00 A.M. meeting with Chuck at his Venice studio. I had forgotten how his building was surrounded by a grungy auto repair yard and a vacant lot covered with debris, giving the appearance of a crime-infested neighborhood—which it was. I buzzed his intercom and a huge graffiti-scarred steel door slowly slid open, making an uneven grating sound on the concrete pavement. I felt like Mad Max, trapped in the wasteland of *The Road Warrior*. Once the door stopped moving, it revealed the Arnoldi compound's sculpture court filled with Chuck's recent bronzes.

As I looked over the sculptures' curvilinear forms, Chuck strolled in from his studio. His hands and running shoes were covered in paint, as was his torn T-shirt—which revealed the contours of his well-muscled physique.

"Good to see you, man. Let's go into the house—there's something that I want to show you. I just got this Warhol painting from Charlie."

Charles Cowles was his New York dealer.

"Which one?"

"You'll see."

Chuck had designed the living quarters himself as well as many of its distinctive furnishings. In the bathroom, for instance, was a toilet paper holder hand-milled from a solid bar of aluminum. In the kitchen, the entire countertop was sheathed in an unbroken slab of ox-blood colored granite. The massive aluminum dining room table was another Arnoldi creation. According to Chuck, the last time Arnold Schwarzenegger had stopped by, he couldn't resist commissioning one.

Once in the kitchen, I said, "Mind if I grab a glass of juice?"

"Help yourself."

As I opened the door of the Sub-Zero, I noticed that the top two shelves were filled with unopened bottles of Stolichnaya.

"Hey, Chuck, do you think you have enough vodka?"

Chuck gave one of his trademark laughs, communicating something between disdain and contempt. "Katie said I'm not allowed to touch those—it's 'Betty Ford Month' around here."

I took a sip of orange juice. Eyeing the open refrigerator, Chuck said, "Sure you don't want me to pour you some vodka in that?"

"I'm tempted, but it's too early in the morning."

"Since when has that ever stopped anyone?" said Chuck.

In the master bedroom I saw an Andy Warhol *Skull* painting hanging over Chuck's bed. This particular work was from a group of small *Skulls* (15 by 19 inches) that were done as a part of a larger series in 1976. Chuck's Warhol was rather benevolent, or at least as benevolent as a skull could be. The background was painted salmon and moss green and the skull itself was black and white. Its upper mandible was slightly raised, creating the illusion that it was laughing.

When Warhol began the series, it had been three years since he had painted his last significant group of paintings, the *Maos*. Informed by the painterly quality first seen in the *Maos*, the *Skulls* also featured hand-applied color. As Warhol knew, the skull had been a durable subject from the beginning of the Renaissance right up through Cézanne

and Picasso. Only he chose to update the classical memento mori image to symbolize more than death—his skulls were almost joyous and celebratory.

A year later, Warhol embarked on a series of *Hammer and Sickle* paintings. Taking a cue from the politically charged *Maos*, Warhol continued to mine the vein of communist symbols. The *Hammer and Sickles* were predominantly red, which intentionally played on the threat of the "Red menace." While they didn't have the *Skulls'* bite, their stylized abstract patterns created a strong visual impact.

Looking at Chuck's *Skull* I said, "Nice painting. What did you have to pay for it?"

"That's the best part—I didn't have to pay anything. We traded. Do you remember that yellow plywood/chainsaw painting?"

"The big one?"

"Yeah, that's it. Charlie sold it and rather than pay me, suggested that I take this *Skull* instead. I thought it was a good deal for both of us. My painting was sold for $45,000, so I would have gotten $22,500. I figure the Warhol's worth $30,000."

"Sounds like a good deal. I would have made the same trade."

"So you really like it?

"It's great—try and hang on to it."

"What are you doing for lunch?"

"I'm supposed to meet Jim."

"You're having lunch with *Corcoran*? That guy should be institutionalized," said Chuck, only half-kidding. "Tell him I want to play some golf this week."

As we walked back to the studio, I began to think about what Chuck had been through to make it as an artist. He had come a long way from a troubled home life in Dayton, Ohio, where he was a member of a street gang, to Los Angeles, where he was able to carve out a niche among the city's creative elite.

Chuck's rise to prominence in the art world might not have been possible without Warhol. After all, it was Andy who paved the way for artists of Chuck's generation by demonstrating that it was acceptable (and even necessary) to think in terms of careerism. Thanks to Warhol's example, a blatant desire for money and fame was one of the goals of

any respectable artist. Warhol's lesson certainly wasn't lost on Chuck. As he became more established in the Los Angeles artists' pecking order, he began to make friends in Hollywood, play in celebrity golf tournaments, and avidly pursue the good life.

A casual spin through Chuck's Rolodex revealed such names as Dennis Hopper, Michael Crichton, and Meryl Streep. Chuck once told me that even Bob Dylan had been to his studio. However, Chuck's strongest connections were in the world of painting. Chuck had developed friendships with Hockney, Rauschenberg, and other luminaries—including Jasper Johns. During the early 1970s, Chuck maintained a studio in New York and began to meet many of the city's artists. One day he convinced Johns to come over and take a look at his work. As Chuck related the story: "At the time, I was doing these paintings where I took tree branches that had been cut in half and then pressed them into white modeling paste. The branches were arranged in simple cross-hatch patterns. I still distinctly remember how Johns studied those paintings for a long time."

As any student of art history knows, Johns went on to produce a series of highly successful cross-hatch paintings, including the critically acclaimed works of the 1970s, *Scent* and *Corpse and Mirror*.

I looked at Chuck incredulously and said, "Come on—what are you trying to say, that you influenced Jasper Johns, America's greatest living artist?"

Chuck grew angry and for a split second I thought he was going to hit me. "Look, Richard, I really don't give a shit what you think. I'm just telling you what happened. I did not *specifically* say that my work influenced Jasper Johns—but you can draw your own conclusions."

At that point, I figured that I'd better ease off. I genuinely admired Chuck and certainly didn't want to get on his bad side. Moving on, I asked him about his rise to the pinnacle of the Los Angeles art scene. He explained how he had gotten his start studying commercial art at the Chouinard Art Institute but quit after two weeks because, as he put it, "I realized that I didn't want to spend my life drawing ads to sell vodka and golf clubs." Soon he embarked on a new path and decided to become a fine artist. His breakthrough came in 1980 when he saw photos of the Mount St. Helens eruption. Noticing the strong linear element

of the blackened denuded trees, he hit on the idea of using branches to make paintings. Not long afterward, he won the Los Angeles County Museum's "Young Talent Award" and was on his way.

Chuck's tree branch paintings began to sell even as the paint dried. He developed into one of those rare artists who produced high-quality work that was also salable. His macho follow-up series of thick sheets of laminated plywood carved with a chainsaw was met by almost equal demand. He developed a network of dealers who consistently kept his mailbox filled with checks. Chuck told me that by the end of the early 1980s, not only did he own a sizable studio, but he had also saved almost a million dollars.

When he married Katie, her parents gave them a breathtaking piece of property in Malibu that had been held in a family trust. Chuck used every penny of his savings to build a spacious house of his own highly contemporary design. The house was situated on the edge of a cliff overlooking the Pacific where the sunsets brought nature's canvas to life. Johnny Carson was one of his neighbors in this exclusive area. The catch was that the property could never be legally sold and had to remain in the family for future generations to enjoy.

One might say that Chuck had it all: good looks, a successful career, an attractive wife, healthy children, a great house in California, a vacation home in Hawaii, a Porsche Carerra, and friends in the entertainment world. Yet Chuck was disatisfied with his career. He frequently lamented how his contemporaries in New York, such as Brice Marden, received far more attention and higher prices for their work.

Obviously, Chuck wasn't the first artist to complain that his work was under-appreciated, but he was more successful than 99 percent of all living contemporary artists—maybe even 99.5 percent. When you examine what most artists have to overcome in order to make it in the piranha-infested art market, it's amazing that so many stick with it. What's so frustrating for most artists is that there's no blueprint for success. Each year, thousands of (freshly minted) artists graduate from art school, ready to colonize new territories. The harsh reality is that as soon as you leave the security of art school, you're on your own. To succeed as an artist, you have to use almost as much creativity to figure out a career strategy as you do to make the art itself.

Once you've found a way to support yourself, your first order of business is to develop a mature body of work with a signature style. The work should, preferably, be grounded in art history but not derivative of any other artist. Usually, that doesn't happen until an artist is approximately thirty-five years old—if it happens at all. Assuming your work is up to snuff, you then need to find a gallery. Unfortunately, it's a sad fact of life that there aren't nearly enough galleries to exhibit all of the worthwhile work out there, nor enough collectors to buy it. The competition for representation is brutal, and success often depends more on your connections than your talent. As Ivan Karp once observed, "If you want to make it as an artist, go to every gallery opening that you're invited to. Get there at the beginning and stay until the end."

If an artist is fortunate enough to receive a commitment from a gallery, then the real "fun" starts. An artist is faced with many questions: Is it a gallery with a prominent reputation? Can they attract critics to review their shows? Are they willing to spend money on advertising and promotion? Will they pay their artists? Do they work with serious collectors who regularly entertain so that the work receives maximum exposure? Or do they sell to collectors in Keokuk, Iowa, where the work disappears down a black hole, never to be seen again?

Let's say that the gallery is capable of accomplishing all of the above (which would be the exception, indeed). What happens if your show is a critical success but doesn't sell? Or what if the work attracts buyers but receives a scathing review in the local paper? Will the gallery stick with you? What if you've been loyal to a particular gallery in Los Angeles and you're selected for an important museum show, like the Whitney Biennial, and an established New York dealer wants to represent you exclusively? The career questions are endless.

To visualize what percentage of living artists become successful, envision the art world as a large pyramid. At the peak of the structure, there are only about fifty artists. These are the superstars: artists like Jasper Johns, Chuck Close, and Bruce Nauman. Virtually all of these upper-echelon artists are over fifty years old and most are over sixty. Each of them is already in the art history books, shows with the most prestigious galleries, and has a seven-figure income.

Right below the superstars are the stars. This group contains perhaps between 250 and 500 artists. All of these people earn a six-figure income and make a living entirely from their art, although a few may teach out of fear that their career might fall apart. They show with the better galleries, though not necessarily the best. Each of these artists produces work that has the potential to get into the art history books, but the jury is still out. Most of these artists are over forty years old and many are over fifty. Artists in this category include Chuck Arnoldi, David Row, and Christopher Brown.

Ranking below the stars is a group that I refer to as the potential stars. This cluster of artists might number five thousand. Chances are that most of these artists make a living by teaching and supplement their income with the occasional sale. This group covers a wide swath of ages, from thirty to eighty. Their income level is approximately $50,000–$100,000. While many have galleries, they're not considered to be first-tier. Potential stars produce competent work but have yet to create work that's considered innovative.

Below the potential stars is virtually everyone else. You might call this group the struggling artists. This designation includes over two hundred thousand people who went to art school and received B.F.A. degrees. Whether any of these aspirants will demonstrate the talent, ambition, and tenacity to stay the course remains to be seen. The odds are against them —it is an accepted statistic that most artists give up by the age of thirty. The reasons are varied and include diminishing interest, lack of confidence, marriage and other life events, and taking jobs to support their art that eventually turn into careers. Anyone still making art at forty is probably in it for the long haul.

That day, as I looked at Chuck in his studio, I empathized with the fact that he hadn't become a superstar, but you never know—he still had much of his career ahead of him. We shook hands and I left to meet Jim Corcoran for lunch.

When I arrived at the gallery, Jim said, "I thought we'd go eat some Japanese food. Have you ever tried Kobe beef?"

I had heard of the Japanese delicacy but had never experienced it, mainly because of its prohibitive cost—said to be greater than caviar.

"No, I never have. But I'd love to try it."

"Fine. Hop in the car and I'll take you as my guest."

I opened the door to his new black Taurus—he had finally ditched the Cadillac. Only Jim could get away with owning a Ford and still come across as cool. Surprisingly, he was a conservative driver who was in no rush to get anywhere.

We arrived at the restaurant, and when I looked over the menu I noticed that Kobe beef was priced by the ounce. I ordered the minimum, so as not to take advantage of Jim. The beef itself was rich and incredibly flavorful—so much so that I couldn't wait to have it again. Meanwhile, Jim ordered some miso soup and a small seaweed salad. I figured he was on one of his periodic diets. When we finished our meal and the check came, Jim grabbed it and threw down a one hundred dollar bill.

Before I could thank him, he said, "Let's see here, the bill was eighty-nine dollars—my share was nine and yours was eighty. Do you *always* do this to people when they take you to lunch?"

13

DIVIDING THE *MAP*

ART DEALING IS A LOT LIKE playing poker: when you're hot, you're hot. However, as any serious poker player will tell you, at any moment lady luck can turn into a woman scorned. In terms of the art market, despite all of the brave talk among dealers that the good times would go on forever, there was a creeping sense of paranoia as 1989 came to a close. Ominous clouds started to gather as the world's economic climate darkened. Rumors circulated about looming financial problems, especially in Japan. Still, I decided there was time to run to New York to try and pry loose one last big deal.

On the surface, little seemed to have changed. A survey of New York's most publicized dealers revealed that Mary Boone was still buying expensive designer shoes, Arne Glimcher was torn between making movies and selling art, and Larry Gagosian was being accused of doing all sorts of amoral things—but was still presenting the best shows in town. The East Village gallery/real estate experiment was coming to an end as the better artists fled to SoHo for representation. However, since it was November, most of the talk centered around that week's fall sales at Sotheby's and Christie's.

During good times amazing quantities of art come out of hiding as opportunistic owners attempt to cash in. The last three or four sales had been extremely successful, and that November's offerings promised to be the most lucrative of all. At the time, the most prominent player

was a Japanese dealer named Shigeki Kameyama, who represented the Mountain Tortoise Company; his name had become synonymous with overbidding at auction. True to form, that November at Sotheby's he paid $20 million for de Kooning's 1950s masterwork, *Interchange*—the most ever paid at auction for a contemporary painting.

Warhol was also doing well. As word got out that I owned a gold *Self-Portrait*, I began to receive unsolicited offers for my painting that approached twice what I had paid for it only a few months before. It wasn't that my painting was so important, it was more the classic scenario of demand exceeding supply. For the last couple of years, you could have bought virtually any painting by a blue-chip artist and doubled your money before the ink was dry on your check. As the San Francisco collector Richard Mendelsohn put it, "If you didn't make money during the 1980s, you were a schmuck."

As a dealer looking to flip a painting, I felt like I was playing an expensive game of musical chairs. You knew the music was going to stop, but you didn't know when—which meant you didn't know who was going to get stuck with a bunch of overpriced paintings. It used to be that if you bought a painting and waited six months to put it up to auction, you were guaranteed a profit. Suddenly, you couldn't really tell if you had six months—or six weeks.

I began to scour the city's galleries looking for fresh inventory. The only problem was that everyone else was doing the same thing. Not only that, but dealers were starting to price everything above market, anticipating each painting's *future* value. It soon became painfully obvious that I was wasting my time, especially trying to buy Pop material. Changing tactics, I elected to look for some Californian works and decided to visit the venerable dealer Allan Stone. Back in 1961, when Andy Warhol was hungry for representation, Stone was one of the first dealers he approached. As Stone tells the story: "When I went to his studio, there were all of these *Soup Can* paintings, including some painted with the labels peeling off. I had also been to the studios of James Rosenquist and Robert Indiana. I didn't want to make a serious commitment, so I wound up offering them a three-man show, but they turned me down. Warhol and the others were each holding out for their own show, which history proves they were smart to do."

I stopped by Stone's gallery, intentionally located away from the mainstream, on East 88th Street. As anyone who has ever visited the gallery will tell you, it is an experience that you don't easily forget. Once you enter the gallery, perhaps tripping over the snow shovel that stands in the entrance year-round, you're transported to a world of pure fantasy. There's always a challenging exhibit to see in the gallery's main room—that is if you can squeeze into it. The gallery's overwhelming clutter is like a bus in India with passengers clinging to the roof and hanging out the windows.

Room after room is piled to the ceiling with Stone's bizarre collections—including a handful of authentic shrunken heads. The gallery seems to be filled with more African masks and sculptures than Mali, the Congo, and the Ivory Coast combined. There are also fragile Joseph Cornell boxes, stacked one on top of another, as if they're worthless pieces of junk. Stone's large house in Purchase, New York, is stuffed with even more objects, to the point where if he were to cram in one more ostrich-sized Senufo bird, it might burst.

Oddly, for such a gregarious person, Stone is perhaps the most difficult person to reach on the phone that I've ever come across. If it's your first time calling him at home, you're not sure if you've dialed the right number because the voice you hear isn't human—it's seven consecutive "woofs" from a barking Labrador Retriever.

During my visit to Stone's home, I didn't detect any visible form of security. But he may have been employing the same low-tech system he used at his gallery. Most galleries have elaborate alarms that are wired to the closest police station. But Stone devised his own unique form of protection. In a moment of inspiration, he bought a bag of glass marbles and hid three or four of them on the inside of each picture frame. If anyone tried to swipe a painting during gallery hours, the unsuspecting thief would be exposed the minute the marbles fell onto the gallery's hardwood floors. Once, when they had run out of marbles, he tried a variation on this theme by substituting pennies.

Another eccentricity of the gallery was its employees. The front desk was manned capably for almost thirty years by the now-late Joan Wolf. Her claim to fame was that she could remember the work of every artist seeking representation who had appeared at the gallery since the

beginning of her employment. Peering out from behind her oversized black designer frames, she was always ready with a quick smile and the encouraging words, "Allan isn't in yet, but he can usually be found in his office from five to six." By five o'clock, the gallery resembled a doctor's waiting room and was often filled to capacity.

But at least Wolf gave the appearance of being normal; the same could not be said for Stone's other staff member, Duchman (pronounced Duke-man). "Duch," as he is known, is a Vietnamese immigrant artist who was in dire straits when he met Stone. Duch was missing all of his front teeth, the result of an unscrupulous dentist who had offered to take one of his paintings in exchange for dental work. Duch had gone to the dentist in hopes that his rotting teeth could be saved. The dentist saw no alternative other than to remove them. Midway through the process, the dentist decided that he no longer wanted the painting—he wanted money. In an act of remarkable compassion, Stone went to see the dentist and offered him a valuable small Arshile Gorky drawing to finish the job and restore Duch's missing teeth.

After that, Duch attached himself to Stone and declared his loyalty for life. Stone began to think of him as a "rabbit's foot." He let Duch sleep in the gallery and put him on the payroll as the general caretaker. Eventually, Duch took over the responsibility of installing shows and even wound up working with a few clients.

But what attracted serious visitors to the gallery was Stone himself. A first-class raconteur, Stone is often sought out by serious collectors for his knowledge of the artists and the market. As the only active dealer to work with both the Abstract Expressionists and the post-1960 artists, Stone has seen it all. You might say he is the ultimate insider. During his lengthy career, he also managed to amass a significant hoard of art, including major holdings in Franz Kline, Willem de Kooning, John Chamberlain, and Wayne Thiebaud, the renowned West Coast painter of cakes and pastries.

One of Stone's better stories involves Thiebaud's seemingly nonthreatening work. During the early 1960s, the aristocratic Abstract Expressionist Barnett Newman was becoming deeply disturbed by the advent of Pop art. One day, he and the other Allan Stone Gallery artists held a secret meeting in an attempt to take action and draw the line. The

next day, an agitated Newman stormed into the gallery and said to Stone, "I've just met with Bill [de Kooning], Philip [Guston], and the other artists and we want you to get rid of that 'pie guy.'" He was referring, of course, to Wayne Thiebaud. Luckily, Stone had the foresight to hang on to him as Thiebaud went on to become his greatest discovery and made him a millionaire many times over.

When I approached Stone that day, he was entertaining an African art dealer who, by the look of things, was having a hard time closing a deal. After he left, I said to Stone, "Is any of this African stuff real?"

Stone smiled broadly and said, "Who knows? But some of it is so great looking that I buy it anyway. Nowadays, they take new carvings and bury them in the ground, piss on them, throw blood on them— whatever it takes to give wood the patina of age. Anyway, what can I do for you, Richard?"

"I was hoping you might be willing to offer me a small Thiebaud, perhaps a pastel or a painting on board."

Stone thought for awhile. Surrounded by a bunch of hippopotamus skin shields from Ethiopia, I couldn't tell whether I was on a Tarzan movie set or in an art gallery. Finally, the great man spoke, "I'm really sorry, there's nothing that I want to sell and there's nothing left from last month's Thiebaud show—everything was sold."

"But you once told me that at the beginning of each Thiebaud exhibition, you simply total up the costs of the work and write Wayne a check for the entire show—which means you have an automatic sellout."

"Did I tell you that? Well, that's not true. The thing is, I'd rather live with his work than sell it. So at the beginning of each show, I put red dots on those pictures that I want to keep for myself."

"So how do I get a painting?"

"Maybe you can get one from Berggruen or at auction."

"Thanks a lot," I said, making a face.

"Listen," he said kindly. "We'll do something else together. Do you still have any of those Philadelphia Wireman sculptures?"

Stone was referring to a group of tiny sculptures made out of thick wire, wrapped around a handful of found objects, such as coins, bottle caps, and other bits of urban flotsam and jetsam. Around 1979, about

twelve hundred of these wire bundles were found thrown out with the trash in a predominately black neighborhood in Philadelphia. A graphic designer found them and sold the majority of them to the art dealer, John Ollman. Despite Ollman's repeated attempts to track down the creator, including the posting of flyers in the neighborhood of the discovery, the artist was never found—hence the invented name, Philadelphia Wireman. Earlier that year, Acme Art had done one of the first shows of his work, with sculptures selling for an average price of $300.

Although I wasn't keen on selling my remaining Wireman works, I was anxious to salvage something from my visit, so I said, "Yeah, I've still got a dozen left."

"Well, why don't you get back to me with a price and maybe I'll just buy the whole group from you."

I stood up and almost stumbled over a Nigerian chief's foot stool. When I left the gallery, it was almost six o'clock and the space was still crammed with art-making subjects patiently waiting for an audience with their king. Disappointed that I was not offered a Thiebaud and realizing that finding a painting to speculate on wasn't in the cards, I promised myself I'd spend my last two days in New York doing something worthwhile. I began to think about Stone's story about Barnett Newman and the overt hostility that his generation had displayed toward the next wave of artists. My thoughts raced ahead to the man who broke the ice for Newman, his peers, and in some ways Warhol— the first American art world legend, Jackson Pollock.

I realized that I had never seen Pollock's studio, which was now open to the public. As soon as I got back to my hotel, I made an appointment with the Pollock Foundation to visit the shrine the next day. By nine the following morning, I had rented a car and was on my way to the Hamptons (Springs, to be specific). During the drive, I thought about *Life* magazine's 1949 feature article titled, "Is Jackson Pollock America's Greatest Painter?" The artist was photographed standing next to one of his trademark "Drip" paintings, posing with a cigarette dangling from the corner of his mouth. I always wondered what Warhol had thought of Pollock, since he was Warhol's only peer to transcend the art world and become a celebrity of popular culture.

Pollock had led a romantic yet star-crossed life. He left his native Wyoming and came to New York determined to make it as a painter and find his place in the art world. Fame came his way not long after he married the painter Lee Krasner, who put aside her own work to promote Pollock. Thanks to his ground-breaking body of "Drip" paintings—where he flung and dripped paint, creating an all-over surface of organic lines that seemed to vanish and resurface within one another—Krasner succeeded in driving Pollock's career to the pinnacle of the New York art scene.

But along the way, her marriage and self-esteem suffered grievously. Pollock's insecurity, fueled by a steady stream of alcohol, led him to abuse her. Eventually, Krasner discovered he had another woman in his life and left him. Pollock fell apart completely and his life ended in a spectacular car crash not far from his studio. It was the sort of tragic ending that the media thrives on, and it wasn't long before his legend was firmly established.

That day, I couldn't help but think about Pollock's demons as I visited his studio. The tour was fantastic. Visitors were allowed to walk on the barn's wooden floor once they had removed their shoes and put on a pair of hospital green paper slippers. The floor was still covered with skeins of dripped enamel which formed an enormous pseudo-Pollock painting. Based on the still-vibrant colors, a Pollock expert could probably identify each of the famous paintings that were created there. As I looked up at the rows of shelves, I could see battered cans of paint and clusters of Pollock's brushes still sitting in old Hills Brothers coffee tins. It was as if time had been arrested in 1956, the year Pollock died.

Visitors were also allowed to view some of the rooms in the adjacent house that he lived in. The house itself was far less remarkable than the studio, although there were a few attractive paintings on the walls by Krasner. After a few minutes, I was ready to go, but decided to use the facilities before I left. The Foundation's caretaker pointed me in the direction of a bathroom reserved for guests. When I asked if that was the bathroom that Pollock had used, I was told that it wasn't. His bathroom was upstairs—but that was off-limits.

In a moment of insanity, I decided that I wanted to sit on the same toilet Jackson Pollock had used. I waited until the house became more

crowded and quietly slipped upstairs. At the end of a long uncarpeted hallway was the bathroom. Not bothering to switch on the light, I pulled my pants down and lowered myself onto the throne. I was hoping that through osmosis some of Pollock's greatness might be transferred to me. After about thirty seconds, failing to detect any changes, I pulled up my jeans. But I couldn't resist a big grin. Although many people had seen Pollock's *Lavender Mist* at the National Gallery, I didn't know of a single soul who had ever sat on his toilet!

Having a "meaningful" experience at Pollock's studio proved to be just the antidote I needed to cheer me up about not having done any real business. Later that day, I returned to the city and then caught a flight back to Los Angeles.

The following day, Jonathan Novak asked if I'd join him for lunch. "I'm supposed to go with Michel Cohen over to Marcia Weisman's to show him her collection," he said. "I'm sure if I called her, I could get you invited."

Having never seen her famous collection before, I said, "Sure. I'd love to see her paintings."

A half-hour later, Jonathan picked me up. When we walked into Weisman's home, Cohen was already standing there in the foyer, snooping around. True to his reputation as the city's most aggressive private dealer, he greeted us by saying, "Where's the price list?"

We got a kick out of his crass remark. What else would we expect from someone who refused to go to a museum because, as he put it, "What's the good of it—nothing's for sale!"

Weisman was in her late seventies at the time, but she still had the energy of someone half her age. Years ago, she and her husband Fred had been Warhol portrait subjects. As her maid served us a lunch of poached salmon, Weisman told us about her incredible odyssey to acquire the masterpiece in her collection, *Map*, by Jasper Johns. In 1961–63, Johns had painted three panoramic maps of the United States. The paintings were extraordinary, mainly because of the frisson Johns created between the two predominant movements of the day: he gave the works a Pop sensibility by using stencils to label each state, yet the vigorous brushstrokes were completely grounded in Abstract Expressionism. The most colorful of the *Maps* was on display at MoMA,

a gift of the Sculls. Another painting was in a private East Coast collection. Weisman owned the third, for which she had just turned down a $15 million offer from a Japanese collector.

As she recalled: "Back in 1962, Fred and I went to Jasper's studio. He was working on the second of the *Maps* and I was immediately struck by the beauty of the painting and told him that I wanted it. Even back then, Jasper never liked to sell anything, but our enthusiasm won him over. We paid $10,000 for it, which was, by far, the most we had ever spent."

Weisman continued, "Did you ever look at the other two *Maps* in person?"

I volunteered, "I remember seeing all three at the Johns retrospective during the 1970s. You know, one thing that I was always curious about was why he stenciled the word 'Hell' on one of the paintings, right next to the date and his signature—in the lower right corner of the Atlantic Ocean. I always figured he wanted to share what he was going through."

"Nice try," said Weisman. "The painting was bought by the collector Ben *Heller* and this was Jasper's way of paying him a compliment."

I said, "That's hard to believe. Knowing of Johns's independent personality, I can't imagine that he would alter a painting just to please a collector."

Weisman responded, "If you don't believe me, why don't you ask him yourself?"

With that, she got out her phone book and called Jasper Johns, without a doubt the most reclusive major artist in America. After what sounded like a warm greeting from Johns, Weisman handed me the receiver. I couldn't believe it—not only was she able to get Jasper Johns on the phone, but now *I* was talking to him. I quickly got to the point and, sure enough, he confirmed her story. I was totally blown away, feeling like I had just had a brush with art history.

Many years after buying the Johns, the Weismans got divorced. Although they owned a number of world-class art objects, the Johns *Map* was considered to be the prize of the collection. Both of the Weismans had consulted art experts about the value of each work, and when it came time to divide up their holdings, they agreed to flip a coin to see who got first pick. I can only imagine the tension in the room as they flipped the coin, and Marcia's state of dismay when Fred won the

flip. However, proving that sometimes there's justice in the world—it had been Marcia's idea to buy the Johns in the first place—Fred inexplicably picked a Giacometti bronze. It made me wonder what his adviser had been smoking. I'd like to believe, though, that he knew exactly what he was doing and was just being kind to her.

Weisman described her incredible relief as she snapped up the Johns. Before her death in 1991, *Map* was bequeathed to the Los Angeles Museum of Contemporary Art—where it can be seen today.

14

LIQUIDITY

LIKE A DRUNKEN SAILOR WAKING up with a bad hangover, the art world woke up in early 1990 with a painful headache—the art market was on the verge of collapse. The 1980s were over, and the market was about to experience a chain of financial setbacks that would reverberate for years. The collapse of the Japanese Nikkei index acted as a blasting cap that began to loosen the mountain of blue-chip paintings held by the upper-echelon dealers. Soon, the trickle down of paintings would form an avalanche of unwanted art as dealers raced to dump their inventory. Suddenly, one began overhearing comments like, "I paid $175,000 for this Frankenthaler, but I'll take $90,000 for it."

In retrospect, the drop in the Japanese market was bound to happen sooner or later. Along with their art-buying junkets of the late 1980s, they had also been snapping up scads of New York real estate, including Rockefeller Center. Fear was in the air as the *New York Times* ran an editorial that half-seriously wondered if the Japanese were going to buy up all of Manhattan island.

As far as the art market was concerned, one magazine speculated that the Japanese had been responsible for approximately one-third of the buying at auction. The other two-thirds was split almost evenly between the Americans and Europeans. Logically, if you remove 33 percent of the buyers from any market, prices begin to go down and eventually the whole industry craters.

The first hiccup in the art market was felt during that February's small-scale winter sales at Sotheby's and Christie's. I was at the Mark in New York at the time and remember talking to Jonathan Novak, who was staying further downtown at the Waldorf Astoria.

"When did you get into town?" I asked.

"Last night. I had a great flight. I know you make fun of me for holding up transparencies of my inventory and pretending to view them, but it works. There was this woman sitting next to me who asked to see what I was looking at. The next thing I know, she's telling me that she's a collector and I should give her a call if I come across a Motherwell *Elegy*. I'm telling you, it's time you started flying first-class. You'll certainly never meet any collectors in coach."

"Give me a break. So, have you looked outside and seen the snow flurries?"

"Oh, my god—it's a real blizzard out there!" said Jonathan, always one to overreact.

"How's your room?"

"Well, it's fine now, but I had to move three times. I requested my usual suite in 25-Y, but it was already taken. So, they tried to stick me in this room right by the ice machine, then in one near an elevator. But I read them the riot act and finally ended up with this great corner suite—you've got to see the size of this place—it's bigger than your apartment."

"So, how much are they *paying you* to stay there?"

"Funny."

"Listen, do you want to go with me to the auction this morning?"

"Sure, I'll meet you there, just as soon as I have breakfast in the 'Astoria Level' dining room."

By the time I made it down to Sotheby's, the auction was already underway but the room was barely full—only three months ago it had been standing room only. The sale itself wasn't a disaster, but describing it as lackluster would have been generous. If you observed closely, there were plenty of ominous signs. For instance, over the last two years, one of the hottest markets around was for Ed Ruscha's work. His signature ribbon-letter drawings had zoomed from an average price of $4,500 in 1986 to a record price of $82,500 by the end of 1989. Now, only ninety

days later, a good-quality drawing had just been hammered down for $38,500.

The final results of the February sales had scary implications for the all-important May auctions, a scant three months away. After walking out of Sotheby's sales room, I felt a twinge of panic. Maybe I was being foolhardy by hanging on to my gold "Fright Wig." Up until now, I had felt confident that even if the art market slipped into a recession, the value of my painting would hold up. After all, we were talking about Andy Warhol. Yet I was still haunted by an observation made by Paul Siegel, the owner of a San Francisco hedge fund, who once said, "When a market goes, it all goes."

Surprisingly, most of the dealers that I dealt with seemed unconcerned, even oblivious. Their nonchalant attitudes made me think of the Beatles singing, "Nothing's going to change my world." Many of the dealers offered a host of lame excuses: "Well, you know, it's February—nothing much happens then," "What did you expect?—the material wasn't very good," and my favorite, "Of course the sale was a dud—the auctioneer was terrible." The only reason I could find for the weak auctions was that the world was going into a recession and the art market was going with it. Equally depressing was that there wasn't a darn thing I could do about it.

After a long talk with Lia, we decided to adopt a defensive position. Over the last couple of years, we had quietly amassed a group of small-scale works by well-known artists—"minor works by major artists," as I liked to call them. These works comprised our personal collection. We were typical of many dealers who bought works for their home as well as their inventory. An intelligent dealer always makes the distinction between "collecting" money and "dealing" money; if you want to run a successful business, you should never confuse the two. We tried hard to stick to this principle. In theory, once a work of art crossed the threshold of our apartment, it was no longer on the market. But in reality, everything was potentially for sale—especially if someone made us a ridiculously good offer.

At this point in time though, we were more concerned with liquidity than price. With the exception of the Warhol, we agreed to put everything else up to auction, including one of my favorite works in the collection,

a Joseph Cornell box. It wasn't that we thought we'd make a killing, it was more that we expected the May auctions might be the last gasp before prices really plummeted.

It was especially frustrating to be selling the Cornell, since I had acquired it only six months earlier in a trade with the Southland Corporation. That acquisition was in many ways my finest moment as an art dealer. During the 1980s, a large number of American corporations began to collect art. The concept of corporate patronage went all the way back to 1957 when Chase Manhattan Bank commissioned Sam Francis to paint a large mural for their headquarters. The painting proved popular with the employees and paved the way for the bank to begin buying work by other artists. Before long, they had put together a substantial art collection, including pioneering purchases in the emerging field of folk art.

In years to come, many other companies took notice and began to assemble collections of their own. Among the corporations smitten by art was the Dallas-based Southland Corporation, also known as the parent company of the 7-Eleven convenience stores. Following the lead of Bank of America and Progressive Insurance, they created a new position and hired a curator for their collection. In Southland's case, they appointed a character named John J. Jasinski. His mandate was to acquire art purely for employee enjoyment, rather than with an eye toward potential appreciation.

Jasinski had one of the most desirable jobs in the art world. With a yearly budget rumored to be five million dollars, he began to travel the country in search of art. When he walked into a gallery, it was like one of those old E. F. Hutton commercials where everyone froze so they could listen to what he had to say. Unlike most curators, who needed the approval of either a committee or a high-placed executive, Jasinski had the power to buy on his own authority. He was arguably the most powerful corporate curator in America—and knew it only too well. The stories about Jasinski and the abuse of his position could fill their own book. Though I was fortunate to count him among my best clients, I had the misfortune of having to constantly ply him with expensive meals—like the time he ordered a separate lobster entrée along with a complete filet mignon dinner because he didn't see his favorite "surf and turf" combination on the menu.

I was always amazed at Jasinski's diverse and often incongruous interests. A classic example of his unpredictable ways was the time he insisted that I treat him to a reggae concert in Berkeley to hear the Jamaican group Black Uhuru. Jasinski was completely enthralled at the concert—singing along with each song, praising the merits of ganja, and proclaiming his allegiance to Haile Selassie. After the performance, he talked me into going backstage with him to meet the musicians. The next thing I knew, he had befriended someone named Babatunde. As Jasinski motioned me over to make introductions, I watched the two of them exchange addresses and pledge to write each other. Jasinski even discussed the possibility of doing a show of Rastafarian art at Southland. The whole thing was insane.

Perhaps the defining John Jasinski story took place during his last visit to San Francisco. When I picked him up at the airport, I received an impromptu lecture about how valuable his time was. He went on to explain that as the curator who was setting the pace for corporate patronage, it was crucial that he maximize his visits with art-related activities. So, at his insistence, where did I find myself an hour later? At the East Bay Vivarium—the West Coast's largest emporium for reptiles and amphibians. Once we were inside this glorified pet shop, he proceeded to inquire whether he would receive a "curator's discount" if he purchased a breeding pair of four-foot long Komodo Dragons.

But the good times didn't last forever. As the recession got under way, many companies, including Southland, terminated their art-acquisition programs. Even though Jasinski was out of a job, I maintained a relationship with the chairman of the board, John P. Thompson. Although he only took a passing interest in the collection, I could tell it gave him a sense of pride to be a supporter of the arts.

When I thought about all the works Southland had bought from me, including the *Dollar Sign* I had purchased directly from Andy Warhol, there was only one object that I truly regretted selling—a Joseph Cornell *Sun* box. This series of boxes was noted for their half-dollar-size old-fashioned sun faces, which Cornell had cut out of tins of imported olive oil. I wondered if now that Southland was no longer collecting, maybe there was a chance they would consider selling the box back to me. At the height of the market, the *Sun* box may have been worth as much as

$150,000. I wasn't in a position to pay that for it but was hoping a trade could be worked out.

I called John Thompson and told him what I had in mind. He said that he didn't want to sell anything but was open to a trade, mainly because the box had proved hard to display. When I informed him that I had a couple of choice Cornell *Penny Arcade* collages available, he sounded interested. One thing led to another, and a week later I found myself in Dallas carrying two carefully wrapped collages.

I was only in town for the day, so I wound up hiring a car and driver just so I could concentrate on the business at hand. As I arrived at the Southland Corporation, I took the elevator up to the forty-third floor of the company's elaborate new granite-clad high-rise. The elevator opened to reveal a long gallery lined with a series of vintage photographs by Ansel Adams. Despite all of John Jasinski's shenanigans, he had done a credible job of selecting art that was both enjoyable to live with and had historical resonance.

At the end of the hallway, I came across the picture that once almost brought my relationship with Jasinski to an end. The work in question was a David Hockney colored-pencil drawing of a neat Southern Californian garden. But the problem wasn't with the drawing, it was with the frame. I had originally bought the drawing out of a private collection. When I had made the purchase, I examined the condition of the work but paid little attention to the frame.

One day, out of the blue, Jasinski called me and opened the conversation with the cryptic words, "Richard, the reason for my call is not a happy one."

I immediately feared the worst—Jasinski had lost his job and I had lost one of my biggest clients. I began to rub my forehead as I heard Jasinski speak in his melodramatic voice, "I want you to picture the following scenario: John P. Thompson, chairman of the board, strolls down the corridors of Southland on his way to his office, when suddenly his interest is piqued by a David Hockney drawing. He stops in front of the drawing to admire it, then decides to take the drawing off the wall, perhaps to examine it more closely. He removes the drawing and turns it over to read the identifying label. But to his shock and dismay, what does he find on the bottom ledge of the frame's interior? DEAD INSECTS."

I was confused—what the hell was he talking about?

"So there's John Thompson, in a state of revulsion. He says to himself, 'How could this be? Is this what I pay Jasinski for—to purchase works of art with *dirty frames*?' Now, Richard, fortunately my eagle eye spotted this indiscretion before any real damage was done. But surely you can see the implications of the ugly scenario that I just painted for you. If this ever were to have occurred and I had needed to answer for it, you'd better believe that John Thompson would have asked me who was the vendor that sold me the work of art. I'd then have had no choice but to implicate you."

I continued to listen to Jasinski's monologue in silence. I always knew Jasinski wasn't wired right, but even still, this conversation was beyond absurd. I distinctly recall that when he bought the Hockney, he only gave the actual work a cursory glance, preferring to concentrate on a minute scratch on the silver-leaf frame. Now, once again, he was more concerned with the frame, and the *back* of the frame at that—rather than whether his boss would be pleased by the actual work of art.

Speaking in the third person, he continued, "So in conclusion, you can see that John J. Jasinski is not pleased. I hope you understand the severity of this transgression and will take every future precaution never to let it happen again."

Trying not to laugh, I replied, "John, I read you loud and clear. You can rest assured that every work of art that you purchase from me from this day forth will be carefully inspected for dead insects. This will *not* happen again."

Now John Jasinski was history and I was about to have an audience with his former boss. I knocked on Thompson's door and was invited into the office of one of the wealthiest men in Dallas. We shook hands and Thompson opened the conversation with a sincere inquiry about how my business was doing. He was about sixty years old, self-assured, and extremely down-to-earth. In other words, he struck me as a man who knew how fortunate he was. Breaking eye contact, I spied the object of my desire. The Cornell *Sun* box was sitting on his mahogany desk, looking every bit as magical as I remembered it.

"So what have you brought to show me?" he asked.

I unwrapped the two Cornell collages and handed one of them to him. I also passed him a fact sheet I had prepared that listed past auction

results for similar *Penny Arcade* collages, as well as *Sun* boxes. From the numbers, Thompson could see that my two collages were worth approximately as much as his box. Based on his accommodating demeanor, I felt confident that he would agree to the trade. But he was also a businessman and therefore expected us to engage in at least some brief form of negotiation.

"I want you to explain to me why I should make this trade," he said.

I began to pitch him on how my collages would not only be more practical to display, but in some ways were more desirable than his box. Cornell had completed fewer than twenty collages with actual pennies and most were off the market. I also elaborated on how the *Penny Arcades* referred to the artist's nostalgic reminiscences of the old penny arcades in New York's Times Square. I waxed eloquent about how these two collages reflected the mystery and melancholy of a vanishing era. By the time I was through, I almost began to wonder why I *was* making the trade.

Thompson nodded appreciatively at my explanation. He then studied one of the collages more closely. The one that he examined contained a shiny steel penny from 1943—the peak of America's involvement in World War II, which led to the rationing of copper.

With a frown, Thompson said, "You know, it really bothers me that this penny is made of steel—a penny should be made of copper."

I just looked at him, not knowing what to say. As a veteran dealer, I was used to overcoming all sorts of objections, but never did I have to defend an artist's use of a steel penny.

"I agree with you, John—a penny *should* be made of copper. But I have to assume the artist believed the silver color of the coin was aesthetically more pleasing."

I wasn't sure if I had said the right thing, but it was all that I could think of. Thompson looked at me, looked down at the offending penny, and then looked up at me again.

With a smile, he finally spoke. "Fine. I'll make the trade."

I shook his hand, expressing my gratitude. Then, he said something that I will never forget.

"I hope you're going to keep the box and not sell it to the Japanese."

His remark proved prescient because less than a year later Southland fell into serious financial trouble and Thompson wound up selling his company to—surprise—the Japanese.

Now, only six months after our trade, I was signing a contract giving Sotheby's the right to sell the box. Deep down, I knew I was doing the right thing. But I still felt a strong sense of loss, given what I had gone through to acquire it. Since it was obvious that hard times were ahead, I knew the money would come in handy.

If the box sold.

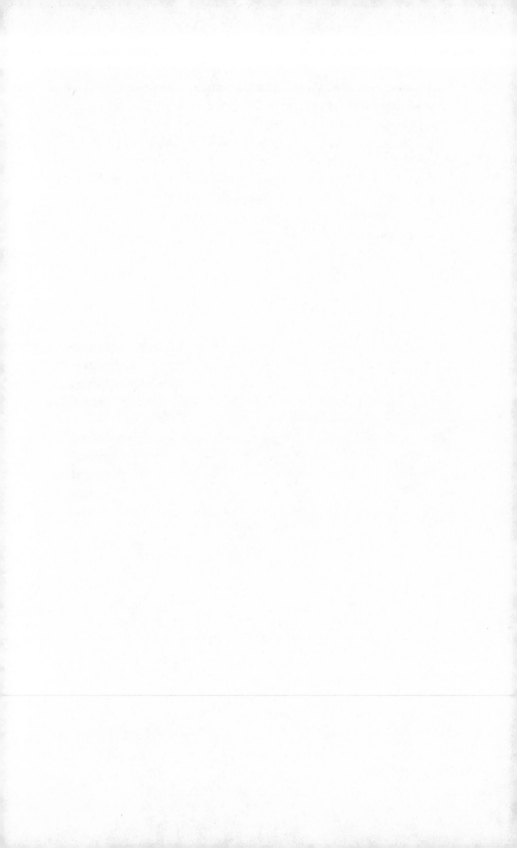

15

WOULD SOMEONE GIVE ME A MILLION?

ALL EYES IN THE ART WORLD WERE firmly focused on the May 1990 auctions. Since Sotheby's stock was publicly traded, even Wall Street was paying attention. But price-to-earnings ratios were the furthest thing from my mind. All I cared about was whether my Joseph Cornell would pay any dividends that quarter.

On the surface, things didn't look so bad. Sotheby's Anthony Grant had assigned my work a generous estimate of $150,000–$200,000, which meant I had a lot of leeway to set a reserve since I only had $55,000 tied up in the two collages I traded for the box. After a reassuring conversation with Anthony, I decided to set the reserve at a conservative $100,000. I was also counting on the fact that my Cornell was the only one consigned to their evening sale. My confidence quickly evaporated, though, once the sales catalogues arrived. Apparently, Sotheby's had received a last-minute consignment—five additional Joseph Cornell boxes from the esteemed collection of François de Menil.

After looking over the Cornells that he had consigned, I concluded that only one of them was superior to my *Sun* box. Still, the added competition was unsettling. The public's perception of Cornell had always been that his work was scarce. Each round of sales usually contained only one or two boxes. Now there was a glut of six—at Sotheby's alone.

That season it was Christie's turn to host the first night of auctions. I arrived at the opening sale, found my assigned seat, and impatiently

waited for the proceedings to get underway. Since the Christie's sale contained an additional three Cornells, I was feeling tense. Before I knew it, the evening's auctioneer, Christopher Burge, began reading the preliminary announcements and then the sale was off and running. Unfortunately, "off and stumbling" would be more accurate as the first of Christie's Cornell boxes failed to sell, but I rationalized that the *Cockatoo* box's $350,000–$450,000 estimate was far too greedy. The next box's more modest $120,000–$180,000 estimate failed to make a difference as it too bit the dust. Finally, the third time proved to be a charm as an attractive *Constellation* box hit the exact low end of its estimate to hammer for $120,000. It could have been worse.

A few lots later, it *was* worse. Earlier in the sale, a rare Abstract Expressionist canvas by Clyfford Still had failed to sell within its $3.5–$4.5 million estimate. Still's paintings were known for their high emotional content and the artist's rigorous use of a palette knife to apply pigment. Although this predominantly red and black painting passed, there had been some real bidding until the price stalled out at a respectable $3.2 million. Now, a second Still appeared on stage, this one carrying a similar $3–$5 million estimate. Once the process began, it became obvious that Burge was bidding against himself—there were no legitimate bidders. Usually, when it appears that an important painting isn't going to sell, a highly audible wave of gasps flows through the audience. In this case, there was cold silence, as if everyone was at the edge of their padded seats, fearful of making any sound that would encourage an onslaught of negativity.

Grasping at straws, Burge did something that I couldn't recall ever having witnessed before—he lowered his opening bid. General auction procedure called for the bidding to open at half of the low end of a painting's estimate, which meant the bidding would have started at $1.5 million on the Still. When there were no bids at that level, Burge threw out a desperate request: "Would someone give me a million?" A paddle shot up from the audience. People in the crowd let out a nervous laugh, thinking that Burge was bluffing just to get the momentum rolling. But when there were no follow-up bids and Burge cried out, "Sold!" even the apparent buyer—the voracious collector/dealer Jose Mugrabi—probably thought it was a joke. But it turned out to be no laughing matter, and

the sale stuck. Mugrabi had just purchased a Clyfford Still painting that had been valued as high as $5 million for just a million.

The next evening's sale at Sotheby's began before I was ready to handle it. Adding to the tension surrounding the five rival Cornells, there was an equal number of Andy Warhols coming up. Mercifully, all of the Cornells were scheduled for the beginning of the sale. The first of the de Menil properties was an *Owl* box illuminated by an electric light, which failed to sell. Then a hinged box construction, which contained a group of tiny wrapped packages, brought $176,000—far below its $200,000–$250,000 estimate. But at least it sold, giving me a momentary glimmer of hope. Next, a Cornell *Sand Tray* also sold below estimate for $88,000. It was followed by a *Dovecote*, which passed. Then, finally, a miniature pillbox-size work brought an unspectacular $27,500. The final de Menil box score read: five Cornells offered, three sold, for a total of $291,500, against expectations of $690,000-$880,000.

The rest of the sale wasn't doing much better. Even a vintage Claes Oldenburg painted plaster wall relief of bacon and eggs, once owned by Leon Kraushar, failed to sell. Then the lot preceding my Cornell appeared. It was an exceedingly rare Willem de Kooning painting from 1954, *Woman as Landscape*. It was rumored to be the property of the comedian Steve Martin, and its $9–$12 million estimate made it the most expensive work in the sale. Alas, there were no bidders and the work passed at a pathetic $4.75 million. An obligatory collective gasp rippled through the audience. I was doomed and I knew it.

Thinking fast, I quickly scribbled on one of my business cards "I'm the consigner of Lot #25, please lower my reserve to $75,000." Then I signed it and rushed it up to Mr. Burge's assistant, who nodded and handed it to him. Then the carousel turned to reveal my Joseph Cornell *Sun* box. Christopher Burge started the bidding at $50,000 and it kept climbing in $5,000 increments until it hit $95,000. Sensing the bidding had come to an end, he unceremoniously hammered it down. With the buyer's premium, its final selling price was $104,500. What a relief.

As for the sale's menu of Warhol paintings, it was tough sledding all the way around. A late colored *Soup Can* that had been screened in 1965 sold for $253,000 (est. $300,000–$400,000). The next Warhol, *12 Jackies*, couldn't find a buyer at $1.3 million (est. $2–$2.5 million). It was

followed by the multi-panel *The American Male: Watson Powell,* one of
Warhol's earliest commissioned portraits. Painted in 1964, the work
failed to attract any bidding and was bought-in (failed to sell) at $1.3
million (est. $2.5–$3.5 million). The auction experienced a "dead cat
bounce" when a nine-panel *Flowers* painting brought $473,000 (est.
$450,000–$650,000). Unfortunately, that night's selection of Warhols
ended on a down note, when a large *Mao* was offered to an indifferent
crowd and passed at $370,000 (est. $400,000–$500,000).

As I walked out of Sotheby's, drenched in perspiration despite the
air-conditioned auction room, I ran into the Los Angeles dealer Manny
Silverman. For lack of anything better to say, I asked him, "So how do
you think things will do in November?"

Silverman paused and then said something that chilled me to the
bone, "I don't know, but I hope they do *as well.*"

At that moment, I knew exactly what I had to do once I returned to
Los Angeles: find the right buyer for my gold "Fright Wig."

Having just sold the Cornell, the prospect of now having to sell my
Warhol painting was not only daunting, it was downright depressing.
Although the gold *Self-Portrait* may have been worth as much as
$100,000 at the market's acme, it was difficult to say what it was worth
now. Even though my Warhol had cost only $45,000, I could envision a
not-too-distant future where that might be all it was worth. While it was
bad enough not to have sold it at the peak of the market, it would be
even worse not to make a profit.

Although I knew that I was doing the prudent thing by selling, my
goal of owning a great Warhol may have suffered a fatal setback. The
hard-to-admit truth was that I lacked the cash reserves to hold on to a
painting that had suddenly become a questionable investment. I could
no longer afford the luxury of an ego-boosting trophy hanging on my
wall. All of a sudden, my long-term financial survival felt tenuous and I
wondered if I'd ever be in a position to buy a Warhol again. I was learn-
ing a tough reality about collecting: it was one thing to be enough of a
visionary to buy an undervalued painting and another to have the
wherewithal to hang on to it.

Soon after my sobering conversation with Silverman, I ran into
Allan Stone and asked him if he thought things were as bad as they

seemed. He replied, without the slightest tinge of sarcasm, "If you run out of money and all you have left is art, just remember—you can't eat art."

Back in Los Angeles, with Stone's words still ringing in my ears, I scanned my Filofax looking for a likely candidate for the Warhol. Despite my being in touch with many dealers who were interested in Warhol, virtually all of them were in the same boat—and the boat was taking on water. Most of the dealers I knew were heavily invested in the art market and the last thing they needed was another piece of inventory. I considered calling various collectors, but that presented a different set of problems; most of my clients were never interested in Warhol to begin with. The only person I could come up with approaching was a name from the past: Jack Glenn.

Years had passed since Glenn's offer to sell me works from his private "Warhol" stash. Even though we hadn't talked since then, I was aware that Glenn had acquired new financial backing. With nothing to lose, I made an appointment to see him. When I got off the phone, I walked into my living room to take one last look at my painting. "What a shame," I thought.

Later that day, I drove over to Glenn's with the gold "Fright Wig" sitting unwrapped on the seat beside me. At every red light I glanced at it, trying to convince myself that I was doing the right thing. Once I reached Glenn's, I walked in and found him sitting behind a desk, grinning.

"What have we here?" said Glenn, ever jovial.

I handed him the painting, which was in an exquisite hand-crafted frame. Glenn's face seemed to take on a golden hue as he bathed himself in the painting's 24-carat glow.

"Wow, it's a real beauty! Where did you ever get this?"

I went on to explain how I had acquired it from Judith Goldberg. I also mentioned that my research revealed that Warhol had painted only around a dozen of these paintings in the 12-by-12-inch format and that this was one of only two gold ones. By Glenn's anticipatory body language, I knew he needed little convincing.

"So, how much do you want for it?" he asked, rocking back and forth in his chair.

"$65,000, nonnegotiable."

Glenn immediately countered, "Would you take $55,000?"

Experience had taught me that someone will usually pay your price when they really want something. So, it was easy to say, "No."

"How about $60,000?"

"Sorry."

"Come on, Richard. You have to let me win once in awhile!"

"You're a nice guy, Jack. But if I can't get what I consider to be a fair price for my 'Andy,' I'd rather just hang onto it," I said, with full conviction.

"Alright—I absolutely love this painting—I'll take it! Let me get out my checkbook."

A minute later, I held a check for $65,000 in my hand, while Glenn continued to relish his new Warhol. Once again, I felt a surge of mixed emotions. I had spent two years looking for this painting and now, with the quick flourish of a pen, Glenn was able to acquire it in a matter of minutes. I immediately began to experience seller's remorse.

I thanked Glenn, went through the motions of suggesting that we get together soon for dinner, and drove straight to Santa Monica Bank to deposit my winnings. As I cruised down Sunset, I reminded myself that a $20,000 profit was a $20,000 profit, and I felt a little better. By the time I got a receipt from the teller, my mood had improved considerably. As disappointing as it was to give up the painting, I rationalized that it was only a tactical retreat until conditions improved.

The next day, I began dealing with a new dilemma. About a month earlier, Jim Corcoran and I had made a deal to convert a building in Santa Monica that he had been using for storage into a small art gallery and office. My deal with him was disarmingly simple: in return for the use of his space, I would offer him a half-share of any blue-chip painting I found. If he turned it down, I was free to buy it myself. On the surface, it sounded like a win/win proposition.

Typically, nothing was ever that straightforward when I collaborated with Jim. Although I offered him several paintings that I thought had profit written all over them, a month went by without our concluding a deal. Meanwhile, I was enjoying my new space so much that I was kicking around the idea of doing a few exhibitions. With my current arrangement, I felt that I could experience the best of both

worlds. I could maintain an identity in the community by having a gallery while retaining my independence by not officially calling it one.

Despite Jim's consistent rejection of the paintings I brought to his attention, I continued to call him with potential deals. One afternoon, I phoned to see if he might be interested in an early Billy Al Bengston "Dento" painting.

Even though the tone of Jim's voice indicated he was in a bad mood, I couldn't delay asking him about a more pressing business matter. I said, "You know, at some point, we need to talk about how we're going to handle insurance on the space."

"Oh, so now you expect me to cover the insurance. Is there anything else I can do for you?"

I decided to let it go. It was obvious that after only a month, Jim was becoming disenchanted with our arrangement. His hostility was evident a few days later, during one of our frequent early-morning runs. We had just passed the Shangri-La Hotel when I mentioned that I was holding off on doing an art fair because I didn't need another expense.

Jim looked at me, full of loathing, and said, "Why are you so worried about money? You're not paying any rent."

"Fine," I retorted. "If you're really that unhappy with our deal, maybe I should just give the space back to you."

We had been jogging down the palm-lined path on Ocean Drive in Santa Monica when Jim took a quick left. We darted through a tunnel to continue our run along the ocean. Surprised that I might be willing to walk away from our deal, Jim calmed down and said, "Look, I'm not kicking you out but I want you to start paying rent."

I didn't say anything. I had been quite satisfied with our arrangement, and had Jim been more responsive to my frequent offers of paintings, I believe he would have been satisfied too. On the other hand, I was growing increasingly tired of his sniping at me—the spirit of goodwill between us had evaporated. As we picked up the pace, I looked down at the waffle imprints made by my running shoes on the smooth hard-packed sand. I decided at that moment that it wasn't worth ruining a friendship over a space. Life would go on and I would simply pursue being a private dealer.

As I was about to announce my decision to abandon our joint enterprise, Jim caught me by surprise, "Hold up for a minute. What do you say we go for a quick swim in the ocean?"

Looking at the three-foot waves, as well as anticipating the cold water of the Pacific on my skin, I said, "No, thanks. Why don't you go and I'll wait for you."

"Come on. Have you ever been in the ocean before?" he teased.

"Yeah, but I'm not in the mood."

"I'm telling you, it's really refreshing after a run."

"I'm sure it is, but I really don't want to."

"Tell you what, if you go in the water, I swear I won't bug you about the rent again."

Now here was a new one. I said, "Do you really mean it?"

"You bet."

Not sure if I was being set up, I said, "Fine—I'll do it."

With great reluctance, I walked over to the ocean's edge. As the remnants of a small wave lapped up on the shore, I stuck my hand in the water and felt its icy grip. I thought to myself, "Do I really want to do this?" But the lure of no longer being under Jim's thumb proved too powerful. At this point, Jim was body surfing about twenty feet from shore. He caught my eye and waved vigorously for me to join him. It was now or never. I slipped off my Nikes and Pep Boys T-shirt, let out a samurai scream, and charged into the approaching surf.

The water was beyond cold, but after a few seconds, my body began to adjust. I hated to admit it, but once the initial shock wore off, I actually began to have fun. In the distance, I caught sight of a few brave surfers, insulated in black neoprene wetsuits. I swam around for about ten minutes and then slowly made my way to shore. Jim was already there, using his shirt to towel off.

"That felt great!" I said.

"Did you see those dolphins out there feeding? Boy, the bite's really on today!"

I never saw any dolphins but figured it was wise not to challenge Jim.

With that, I headed back to my apartment and Jim went over to his place to change. Later that day, I realized that I needed to borrow a Peter Alexander painting from him to show a client. I walked into the

Corcoran Gallery, past a snoozing dog as well as Squid, who was fiddling around with a plunger. I ignored the gallery's exhibition and found my way back into Jim's inner sanctum. His door was closed, so I figured I had better knock.

"Who is it?"

"Jim, it's me. It's Richard."

"Oh, good, come on in."

Jim was reading a copy of a biography of Sonny Liston that I had lent him.

"Listen, we need to talk about something," he said, in all seriousness.

"What's that?"

"When are you going to pay your rent?"

HOW TO BUY ART

CHUCK ARNOLDI WAS SITTING around his deluxe Malibu digs with a group of friends and supporters. Among the crowd was the dealer Fred Hoffman, the architect Frank Gehry, and Chuck's wife, Katie, a body-builder and novelist. Inevitably, the discussion turned to Chuck's career.

Katie spoke out, "I don't understand why there isn't a myth that surrounds Chuck—like Jean-Michel Basquiat."

"Tell you what, Katie," interjected Hoffman. "Give me a couple of days and I'll work up a script."

What Hoffman may have known, but wasn't willing to acknowledge, is that myths can't be artificially created. In the world of postwar art, there have been only two artists with legitimate myths, Jackson Pollock and Andy Warhol, along with one who was well on his way to developing a myth, Jean-Michel Basquiat. Thanks to a combination of talent, timing, personality, looks, and lifestyle, both Pollock and Warhol had become part of the greater popular culture; their celebrity had transcended the art world.

Clearly, Chuck Arnoldi was a genuine talent, but how many lives take on mythic proportions? Pollock and Warhol were the exception. Of the two artists, Warhol's tale has been the most widely reported by the non-art world press. Yes, Pollock had his moment in *Life* magazine, as well as a film made about his story in 2000 (*Pollock*, starring Ed Harris). But Warhol? It just went on and on. Whether in music, fashion, or art, even

during the deepening recession, his name recognition continued to expand exponentially. His legacy and influence had come to resemble that of the Beatles.

That being the case, it came as a surprise to me that Warhol's prices were starting to sink. It wasn't just his less important works that were dipping, it was his full oeuvre. My decision to sell the gold "Fright Wig" was looking better and better. As 1990 merged into 1991, I was beginning to sense that the art market recession was going to be long and deep. I began to spend more time at home working on the phone, rather than traveling, in an attempt to conserve funds. One day, Jonathan Novak stopped by and noticed that I barely had anything hanging on my walls.

He observed, "You don't have any inventory."

I replied, "Pretty smart, huh?"

Though I may have felt smug about having sold my stock, the reality was that even without its financial burden, I was still concerned. Fortunately, I managed to retain a small core of loyal collectors who, even during hard times, remained insatiable buyers. One of the shining lights among my clientele was David Flaschen. The story about how he became a collector (though he would blanch at the label), was fairly typical of the art world.

One morning, back in the early days of Acme Art, an attractive brunette walked in with her decorator and introduced herself as Deborah Flaschen. Deborah was a Wharton-trained public finance investment banker who had achieved enough success to begin collecting art. Looking around, the two women expressed interest in purchasing a work by the young Los Angeles painter Jim Morphesis. The painting they singled out was a figurative work of a male torso richly slathered in thick oil paint and flakes of gold leaf. At $1,800, it was not exactly a major purchase, but at least it was a start. Although Deborah was tempted to make the commitment right then and there, she decided it would be prudent to show it to her husband first.

The following weekend she returned with David, whom she had met at Wharton right after he had finished a brief career as a professional soccer player. As I assessed David, I was impressed by his tall, athletic good looks, as well as his quiet, self-assured aura. At the time, he had already completed a stint at IBM and was an executive with Dataquest, a leader in marketing data analysis.

I assumed my art dealer persona and began to sell David on the joys of collecting contemporary art. Apparently, I wasn't doing a very good job because he appeared to be totally distracted. He did everything but yawn, and his bored expression seemed to say, "Just let me know when you get to the part about how much it costs and who I have to write the check to." Sensing that I had better get to the bottom line, I quoted him a price. We struck a deal and David left the gallery, relieved to be through with this minor ordeal.

Over the next six months, the Flaschens visited Acme Art three or four times. On two of those visits, they made purchases that once again totaled less than $2,000. But on the last visit, for some unknown reason, David began to perk up and ask serious questions—not so much about the specific works of art, but about the artists, their careers, and their markets. I sensed a transformation in David. I didn't know if he was hooked, but I was certain he was intrigued about why a couple hundred dollars worth of paint and canvas could drive people to distraction. To feed his curiosity, I gave him the book *Duveen*, which chronicles the colorful misadventures of the man generally considered to be the greatest art dealer of all time.

Sir Joseph Duveen was credited with turning many of America's early twentieth-century millionaire industrialists and entrepreneurs into serious art collectors. His flamboyant career was built on the simple premise that Europe had plenty of paintings and America had plenty of money. By introducing the two, Duveen set the stage for this country's golden era of art collecting. He is also credited with convincing his clients, such as Andrew Mellon, to donate their collections, thus forming the foundations of some of America's greatest museums—including Mellon's legacy, the National Gallery of Art in Washington, D.C.

Lia and I were later invited to the Flaschens' home for dinner. David couldn't stop talking about *Duveen* and continued to pepper me with questions about both him and the art market. He especially wanted to discuss the unprofessional behavior that he had recently witnessed when visiting other galleries. Naturally, I had a field day listing the assorted misfits in the art business and their counterproductive approaches. As someone immersed in the buttoned-down world of corporate America, he was simultaneously enraptured and appalled by what went on in my profession.

A bottle of Merryvale Cabernet later, David had become a convert. Even though Deborah had been the instigator, it was David who soon took the lead in their collecting activities. Though he and Deborah continued to add to their collection, they still did so modestly and with a fair amount of caution. Then, one day, all hell broke loose.

I was interviewed for an article on young collectors that was to appear in the *San Francisco Chronicle*. At the end of the interview, the reporter asked me if I could recommend a young Bay Area couple who were starting to collect. Naturally, I suggested that she contact the Flaschens. At first, they didn't want to participate. They preferred to maintain a low-key profile and valued their privacy. But somehow, I convinced them that doing the interview was harmless and would be a lot of fun. Reluctantly, they acquiesced to my request and invited the reporter over.

To their mild surprise, she showed up with a photographer. I guess the journalist must have been charming because the Flaschens agreed to pose for a photo. Two days later, the article appeared and it turned out to be a major half-page feature: "Yuppies Discover Art." It included a photo of a smiling David and Deborah, standing in front of a "space and light" painting by Eric Orr that they had purchased from me. The quality of the photo was fine. The problem was with the text. Not only was Deborah referred to as "Barbara," but their last name appeared as "Flasheon." Even worse, David was misquoted and came off sounding like a know-it-all. Later that day at Dataquest, he was subjected to some good-natured ribbing from his colleagues. Fellow executives kept asking him, "How's your wife, Barbara?" and so on. From that moment on, David became wary of the art world, pulling back from buying art.

About a year later, Lia and I met the Flaschens in New York, hoping to revive their passion for collecting. We visited a few artists' studios, including the atelier of the abstract painter David Row. The visits were enjoyable and went a long way toward restoring the Flaschens' faith in the art world. After they made a few inexpensive purchases, we decided to pursue some relatively big game: a Sean Scully pastel. Scully had emerged as the leading painter among a new generation of abstractionists who were influenced by the current spiritual godfather of abstract painting, Brice Marden.

The only problem with pursuing a Scully was that he was represented by one of the most high-profile dealers of the 1980s, Mary Boone. Much has been written about her dramatic personal style—her exotic Egyptian features, her Chanel wardrobe, her heavy attitude. But unlike many of her envious colleagues, she at least walked the walk. In the world of 1980s contemporary art, Arne Glimcher was the highest-grossing dealer on the primary market and Larry Gagosian was the king of the secondary market, but Mary Boone was the most influential dealer.

At the beginning of the decade, when art sales were moribund, Boone and her artists brought a fresh wave of energy and excitement to the scene. After years of minimalist abstraction, where the content of each painting seemed to be purely intellectual, she somehow sensed the timing was right to introduce artists whose paintings were laden with emotion and recognizable imagery. Thanks to Boone and the press she was able to generate, David Salle, Ross Bleckner, Eric Fischl, and Julian Schnabel quickly became stars.

Boone's artists became so sought after that she eventually introduced the concept of the "waiting list" for collectors not fortunate enough to be part of her inner circle. What's more, those who wanted to move up in the pecking order were supposedly pressured to buy works by Boone's less desirable artists (remember Michael McClard, Troy Brauntuch, and Gary Stephan?). If you did, when a work by the highly desirable Eric Fischl became available, you had a much better chance of being offered it. Boone's greatest coup was when she convinced Leo Castelli to corepresent Julian Schnabel and David Salle, thus giving them his royal seal of approval. The only downside to Mary Boone as a dealer may have been that, at least for a short period of time, she was a bigger star than any of her artists—and she knew it. Rumor had it that the main reason Julian Schnabel eventually defected from her gallery (to go to Pace) was that she received more ink than he did.

My only contact with Boone dated back to 1983, when she had just emerged as the new "Queen of SoHo." I clearly recall visiting her and the high-handed manner in which I was treated. Despite my punctuality, I was told to cool my heels at the front desk and was made to wait for an audience with Her Majesty. Looking around, I tried to say something complimentary to the snooty young receptionist. "I'm amazed at all the

attention your gallery has been getting," I said. "You must have the hottest artists in New York."

Looking at her young face, I couldn't figure out how it had already developed into a "farbissener punim," (Yiddish for prune face).

She replied, "Hot artists? I prefer to think of them as important. Referring to them as hot means they might cool off."

I was about to offer a snappy comeback when the phone buzzed to indicate Boone was ready to see me. The actual meeting with her was a letdown, and our conversation was unmemorable. What I do remember, though, is her desk, whose deep ebony surface was buffed to a mirror shine. Even better, all she had on her desk was a Rolodex, a sleek black phone, and a glass of effervescing champagne. I left the gallery that day more impressed by the thought and energy that went into her image than by her artists.

In 1991, times were different. Even though her painters were still in demand, their prices were on the decline. I made an appointment with Boone to show the Flaschens some Scullys. When we arrived, it was evident that times were tough because we were quickly ushered into the viewing room. The gallery itself was drop-dead gorgeous, easily the most attractive space in SoHo. Everything was perfect, from the floor-to-ceiling wall of identical black binders to the classic black Corbusier furniture, spaced carefully on a floor of smooth cream limestone. When it came to making a statement, Mary Boone was in a league of her own.

I cautiously introduced my clients to Boone by saying, "I'd like you to meet David and Deborah Flaschen, who are interested in exploring the possibility of buying a Sean Scully pastel."

Boone gave the Flaschens the once-over and said, "As you know, Sean's work is in very short supply, but you're in luck—I happen to have two wonderful pastels available."

An assistant appeared and spread the two drawings on a neighboring table. Scully's work is best described as rows of thick stripes, stacked both vertically and horizontally against each other. He's a strong colorist and has a particularly good feel for the pastel medium.

I looked over the two drawings and both were of good quality, though nothing out of the ordinary. If forced to assign them a grade, I would have given them a "B." Since each work was priced at $20,000,

they weren't outrageously expensive, nor were they a giveaway. The Flaschens studied the pastels carefully but said nothing.

I finally broke the silence by saying, "They're both very nice."

Ignoring the Flaschens, Boone turned to me and said, "Yes, but how do *they* feel about them?"

Trying to interject some sorely needed levity, I turned to David and Deborah and said, "So how do 'they,' I mean you, feel about the drawings?"

The two Californians looked at each other uncomfortably for a moment and then shrugged. Having known them for awhile, I could tell they were unimpressed. David had done his research and knew there were better Scullys in existence.

At that point, David turned to an increasingly disinterested Boone and said, "We're really looking for something a little more dynamic by the artist and we're willing to wait and be patient. If you get something in the future that you think is exceptional, I'd like you to send us a picture of it."

Knowing full well that she wasn't going to make a sale at that point, Boone smiled insincerely and waved for her assistant to remove the drawings. Just in case she was holding back, I asked her if there was anything else she'd like to show us. Boone shook her head and mumbled something about being busy and having to get back to work—as if what she was doing with us was of a different nature. Then the Flaschens went through the formality of saying that they looked forward to hearing from her, even though they knew they never would.

Once we had left the space and were standing on West Broadway, David and Deborah looked at me and began to laugh. Then Deborah smiled and said, "Now she knows how 'they' feel about the drawings." I had to laugh too, although I also felt embarrassed for both the gallery and the art business. Unfortunately, the Flaschens' experience was all too common.

Imagine looking at the art world from a collector's point of view. Let's say that you've decided to start collecting art and you know that you want to buy an Andy Warhol painting. Now what? It's not as if you can look in the Yellow Pages under "Warhol." Sure, with the emergence of the internet, you can type in the word "Warhol" and instantly receive hundreds of listings, but only a few of the listings will be dealers. And as

you begin to sift through the offerings, you realize that many of the dealers have only posters or other memorabilia. Sooner or later, you will need help—and that's when your troubles usually begin.

For the sake of argument, let's suppose you have a friend who's an established collector and he takes you under his wing. Your friend introduces you to a dealer whom he considers reliable. After a preliminary conversation with the dealer, he mentions that he has an Andy Warhol for sale. So, you set out for the gallery, meet the dealer, and he brings out his Warhol. It turns out to be a 5-inch-square *Flowers* painting, with fuchsia-colored flowers.

At this point, the following imaginary conversation might take place:

Collector: "Tell me about the *Flowers* paintings."

Dealer: "Back in 1964, Andy Warhol began a large series of paintings whose imagery was the most mundane that he could find: four pansies on a background of blades of grass. Many critics think that Warhol turned to the *Flowers* to take a visual break from his previous gruesome images of death and disaster. The *Flowers* were done in a wide variety of sizes, ranging from 5 by 5 inches all the way up to 10 feet square. There were also an astonishing number of color combinations."

Collector: "How many did he do?"

Dealer: "No one knows for sure."

Collector: "Well, could you give me an educated guess as to how many 5-inch *Flowers* he might have screened?"

Dealer: "It's hard to say. If I were to hazard a guess, I would say maybe as many as five hundred. But I do know that as the paintings got larger, the numbers got smaller."

Collector: "So, you expect me to buy a painting when I don't even know how many of them exist."

Dealer: "You shouldn't worry because each painting is one of a kind."

Collector: "How can this be if he used the same screen for each painting?"

Dealer: "Because of all the different colors or combination of colors. Even when Warhol repeated a color, the variation in how much ink he used gave each painting a unique quality."

Collector: "Alright, I'll accept your explanation—for now. Then which is the best color or colors to have?"

Dealer: "Virtually all of the 5-inch *Flowers* were done with a single color on a black and white background. With the larger *Flowers*, such as those that are 2 feet square, you want a painting with a green background and multicolored flowers—the more 'Pop' the colors, the more desirable."

Collector: "But you still haven't answered my question. Since I'm looking at a 5-inch *Flowers*, which is the most sought-after color?"

Dealer: "You want a painting with a bright color, rather than one with all white flowers. But if I were forced to choose, I would pick fuchsia."

Collector: "You're just saying that because your painting is fuchsia."

Dealer: "If you don't believe me, you can call around or I can show you the results from past auctions. But that would take a long time to assemble for you."

Collector: "Fine, I'll assume you're being straight with me. Can I see the signature?"

Dealer: "Sure, it's here on the back. However, I have to warn you that the signature is almost irrelevant. That's because Warhol sometimes didn't even sign his own paintings. Occasionally, one of his studio assistants signed his boss's 'John Hancock.' There were also instances of his dealer or even his mother signing paintings. What really matters is the work's history of ownership."

Collector: "So, what's this work's provenance?"

Dealer: "It came from the Ileana Sonnabend Gallery in Paris, which was the first European gallery to exhibit the *Flowers*."

Collector: "Alright, how much do you want for it?"

Dealer: "$15,000."

Collector: "But we're in the middle of a recession. That seems like a lot of money for an awfully small painting—where hundreds might exist."

Dealer: "The price is simply based on demand, and there are plenty of potential buyers for *Flowers* canvases. But the price is also based on auction history."

Collector: "Tell me what the last 5-inch *Flowers* brought at auction."

Dealer: "The last one brought $13,500."

Collector: "Then why am I being asked to pay over 10 percent more?"

Dealer: "I'm entitled to a profit. Besides, the last one that came up featured light blue flowers—nice, but not fuchsia."

Collector: "You've done a thorough job answering all of my questions. I'd like to buy the painting."

The problem with the above dialogue is that it's purely fictitious. Honest give-and-take discussions of this sort rarely take place. One reason why is that collectors often aren't informed enough to ask the right questions. What's more, many dealers aren't educated enough to provide accurate answers.

What usually takes place sounds more like this:

Collector: "Tell me about your *Flowers* painting."

Dealer: "It's over there hanging on the wall. What's there to know? It's a *Flowers* painting, it's by Andy Warhol, and it's only $15,000."

Obviously, this is an exaggeration—but not by much. The reality is that people like the Flaschens who want to develop into serious collectors often find that they're on their own. In the art market, there's no substitute for educating yourself. Learning about an individual artist's market requires a lot of hard work. In Warhol's case, to become a bit of an expert requires a Herculean effort. And even one of the world's leading Warhol authorities could still miscalculate his market—as he would soon find out.

17

PASSED

BY 1993, THE ART MARKET'S BARREN landscape began to resemble the land that suffered under General William Tecumseh Sherman's scorched earth policy during the Civil War. Auction houses were having trouble securing consignments, dealers were in desperate need of collectors, and artists were wondering how they were going to pay their studio rents. Caught in the middle of this debacle was Fred Hughes, the late Andy Warhol's business manager.

Having been recently diagnosed with multiple sclerosis, Hughes had begun running up serious medical bills. Even though he had been relatively well off, he was spending huge amounts of money on expensive treatments and live-in nursing care. Taking inventory of his possessions, he tallied some real estate, some choice antique furniture, and an art collection that included some Andy Warhol paintings. During Warhol's lifetime, people familiar with Hughes knew he had bought a few works directly from his boss, including a matched pair of portraits of Princess Diana and Prince Charles and a couple of blue *Jackies*. However, when collectors received their May 1993 auction catalogues from Sotheby's, it was apparent that Hughes had squirreled away many other Warhols. The reason for his secretiveness soon became obvious.

Even though I was temporarily off the hunt for a Warhol, I still closely followed the market for his paintings. When I opened the mail and slipped my Sotheby's catalogue out of its envelope, I experienced a minor thrill as I read the sale title, *Ten Paintings by Andy Warhol from the*

Collection of Frederick W. Hughes. As I flipped through the images, however, I couldn't believe what I was seeing: page after page revealed paintings that, to my eye, didn't appear to be finished.

The first offering, for instance, was *Troy Donahue (9 Times)*. The painting consisted of three rows of publicity headshots depicting the long out-of-fashion actor. The catalogue listed its measurements as 43 by 26 inches. Normally, a painting of this size and subject matter would easily justify its $150,000–$200,000 estimate. However, there was one little thing missing from the *Troy*—color. Hughes's painting was black and white, with pencil lines dividing each image and delineating where each color should have gone. Every other *Troy* that I had seen was colored with subdued reds, blues, and yellows. Sure, it was possible that Warhol's intention was to leave the painting in this raw state, but I seriously doubted it.

On the next page was a painting titled *A Boy For Meg*. Here, Warhol had hand-painted the front page of the *New York Post*, complete with a few headlines and "photos," including one of Princess Margaret. Looking carefully, it was hard to determine if this was a finished painting. But the next lot left no doubt in my mind. Just as the barren canvas of Troy Donahue cried out for paint, so did *Elvis (21 Times)*. It was as if Warhol had screened the singer's image without determining what colors to use to complete the work.

The next six pictures (also from the early 1960s) followed, for the most part, a similar pattern. Either they looked unfinished or they had been screened with way too much ink. Whichever it was, the Hughes Warhols looked like rejects. Of course, without looking at the back of the paintings, it was impossible to say what the artist's intentions had been. If the paintings were signed, it would have been one indication that Warhol had considered them to be finished to his liking. If they were mounted on old stretcher bars, that would at least indicate the work was stretched within Andy's lifetime. Only the very last painting in the sale, *Portrait of Princess Diana*, felt right.

As the other auction catalogues trickled in, I counted two additional Warhols coming up at Sotheby's, immediately following the Fred Hughes sale. The Warhol parade would continue the next night at Christie's with four more "evening sale quality" pictures. One thing was certain, the fate of these works would be determined by the performance of the Hughes offerings.

A few days before the sale, I flew to New York to preview the paintings. When I walked into Sotheby's, I immediately spotted a member of "The Long Island Ladies." This group of six middle-aged housewives played tennis in the morning and then took the afternoon train into the city to masquerade as private art dealers. All of them apparently came from affluent backgrounds, although you sensed that their husbands financed their art dealings just to get them out of the house. Bearing such names as Gerri and Pepi, they resembled a street gang. Like the "Crips" and "Bloods," who announced their affiliations by wearing either red or blue bandanas, the ladies could be identified by whatever was new from Escada that season.

I tried to avoid making eye contact, but it was too late—Ruth was on her way over. Ruth was the smartest one of the group; had they been an actual club, she probably would have been its president.

"Hi, Richard. So what do you think of the sale?" she said, with a nasal accent.

"I just got here and haven't had a chance to look around. But, I'll tell you, I'm awfully curious about Fred Hughes's Warhols," I said.

"I've already seen them. And from what I've heard, there could be problems."

"My take, without even seeing them, is that anyone who buys Warhol on that level knows what they're doing. The Bruno Bischofbergers, Thomas Ammanns, and Peter Brants of the world aren't going to just throw away their money. Besides, most of these paintings aren't in the Crone book." (At the time, this was the closest thing to a catalogue raisonné, a complete listing of an artist's production.)

"Really?" said Ruth. "I hope this doesn't ruin the Warhol market—I have a few small *Flowers*."

"They're safe. It's the upper-end stuff that I'm worried about," I said.

Grasping her hand to say goodbye, I fantasized about her crew having a secret handshake. I walked toward the auction house's main exhibition room. Sotheby's always hung the most valuable property on a long back wall that I had dubbed "The Wall of Honor." When I got within twenty feet of it, I saw all of the early Warhols and stopped dead in my tracks. The display looked like a mini-museum exhibition. Combined with the evening's other two Warhols, a *Tunafish Disaster* and a *Camouflage Self-Portrait*, they created a handsome overview of the

artist's career. But as I drew closer, the fraudulent qualities of the Hughes paintings quickly became apparent. I no longer had the slightest doubt that most of the paintings were unresolved.

I approached one of the guards and asked him if he could take the *Troy* off the wall so I could inspect it. He obliged, carefully putting on white gloves and then lifting the picture off its hanger. I requested that he turn the painting around and lean it against the wall. As soon as he did, it became clear that there was something fishy going on—the canvas had been uniformly stapled to brand new stretcher bars. Early stretched Warhol canvases were stapled haphazardly to bars of wood that looked their age. Alone, this irregularity might not have been enough to arouse suspicion, but combined with the lack of color, it spelled trouble.

I then asked the guard to remove two other Warhols from Hughes's trove, and once again the paintings had been freshly stretched. The canvases also bore faint horizontal creases from having been rolled up for a long time. I was going to ask Anthony Grant, the expert in charge, what he thought but I stopped myself short, realizing that it would have been futile to put him on the spot. The odd thing was that when I asked other dealers their opinion of the situation, they were reluctant to say anything on the record. It was as if we were all at a party and knew the hostess's slip was showing, but everyone was afraid to tell her.

A couple of nights later, I arrived early at the much-anticipated sale and ran into Jim Corcoran. I asked him to predict what would happen, but he wasn't in the mood nor was anyone else. A pall had settled over the room. Even the atmosphere during the disastrous May 1990 auctions had felt more upbeat. Auctioneer John Marion, who always wore his tuxedo well, announced that the sale would commence with property from the collection of Fred Hughes.

Like a children's merry-go-round, the well-lit stage carousel turned to reveal the first opportunity to grab the brass ring, lot number one, *Troy Donahue (9 Times)*. Marion opened the bidding at a modest $75,000, tried goosing it up to $90,000, and then, with a slightly perturbed tone, implored, "Are there any bids at $90,000? I'm going to sell this painting for $90,000. Anyone at $90,000? Selling now at $90,000— passed." Just like that, the gavel came down and the painting was

orphaned. It was Sotheby's worst nightmare: What if we gave an auction and no one bid?

The next lot, *A Boy for Meg,* came up and was quickly ostracized like a leper. Then it was *Elvis (21 Times)* that was humiliated. Three lots, three passes. After each failure, an audible chorus of groans came up from the audience. It was becoming clear that nothing might sell that night. Lots number four and five were placed on stage to face the firing squad. They too, were shot down. The next four paintings barely drew bids, or in some cases, remained virgins. Finally, lot number ten, a kitsch portrait of Princess Di that was signed, sold below estimate for $57,000. The boom in Andy Warhol paintings was over.

After pausing to regroup, Marion launched into the remainder of the sale. The overall results were mixed, but the other two Warhols went down without a fight. The sad thing was that the *Tunafish Disaster* was a great painting with a clean provenance. Ditto for the military green *Camouflage Self-Portrait.* I felt sorry for the consignors because they and their paintings deserved a better fate. As the sale ended, all I could think about was how the *New York Times* was going to spin what went down.

The next morning's paper reported that Andy Warhol had just experienced another fifteen minutes of fame, though the *Times* doubted it was of the sort the artist would have wished for himself. That night's round of sales, at Christie's, added more gasoline to the Warhol bonfire as all five of the evening's "Andys" went up in flames. Once again, each of the paintings was of high quality and impeccable provenance—there was nothing wrong with any of them. If the Warhol market had been buried the night before, that evening's sale had written the obituary.

As a long-time auction observer, I had never seen anything like it. The irony was that Fred Hughes, the man universally credited with building Warhol's market, had almost singlehandedly destroyed it. As the power behind the throne, Hughes certainly should have known better than to flood the market with dubious paintings. But it was obvious that he was desperate and simply did what he had to. One of the reasons for his drastic act may have been that the paintings were originally consigned to Bruno Bischofberger and exhibited at his Zurich gallery. The story circulating in the art world was that Hughes had received a sizable advance against anticipated sales. When none of the paintings sold, he

was still on the hook to repay the gallery. Needing to come up with the money, Hughes was forced to put the works up for auction.

And yet, perhaps equal blame for the catastrophe could be placed on Sotheby's not only for accepting works of questionable provenance, but also for accepting too many works by a single artist in a slow season. The sale raised valid questions about how responsible an auction house is or should be for an artist's market. Whenever something goes wrong, auction house executives are always the first to claim innocence. They clearly state that their only responsibility is to their stockholders. Their position is that they have nothing to do with either developing an artist's reputation or maintaining it—they are merely facilitators of sales. Unfortunately, their argument has no teeth. Auction house experts are fully aware that prices set for an individual artist at auction heavily influence the perception of everyone from collectors to curators.

Let's say that you own a gallery and that you are fortunate enough to discover an artist and promote his work to a point where he becomes auctionable. This is exactly what happened to the dealer David McKee. For many years McKee patiently exhibited the aforementioned painter Sean Scully and absorbed all of the associated promotional expenses. Eventually one of Scully's mature works appeared on the auction block and sold for a solid price. Once an auction house agrees to handle an artist, his work's liquidity is greatly enhanced. From that day forth, anyone who owned a Scully suddenly possessed a work by an artist with a meaningful secondary market.

Until an artist is accepted by the auctions, a collector who wants to resell a work by that artist is stuck with basically only one option—all you can do is consign the work back to the dealer who sold it to you. But that usually places you in a weak position; chances are that the dealer already has other works on consignment directly from the artist—at a full 50 percent discount. So unless you're an important customer of that gallery, it's not in their best interest to resell your painting and make a much smaller commission.

In the case of Scully, McKee had always made a concerted effort to keep his work out of the auctions in order to prevent speculation. Anyone who wants to practice arbitrage can buy up a group of works by an artist, put one up to auction, hire someone to bid it up past the high end of the estimate, and watch the value of his holdings by that artist

soar. The auction houses never care because they make their money from the premiums paid by the buyer and seller.

For years McKee, a rather stubborn, contrarian figure, was successful at keeping Scully's thickly painted striped paintings away from the clutches of the speculators, and you had to give him credit for finding only legitimate collectors to buy Scully's work. McKee was astute enough to realize that once Scully's paintings began to bring higher prices at auction than those charged by the gallery, his market would eventually suffer. The logic behind holding prices down is that it makes the work more attractive to serious collectors and museums. The minute an artist becomes too expensive, the pool of applicants for his work begins to shrink. Ultimately, an artist can price himself out of the market.

After the first Scully was sold at auction, McKee's stranglehold on his paintings began to loosen. Soon, major paintings started showing up regularly at auction and began to bring serious money. Paintings equivalent to those that the McKee Gallery was selling for $85,000 began to attain $150,000 and then $200,000 at auction. Even back in 1990, when collectors bailed on most artists, an untitled Scully painting brought in a record $341,000. Thanks to the auction juggernaut, McKee probably began to have problems with Scully himself. What happened isn't hard to figure out. You have to assume that the artist was tuned in to his rising fortunes at auction and chances are that he began to pressure McKee to increase his gallery prices.

Scully would have been painfully aware that even though his paintings were bringing record-breaking prices at auction, he wasn't sharing in the profits. The artist only benefits on the primary market when a new painting is sold. Trying to maintain his representation of Scully became a battle that McKee couldn't win. He was caught up in the new rules of the 1980s art market; the Castelli era of artist loyalty was over. Under the circumstances, McKee's careful orchestration of his star artist's career ended the only way it could. Scully left for potentially greener pastures with Mary Boone. Most likely he was enticed by promises of higher gallery prices that were more in line with his auction numbers.

It would be easy to blame McKee's loss of Sean Scully on the divisiveness of the auction process. But Sotheby's and Christie's have a valid

argument as to why they can't prevent speculation: if someone wants to support an artist's market to boost or protect the value of their holdings, what can the auction houses do? In theory, the speculator would eventually run out of funds; few people have enough money to support every work by a given artist that comes up to auction. The Warhol market was certainly a case in point. Too many paintings appeared at auction for any one individual to prop up the prices.

At this point, I was really concerned with whether the Warhol market was being "protected." I almost hoped that the collapse of the Warhol market might panic a number of owners into selling paintings at tempting prices—which improved my chances of buying a Warhol for myself. Clearly, there was an opportunity if I was willing to be gutsy. The problem was that I had been taught to "never catch a knife when it's falling." It was obvious that the art market still hadn't bottomed out yet. With such uncertainty hanging over my ability to make a living, I couldn't justify the gamble of buying a Warhol for my own enjoyment. It seemed wiser to wait until things began to improve and pay a little more, rather than try and time the nadir of the art market.

A few days after the Hughes sale, I left Manhattan thinking that if the recession grew any deeper, I might have to consider moving from Los Angeles to New York. It wasn't that business was so good in New York, but it was better than facing extinction in Los Angeles. It began to feel like the only hope of making a living in the art business was to move to its epicenter. Jim Corcoran was a step ahead of me—he had accepted a proposal to form a New York gallery with the collector Robert Mnuchin. He would soon be pulling up stakes from the sunny comforts of Los Angeles and relocating to the harsh reality of New York.

In the meantime, I continued to receive a steady stream of phone calls from collectors and dealers, either canceling deals or rejecting them. The last straw may have been an article I read about the closing of 25 percent of New York's galleries. Dealers interviewed for the article spoke longingly about the 1980s and questioned whether we'd ever experience another boom again. Others, ignoring the market's glory days, spoke about survival and questioned whether there was even a future to the art business. This was starting to get serious.

18

THE TREE COLLECTOR

THROUGH A BUSINESS ACQUAINTANCE, I was offered the rental of a condominium on the Upper West Side of New York. It turned out that the apartment was in a landmark building from 1925, known as the Level Club. The building's unusual name was derived from its previous history as a Mason's club—the carpenter's level was the club's symbol. Even though the neighboring Ansonia and Apthorp were better known, the Level Club was arguably the finest residential building in that section of town. The offer was well-timed and encouraged Lia and me to move to New York. In August 1993, we booked a moving van, packed up our household, and before I knew it, I found myself unpacking boxes on West 73rd Street.

The adjustment between life in Los Angeles and New York was far greater than we expected. Even our cat Magritte seemed discombobulated. At first, the only thing that unnerved me were the random deep-throated screams that punctured the night. I didn't mind the occasional blaring fire engine siren, indiscriminate dog barking, or incessant horn honking. But by our second week, life became unbearable as we found ourselves being awakened at 4:00 A.M. by the shrill grinding gears of a garbage truck. Less than fifty feet away, the Ansonia was undergoing massive renovations and each day's construction efforts produced at least a dozen steel containers of debris. Our neighbors told us not to worry—we'd get used to it.

But we didn't get used to it. I tried everything to block out the noise, from switching on classical music to sleeping with earplugs. Finally, when I couldn't take it any longer, I got up at four and went downstairs to try and reason with the garbage truck operator. Trying not to sound intimidated, I pointed at the Level Club and said, "Hi, I live over in that building. I know you have a job to do, but is there any way you could swing by on your route a little later in the morning, say six o'clock?"

The driver, wearing a navy blue Yankees cap and sporting two days' growth of dark beard, studied me like I was from another planet. "Is this some sort of joke? You're kidding, aren't you?"

Right then and there, I realized that I was way out of my element. I was no longer in California—that was for sure. "No, I'm not joking. You have no idea how *loud* your truck is. I mean, every single morning my wife and I are jarred awake and can't fall back to sleep."

Noticing that the driver had an earring and a short ponytail, I switched to a more low-key approach, trying to interject some hip jargon. "Look, if you can't make it with the sandman at night, your days are going to be pretty miserable."

By the expression on his face, I could see he was unmoved by my efforts to bond. Finally, going for broke, I said, "Is there any way I can offer you some money to make the Ansonia the last stop on your route?"

That got his attention. The driver started to loosen up and began to laugh. "You seem like a good guy, but I don't think you know who you're dealing with. The man who owns this company is currently residing in Joliet, Illinois."

Having seen the *Blues Brothers*, I was familiar with the formerly incarcerated character "Joliet Jake," so I immediately caught his drift. I knew this was a situation that couldn't be fought and I walked away feeling completely helpless. My only hope was that the Ansonia's construction would soon come to an end, but a meeting with the building's super disabused me of that notion.

Other than the chronic sleep deprivation, life in New York was certainly interesting. Though it was summer, the city's mugginess didn't bother me. In fact, in a perverse way, I actually enjoyed the heat and grit of city life. I didn't mind standing in a sweltering subway station waiting for a train that never seemed to come. Even when I splurged on a taxi,

the surly nonEnglish-speaking drivers never disturbed me. After growing up in the sterile suburbs of the Midwest, I welcomed the cacophony of sights and sounds as a taste of authenticity. I was gradually acclimating to my new urban life.

Surprisingly, I had never felt so alive. I had an affordable, luxurious apartment, my savings seemed adequate, and I had access to the greatest art scene in the world. Unfortunately, Lia didn't feel the same way. After a few months, she was already pressuring me to move back to California. The nonstop hustle and bustle of New York street life was becoming too much for her. When she arrived home one day, traumatized because someone had followed her on the subway, I knew our days of living in Manhattan were numbered.

After a long talk, we concluded that it would be nice to get out of town for a week and spend a little time in the Hamptons. Lia had never been there and was curious about its deep-rooted attraction for New Yorkers. I knew that the art scene migrated to its shores during the summer and was anxious to be part of it. I had heard all the stories about "Asparagus Beach," so named because everyone stood around like spears of that narrow green vegetable. And the Hamptons were already on my mind because the SoHo dealer Louis Meisel had invited us to his fiftieth birthday party in Sagaponack.

I called the Meisels to accept their invitation, rented a car, and we set out the next morning on the three-hour drive to the art world's summer playground. I was familiar with the horror stories about traffic jams that turned a mellow trip into a stressful "Are we there yet?" nightmare. The traffic gods were with us, however, and we arrived with a minimum of hassle. We cruised into town, checked into our motel, and changed for the Meisel affair.

Louis Meisel was one of those dealers unfairly labeled as crass and commercial. Sure, it was true that some of his shows were in questionable taste, but then again, even such high-minded galleries as Pace Wildenstein showed funky artists like Kiki Smith (jars labeled with body fluids) and George Condo (a Picasso wannabe). Meisel at least had the guts to stake out his territory and was willing to live and die by it. He had cornered the market on Photorealism, so named because its practitioners derived their imagery from photographs and created their subject

matter in a superrealistic style. Meisel had published several major books on the subject and represented the work of many of the movement's leading artists.

Most dealers took a more scattershot approach, but when you walked into the Meisel Gallery, you knew what you were getting. If you were interested in buying an exquisite Richard Estes painting of an urban landscape or a John de Andrea sculpture of a nude woman that was so realistic that you swore you saw her breathing, then you'd come to the right place. Due to his sense of purpose, Meisel was one of the happiest people I knew in the art business. He surrounded himself with works of art and collectors that shared his vision, and he could not have cared less what the rest of the art world thought.

Meisel also had a knack for real estate and was able to assemble a choice portfolio of SoHo buildings, as well as his postmodern Sagaponack farm house. The walls of its 6,000-square-foot interior were covered with his diverse collections. Taking a page from Ivan Karp's eclectic loft, Meisel and his wife, the artist Susan Pear Meisel, had put together a highly visual grouping of old lawn sprinklers, duck decoys, fish decoys, and bootjacks. There was also an appetizing swimming pool in the backyard and a neighboring sculpture field that he was in the process of developing.

Other than his son and his gallery, the real pride and joy of Meisel's life was his collection of trees. When we arrived at his house, the first thing he did was show us around the grounds. Meisel is a good-looking man of five feet ten inches with a trim build, a full head of dark hair enhanced by a crisp haircut, and roguish blue eyes. You could imagine that he'd been quite a lady's man before he was married. His most outstanding feature was his cocky personality, which stopped just short of being abrasive. Meisel talked so rapidly and with such passion that the listener was challenged to follow everything he said for fear that a momentary lapse in concentration would result in missing a critical fact. He didn't speak in Karp's unique patois, but instead came across as an enthusiastic college professor, eager to impart knowledge.

I pointed to a tree with a magnificent spread of purple leaves and asked, "Louis, what type of tree is that?"

He said, "Oh, that's the town's greatest example of a copper beech. Look at the size of this sucker! The crane operator who brought it in

said it weighed 60,000 pounds. Do you have any idea what that tree's worth?"

I honestly didn't. Until that moment, I had never thought of a tree as a valuable commodity. Before I could hazard a guess, Meisel answered his own question, "I could get $50,000 if I chose to sell it."

Shocked by the substantial number he had just tossed at me, I was intrigued enough to ask, "How do you go about collecting trees? They're not like stamps you stick in an album."

Meisel had been waiting for that question. "Trees are big business here in the Hamptons. We'll take a drive later and I'll show you some of the area's great specimens. Then we'll stop by Marder's Nursery. You'll be amazed at what they have for sale. When it comes to collecting trees, you apply the exact same standards that you do with collecting art. All of the same criteria are relevant: rarity, beauty, potential for apprecia-tion. At this point, I own hundreds of thousands of dollars' worth of trees."

My curiosity continued to grow. I asked, "What's the key to buying and selling?"

"Some of my best deals were made by driving around and making homeowners offers on trees that I spotted in their front yards. Another important factor in the tree business is finding a competent back-hoe operator who is skilled enough to extract the specimen without damag-ing the roots. It's impossible to save all of the roots, but if the operation is done carefully, the tree can be transported and then transplanted with a minimum amount of trauma. The whole process is a real art form."

"Imagine moving a sculpture that had to be kept alive," I mumbled.

We continued our survey of his prize collection of beech trees: a weeping beech, a fern leaf beech, a purple fountain beech, a columnar beech, and a European weeping beech. My favorite tree, however, was his monkey puzzle, a tree of Peruvian ancestry that was popular in old English gardens. After half an hour, I began to get a feel for proportion, configuration, and color. It really *was* analogous to looking at paintings. When we had completed our walk, we headed back to the house, where his birthday party was in full swing.

The pulsating sounds of calypso music resonated from a steel band. The mood was festive and the guests were swaying to the hypnotic rhythms. The sweet island sounds hovered over the bartender's whirring

blender. His potent tropical drinks, gushing with maraschino cherries and pineapple slices, added to the celebration's Caribbean theme. The barbecue pit was blazing, as the tangy aroma of jerk chicken perfumed the air.

The chief topic of conversation was equally spicy: a controversy over a neighboring home recently purchased by the adventurous collectors Donald and Mera Rubell, who were in attendance that day. The house's exterior was covered in a skin of corrugated stainless steel. Apparently, when the sun was shining, the reflections were literally blinding. One fanatical neighbor was worried that the intensity of the light reflected on a surrounding field of hay might set it on fire. When I inquired how the original owners had been able to get a building permit, I was told that the town had no architectural review board. Supposedly, the Rubells had offered to appease their neighbors by planting tall hedges around the house.

Meisel's birthday party was a heady mix of art world personalities. Among the guests was the ultimate Photorealist painter, Chuck Close— an artist who's broken the million-dollar barrier at auction. There was also a large contingent of Meisel Gallery artists who had showed up to honor their dealer. I kept thinking that Meisel really knew how to enjoy his life. As night began to fall, you could see faint traces of phosphorescent stars and an eyelash moon. I was enjoying a slight sunburn on my face —the day had been idyllic and I didn't want it to end.

We spent a few more days in town, exploring overpriced antique stores and bookshops, eating lobster rolls, and checking out a flea market. After a few days of this, I almost dreaded going back to the city—I knew Lia certainly did. The Hamptons way of life was addictive. As we reluctantly made the drive back to Manhattan, we hit a tedious traffic jam but made the best of it, our spirits still buoyed by a great week. Once we hit the turnoff to the city and heard the familiar honking and other annoying noises, I knew our short vacation was over. I also knew it was time to get back to work and try to generate some business. I was anxious to see if I could take advantage of all the gallery resources that were now at my disposal.

Before I could formulate a plan of attack, I received a call from David Flaschen, announcing his forthcoming visit to New York. He and his

wife Deborah had been living in London and were planning to spend a week in the states. When the Flaschens got into town, we met down in SoHo for a selective tour of the galleries. We began by looking exclusively at emerging artists, but nothing seemed to thrill them. As we walked up Prince Street for a quick lunch at Jerry's, David casually mentioned that he had just received a sizable bonus and was thinking of buying his first Mercedes.

I said to him, "Must have been a nice bonus. But if I had enough money put aside to buy a car like that, I know I'd end up buying a painting."

Between bites of a grilled chicken sandwich, David said, "Whose work would you buy, besides Warhol?"

"I don't know. It's such an abstract question until you actually have the money together. Who knows? Maybe a Bill Traylor. But speaking of Warhol, earlier in the week I was out scouting around and came across *the* quintessential 2-foot *Flowers* painting. I mean, this painting had everything—bright pinks, yellows, reds, and oranges on a rich green background. The screening was distinctive and it was in mint condition. I'll tell you, if business weren't so bad I would have jumped on it."

As we were leaving the restaurant, David said to me, "Where did you see that *Flowers* painting?"

"Oh. It's just down the street at Ivan Karp's."

"What did he want for it?"

"He quoted me $75,000."

"What did they cost in the 1980s?"

I thought for a moment and said, "They may have climbed as high as $250,000."

"Really? You know I'm not a Warhol fan, but since we're in the neighborhood, I'd love to see what the quintessential *Flowers* looks like."

"Sure. Why not?"

We walked two blocks down to O. K. Harris. Bypassing their featured exhibition, we made our way straight back to Karp's lair. Before even saying hello, David zeroed in on the *Flowers* painting, which was hanging to the left of Karp's desk. It wasn't easy, but I distracted David long enough to introduce him.

"Hi, this is David Flaschen and his wife, Deborah, who are visiting from London."

"How do?" was all Karp could manage.

Noticing the cigar firmly clenched in his fist, David said, "I see you're a cigar smoker—I've just taken up the hobby."

Karp perked up. "Really? Try one of these," he said, handing David a Cuban "Punch."

Delighted by Karp's friendly gesture, David began to loosen up. "I have to confess that I'm not much of a Warhol fan, but Richard spoke so highly of this painting that I had to see it for myself. To my inexperienced eye, it looks impressive. I'd like to know what makes this a great Warhol."

Relishing an opportunity to show off his knowledge, Karp explained, "I've always considered the *Flowers* to be remarkably subtle and effective. Believe it or not, this happens to be the very first *Flowers* painting ever sold, from the original 1964 show at Castelli. Right before we opened it to the public, Leo's attorney, Al Ordover, admired the series and asked me to pick out the one that I thought was the most successful. The painting that you're looking at is his."

"Do you know why he's reselling it?"

"He didn't share his reasons with me."

David turned to Deborah and said, "What do you think of it?"

"It would look better framed."

"No! That would be heresy!" shouted Karp.

"So," said David. "Richard told me that you want $75,000 for it."

"Not a penny less."

I was surprised that Karp was taking a hard line. I knew he lived to negotiate, so there couldn't have been much room in the deal. David didn't say anything other than to thank Karp again for the cigar. As we left the gallery, David turned to me and said, "I was just thinking. If I buy that car, I know that it's going to depreciate the minute I take possession of it. Then you have to worry about it getting dinged and all of the insurance and maintenance on it. You know what? Why don't you call Ivan later and see if he'll come down on the price. But even if he doesn't, I want to buy it."

Deborah looked startled. They had never spent more than $5,000 on a single work of art in their life. Now, out of the blue, her husband had quickly decided that he wanted to buy a $75,000 painting by an artist

whom, only moments earlier, he had admitted that he never cared for. I was equally stunned, yet pleased that David was willing to take such a great leap of faith.

When I got home that day, I called Karp to see if he'd take $70,000, but I was promptly turned down. He confided in me that he had promised the owner $70,000 and that he considered it "immoral" for him to make less than $5,000 on a deal of that size. When I informed David as to the situation, he agreed to pay Karp's price and worked out a small commission for me. I had to admit that I was envious. I would have given my eye teeth to have owned that painting. But having never before experienced such a drought in the art market, I was simply too paralyzed to make a move.

19

ART MARKET
JITTERS

BY DECEMBER OF 1993, it was becoming increasingly obvious that the art world was nowhere near climbing out of its funk. I had been in New York for almost five months and the only thing more depressing than my state of mind was my bank account. I had come to New York to try to salvage my career as an art dealer and instead I was doing even *less* business than I had been doing in Los Angeles. The only sale I had made during the last six months was a Richard Estes hyper-realist gouache of an urban storefront to Louis Meisel, resulting in a meager $4,500 profit. The thought of buying another Andy Warhol painting for myself was becoming a fleeting memory.

I decided to try a different tactic to jump-start my New York dealing career. I telephoned some of the better galleries with the hope that they might be able to use my services. Instead of being ashamed of looking for a job, I thought it might be a nice change of pace to actually work for somebody else. After years of worrying about running a gallery and all the responsibilities that went with it, I welcomed the idea of letting another person call the shots and worry about the overhead. The thought of a steady paycheck, however small, seemed like a novelty. I envisioned myself putting on a coat and tie each morning and then heading for work on the subway—like any typical New Yorker.

Unfortunately, times were tougher than I thought. I could find only two galleries in the entire city of New York that were looking to hire. In each case, after what I thought was a successful interview, it became

apparent that both galleries were looking for someone with a "New York Rolodex"—they wanted to hire a person with local connections. Even more disconcerting, as each meeting came to a close, I realized that I was more knowledgeable about the art world than my interviewers. I was overqualified and I knew it. Even though I was only thirty-eight, I suddenly felt much older.

After another week passed, I gave up on the concept of working for a gallery. I began to think less about making money and more about gaining experience that might prove useful down the line once the art market turned. Thinking back to the days of Acme Art, I realized that if I had to do it all over again, I would have gone to work for an auction house. Working in one of their Contemporary departments, I would have eventually met every major collector in the world. More importantly, I would have learned about what they were looking to buy, as well as what they had already collected. As anyone with even the slightest bit of perception knows, the key to the art business is knowing where the "bodies" are buried. The only place to gain access to that level of information is through a stint at Sotheby's or Christie's.

I had no idea whether the auction houses were hiring, but I decided to find out. One thing led to another and, through sheer persistence, I was able to land a meeting with Christie's president and chief auctioneer, Christopher Burge. I had disguised the reason for wanting to meet with him by saying that I had a plan that would "revolutionize" his Contemporary art department. With a come-on like that, how could he resist granting me an hour of his time?

On the day of the meeting, I put on my favorite Armani suit—though it was only Emporio Armani, as Jonathan Novak had once "thoughtfully" pointed out. When I walked into Christie's, I was greeted warmly by their charismatic doorman, Gil Perez. What made Perez special was the way he remembered everyone's name and welcomed them personally— which was impressive, considering the hundreds or even thousands of regulars. Whether you were a big player or small fry, he made every collector feel important. His graciousness convinced you that you were doing business with the right auction house. Reportedly, Perez was considered so valuable to Christie's image that he was paid $100,000 a year.

I intentionally passed by the receptionist's desk to swipe a couple of individually wrapped pieces of Swiss chocolate—another subtle but

memorable touch that Christie's used to distinguish itself. I was kept waiting for only a few minutes before I was told that Burge was ready to see me. I walked into his simply appointed office and was asked to have a seat. The only giveaway that he was the head of an auction house was a framed Christie's sale poster of the van Gogh painting *Portrait of Dr. Gachet*, the most expensive painting ever sold at auction: $82.5 million in 1990.

I studied Burge for a moment. He was in his midfifties, conservatively dressed, with a touch of staid British attitude. Once he started to speak, he was witty and had a delightful way about him. It was obvious that he was an elitist, but he'd earned his own stripes and still came across as approachable. I instantly felt a rapport with him.

Once Burge asked what he could do for me, I began my pitch, trying to sound authoritative. "I've noticed how the Contemporary art sales are becoming less contemporary. Do you realize that it's been forty years since de Kooning painted his *Women*, yet they're currently in the same sale as works by Basquiat? It just doesn't make sense. If you were to group the Abstract Expressionist works from the 1950s with the Pop works from the 1960s and the Minimalist works from the 1970s, you could call the sale postwar. Since works by the top artists from these decades have survived the test of time, it would make a powerful sale and probably add value to the paintings. They would be seen as classics. Obviously, works created during the 1980s feel more like art of our times. Works from that decade and, as time went on, from the 1990s would comprise the Contemporary sale."

Christopher Burge nodded politely after each of my points. Either this was a real meeting of the minds, or he already knew what I was telling him.

When he spoke, I knew it was the latter. "I agree with everything you've said. Lately, we've been thinking the same thing around here. But it would be more complicated to make these changes than you think. For instance, if we had a separate postwar auction, it would mean adding another evening sale to the calendar. How could we ask our clients, who come from out of town for sales here and at Sotheby's, to sit through a third night? What about all of the expenses involved in creating a new department? What if we decided to go forward with a postwar sale and Sotheby's didn't follow suit?"

Here was my opening. With complete confidence, I said, "Who cares about Sotheby's? Why not be the leader and be perceived by the collecting public as innovative? I know I've never worked for an auction house before, but I do know that the key to your business is obtaining property. Think of the possibilities of going to your potential consignors and telling them about this new department and how, with this new category, they're likely to realize higher prices for their paintings. What's more, I personally would love to work with you to help organize this department. I happen to know the material and the prices inside and out. I'd even be interested in training to become an auctioneer."

I could tell that Burge liked what he was hearing, but I could also tell that he was skeptical. Not so much of me, but of the headaches and costs of building a new department during such a bleak moment in the art market.

After listening carefully without interrupting, he said, "All of this sounds wonderful—it really does. The problem, and it's a very real problem, is that there simply isn't any money available to hire a new staff member. You've probably read that we've had to lay people off. I'm afraid this isn't the time to undertake a new adventure around here. I certainly enjoyed talking to you and wouldn't hesitate to hire you if times were different. But keep in touch—you never know what will develop."

Reluctantly, I rose from my comfortable chair and shook hands. The meeting was over and I was still without a direction. As I left Burge's office, I walked into the main salesroom and sat down to contemplate my future. My timing in moving to New York couldn't have been worse. There was precious little art business and no jobs. Even though there was plenty of talk that things would improve, I couldn't think of a single compelling reason why or when they would. I walked out of Christie's feeling completely discouraged.

In the following weeks, I continued to mope around. Then, like a lightning bolt out of the blue, I received a phone call from Chuck Arnoldi asking me to come back to Los Angeles to work as his business manager. The deal was straightforward. In return for helping him to arrange exhibitions and develop new markets for his work, I would receive a 10 percent commission on all sales from the studio and his

various galleries. In addition, I would be allowed to continue to privately deal works by blue-chip artists from the secondary market, from which I would give him a taste of the profits. When Lia heard the proposal, she exhaled and said she felt like "the cavalry had just arrived."

It was obvious that she wanted out of New York at any price and was contemplating leaving on her own even if I chose to stay. I knew that her unhappiness with life in the city was only the proverbial tip of the iceberg—I had to face the fact that my marriage was unraveling. Trying to put my relationship first, and realizing that I was running out of options, I agreed to Chuck's proposal. After only eight months, the New York experiment was over. We were moving back to Los Angeles.

I felt like that hapless skier in the opening credits of the old television show *The Wide World of Sports,* where a gargantuan weight lifter thrusting a massive barbell skyward represented the "thrill of victory" and an airborne skier experiencing a spectacular crash embodied the "agony of defeat." It was the first time in my life that I had tasted the agony of defeat. Between rent, buying new furniture, and other assorted expenses, moving to New York had turned out to be a $50,000 mistake—half my budget for the Warhol.

The day we resettled on the West Coast, I was thrust into my new position at the Arnoldi studio in Venice. Later that week, I treated myself to a new Honda Del Sol convertible, just to soften the blow of having to move back. Perhaps it wasn't the wisest thing to do since it was now early 1994 and the blue-chip art market was still moribund. And as bad as the market was for the high-end material, it was even worse for emerging and midcareer artists—like Chuck Arnoldi.

Along with the overall art market jitters, I felt like I had stepped into a parallel universe of uncertainty at the Arnoldi studio. Only months earlier, Chuck had abandoned his distinctive "Tree Branch" and "Plywood Chainsaw" works for the crapshoot of making traditional paintings on canvas. Unfortunately, when an artist is in transition, it usually follows that his work looks transitional (read: unsaleable). Since my income was tied to the number of Arnoldi paintings that could be sold, none of this boded well.

After only two weeks of trying to figure out whether there was a market for his latest paintings, I concluded that there wasn't much of one.

Years later, in 2001, Chuck would finally create an original body of hand-some abstract paintings, a number of which I proudly sold. But at the time, he was far from breaking through.

In order to stimulate business, we decided to hold an open house at the studio. This led to a few small sales, including one to Michael Crichton of *Jurassic Park* fame. Later that week, I had lunch with Chuck and the best-selling author at Chin Chin. I was fascinated to hear how Jasper Johns had once given Crichton a painting for writing the cata-logue essay for his Whitney Museum retrospective. Many years later, Crichton would turn down a rumored $5 million from Larry Gagosian for that same painting. While there is a history of artists rewarding writ-ers with paintings, this is the most lucrative exchange I've heard of.

Despite the occasional sale to one of Chuck's collectors, he was grow-ing increasingly frustrated that I wasn't developing new buyers for his work. Chuck would tell me that if I were a decent dealer, I wouldn't have any problem selling his abstractions. I would angrily counter by saying that I wouldn't have any problem placing his work if he produced some decent paintings. The relationship was rapidly degenerating and after a few more months of unproductive behavior, we were barely talking. Eventually, by mutual consent, we parted ways.

I didn't know what was next, but I knew that the art market would eventually right itself. It was just a question of whether I could survive another year of what had turned into a four-year war of attrition.

20

PRIVATE DEALER

AFTER THE ARNOLDI MANAGEMENT fiasco, I found myself gradually returning to the ways of the private dealer. Basically that meant working in the morning pursing potential art deals and taking the afternoon off to work on creative endeavors. Along those lines, I wound up taking photographs—Polaroids of television characters, to be specific.

To Lia's dismay, I would spend many contented hours in front of the television watching reruns of old black-and-white classics. My distinguished viewing list included *The Beverly Hillbillies, Leave it to Beaver, The Andy Griffith Show, Dennis the Menace, Superman, I Love Lucy,* and *The Three Stooges.* Whenever a scene flashed on the screen that appealed to me visually, I would shoot a Polaroid of it. Since I had my camera set up on a tripod, at the perfect height and distance from the set, it was a simple matter to use a cable release to snap away.

The magic of the resulting image occurred by using color film to shoot black-and-white imagery. The Polaroid would develop into an eerie blue-tinged image. Adding to the photos' *Twilight Zone* quality was the fact that the viewer could identify the character in the show but couldn't quite place him in any context. For example, isolating Curly making a wildly contorted face from having been hit on the head by Moe with a crowbar, gave the shots a familiar yet remote look. Maybe one shot out of ten captured the feeling that I was looking for. This made it a rather expensive pursuit, since the cost of film per picture averaged a dollar. At the peak of my obsession, I was probably going

through fifty shots a day. Although I had no idea what I would do with the finished photos, I was sure that at some point I would frame them and pursue a show. In the meantime, Lia would indicate, not so subtly, that perhaps my time might be more productively spent trying to deal art.

Deciding she was right, I began making calls. I spoke with gallerist Michael Kohn and heard that New York's second most important gallery (at the time), Gagosian, was about to open a West Coast branch. Once that rumor evolved into fact, a second rumor surfaced: the number-one gallery, Pace, was also planning to open a Los Angeles satellite.

The coming of Pace to L.A. was the ultimate confirmation that the city had arrived. The story line was that Pace's owner, Arne Glimcher, was spending an increasing amount of time in Hollywood producing and directing movies. He had already been credited with *Gorillas in the Mist*, where Dian Fossey saved the silverbacks. Now he had the *Mambo Kings* under his belt, the story of two hotshot Cuban brothers who come to America in search of show business fame. Through his relationship with the talent agent and major collector Michael Ovitz, Glimcher began attracting other collectors from the entertainment world. Glimcher's gamble was that these people were often too busy to run to New York to look at art. Now they could simply pop over to Beverly Hills between shoots and visit Pace for their art-buying needs.

On the surface, it wasn't a bad idea. Historically, the problem with owning a bicoastal gallery has been that successful individuals always insist on dealing with the owner—and the owner can't be in two places at once. The other issue is that West Coast collectors correctly perceive that when New York galleries send material to California, it is often inferior work that they can't sell in New York. Even though New Yorkers often think that their West Coast counterparts possess I.Q.s thirty points below theirs, you can only fool some of the people.... In addressing that concern, Glimcher pledged that Pace Los Angeles would only show superior work in their new program.

Glimcher meant what he said and decided to inaugurate his space with a highly prestigious show of portraits by Chuck Close. Through the courtesy of gallery director Marc Selwyn, I was fortunate enough to receive an invitation to the opening reception. When I heard that Glimcher had convinced the city of Beverly Hills to close off Rodeo

Drive and cover it with white carpeting, I knew this would be an event that the art community would never forget. Once the carpet was in place, a giant tent was erected and one of the country's glitziest streets was transformed into a tremendous block party.

And what a party! For openers, Glimcher offered plane tickets and hotel accommodations to any of the gallery artists who wanted to attend. Most took him up on it. As a result, New York stars Joel Shapiro and Jim Dine could be seen strolling through the gallery's vast space. Not only that, but the Regent Beverly Wilshire, directly across the street from the gallery, was festooned with four-foot-long banners, each emblazoned with a black-and-white image of a different gallery artist. I remember looking up at the face of the long-deceased Mark Rothko smiling benevolently down upon the celebration. Knowing his rigorous anticommercial stance, I wondered what he would have thought of the proceedings. There were also film celebrities wandering around, including Dustin Hoffman.

As for the food, the talk of the party was how Glimcher had convinced the celebrated restaurant Matsuhisa to cater the event—something they had adamantly refused to do before for *anyone*. There was a highly animated sushi chef with a maniacal grin slicing red slabs of Maguro tuna, an oyster bar with two rabid shell shuckers (who could barely catch their breath), and a table devoted to outrageous architectural desserts.

However, the show stopper was when Glimcher made his grand entrance holding hands with Julian Schnabel. Glimcher, tall and trim and dressed conservatively in a blue blazer, was positively resplendent as photographers' flashes illuminated the night. Schnabel played the role, with his T-shirt stretched taught over his broad chest, paint-splattered chinos, and deck shoes. The two appeared to be in love, and they were—with themselves. It was the most nauseating sight that I had ever witnessed at an art event—which is saying something.

I wasn't the only one who thought Schnabel had a bit of an ego problem—Andy Warhol thought so too. According to his *Diaries*, he was once at Schnabel's studio and overheard one of his secretaries say to him, "You can either see your editor at Random House at 2:44 and get out by 3:22 or at 3:46 and get out by 4:34,' and Julian says, 'I will take the 2:44.' It was the most pretentious afternoon I ever had."

With Warhol's observation about egotistical behavior fresh on my mind, I called Chuck Arnoldi. Even though I had stopped working for him, we still had an unresolved matter centered around a small Sam Francis painting. I never liked to leave deals in limbo. Chuck owned the Francis painting in partnership with Jim Corcoran and both of them wanted out of the deal. Somehow it was left to me to dispose of it. The Francis was minor, from an unimportant period, and quite unappealing. The only thing attractive about it was its price—they were willing to accept a modest $10,000 for it.

Sam Francis was a second-generation Abstract Expressionist, part of the wave of painters who followed Jackson Pollock, Mark Rothko, and Willem de Kooning. Francis came into prominence by painting floating islands of color that he often connected with drips and dribbled lines of paint. Unlike his peers, he left portions of the canvas blank, allowing the white gesso undercoating to show. The result was that the white sections functioned as shapes that played off the islands of color. These paintings, with their pleasing colors and lyrical brushwork, proved quite popular with collectors.

For about a month, I had been dangling Chuck and Jim's Francis for $15,000. I had a number of bites, mainly because of its scale—the artist had painted very few small canvases—but I was unable to conclude a transaction. That day, however, I had an idea. Sam Francis had recently died and his executors had formed a committee to sell off works from his estate. As everyone knew, Francis was prolific and there was, at least initially, plenty of work in his estate from which to choose. But the Francis team moved aggressively and within a short period of time much of the best work had been sold off.

I found a pay phone and made an appointment to visit the estate. On my way over, I stopped by the Corcoran Gallery to pick up the painting. I wanted the estate to help me establish what it was really worth. I had already received an estimate of $10,000–$15,000 from Sotheby's and was hoping the estate's opinion would support their appraisal. When I arrived at Francis's former studio in Santa Monica, the director took a quick look at the painting with admiring eyes. She pronounced it to be unusual but significant. Already, I liked what I was hearing.

Feeling encouraged, I said, "I'm glad you like it. What do you think it's worth?"

The director pulled out a piece of paper, which turned out to be some sort of price chart. She got out a yardstick, measured my painting, and then multiplied the square inches.

"Your painting is worth $75,000," she said, matter-of-factly.

A smile quickly broke out on my face. Here I had been desperate to sell it for only $15,000—I probably would have taken $12,500. Now she was telling me it was worth five times that.

Thinking fast, I said, "It's really worth that much? I'll tell you what, I'll sell you the painting for only $15,000."

The director looked at me like I was some kind of screwball. She then managed to stutter, "We don't buy paintings. We're only interested in selling works from the estate."

"I understand your mission, but if someone told me that I could buy a work of art for $15,000 that I knew was worth $75,000 and it was by an artist whose market I helped control—I think I would do it."

The director just glared at me. While I had to admit that I was being a real wise guy, I was still appalled by the absurdity of their "official" price structure for Francis paintings. Selling art by the square inch, regardless of quality, bordered on insanity. On my way out the door, I waved my hand in a mock salute. I then returned the unwanted-at-virtually-any-price painting to the Corcoran Gallery and washed my hands of the matter.

When I returned home, I got on the phone and booked a ticket to Chicago to attend the city's annual art fair. Hopefully, that would yield greater results than my futile attempt to sell the Francis. Outside of the Basel Art Fair in Switzerland, the Chicago Art Fair was the most important art exposition in the world and certainly America's premier showcase for Contemporary art. It was held every May at the picturesque Navy Pier. Everyone in the art world loved going to Chicago, probably because of the city's first-rate museums, significant architecture, and great restaurants.

A few months later, I arrived just in time for the fair's opening night vernissage. Collectors paid $150 per person to attend the kickoff party, with the money benefiting the Art Institute of Chicago. Serious benefactors were encouraged to come to an earlier preview, at $500 per ticket. In a hot market, dealers and serious collectors gladly pay the money in order to have first crack at the art. During the late 1980s, the market

was so strong that dealers literally begged for "set-up" passes from their exhibiting colleagues, so that they could sneak in early and buy things as they were being taken out of the crates. But in 1994, there was little urgency.

A friend of mine was currently exhibiting and was kind enough to give me an exhibitor's badge, allowing me to attend the early party. Wearing one of my favorite suits with a Warhol *Marilyn* tie, I took a cab down to Navy Pier and walked into a glittering array of party goers. The food was outstanding, the highlight being an enormous bowl of giant prawns. These were not the cheap frozen ones you find in most restaurant shrimp cocktails, but the real thing—fresh meaty Gulf of Mexico denizens that cry out for horseradish-spiked cocktail sauce and a squeeze of lemon. After eating my rightful share, I grabbed a glass of champagne and headed into the main exhibition space.

As anyone who has ever been to an art fair knows, in order to get anything out of it, you have to adopt a selective attitude. The danger to any fair goer is one of sensory overload—the highly contagious "collector's disease." A fair the size of Chicago contains over two hundred booths. If you figure that each booth averages forty works of art, the typical visitor is bombarded with over eight thousand images. If you don't look selectively, chances are that you'll walk out of the fair completely overwhelmed, with little actual retention. My approach is to make one pass on a given day, stopping only at those booths that are hanging works by the handful of artists on my shopping list.

Another downside to art fairs is their high risk/low yield profit ratio for exhibiting dealers. The average art dealer probably spends $30,000 to do the Chicago fair. Dealers opting for larger booths could easily invest $80,000. The biggest single expense is the rental of the booth itself along with all of the associated costs, including lighting and furniture. Every booth comes with three lights per wall, but both the fair organizer and the exhibitor know ahead of time that nine lights per booth are inadequate. As the exhibitor contracts for extra lights, the costs start to mount. Besides the booth, there is also the expense of shipping and sometimes crating the art (especially sculpture), plane tickets for principals and staff, hotels, meals, insurance, phone, and so on.

As a result, most exhibitors wind up pricing their inventory on the high side in order to recoup expenses. The problem is that most art

world veterans are aware of this, so they attend the fair prepared to bargain. My strategy as a previous exhibitor was to always take the first offer I got (if it was within reason). My logic was that people were easily distracted and if I didn't close the deal right then, there were at least 199 other competitors who might. As Charlie Cowles once described it, "Cash and carry—that's what an art fair is all about." When I was on the other side of the velvet rope and attended as a buyer, I knew how anxious dealers were to make back their costs, so I drove a hard bargain. The reality of art fairs is that participating dealers usually view them as loss leaders. The goal is to break even, while trying to meet one or two people who might develop into long-term clients.

From the vantage point of a collector, art fairs provide an opportunity to ask questions to their heart's content. For once, dealers are a captive audience. What's more, with so much invested, dealers can't afford to write anyone off, even those who ask ridiculous questions. Once in awhile, though, a dealer and a collector will come to loggerheads. One year, at the Los Angeles Art Fair, none other than Marcia Weisman approached the booth of Jeffery Thomas, Dennis Hopper's stepson. Thomas was exhibiting a rare Ed Ruscha print, *Hollywood*, which depicted the famous Los Angeles landmark in shades of violet and burnt orange. In typical form, Weisman had a large entourage of up-and-coming collectors at her heels. She was interested in buying the serigraph and asked, "How much is it?"

Thomas answered, "$45,000."

"What's my price?"

"$45,000."

Appalled by his unwillingness to extend a discount, given her unparalleled reputation in the community, Weisman said, "*Do you know who I am?*"

To which a totally clueless Thomas replied, "No. *Who are you?*"

Another memorable art fair episode was the time I approached the Swedish dealer Jan Eric Lowenadler about a price on a Warhol. He walked to the outside of his booth, looked at the piece in question, and screamed, "I'm buying and selling so many paintings that I have no idea what the price is!"

During the current fair, it wasn't long before I ran into Jonathan Novak. He was looking tan from a recent vacation in Hawaii and, in

contrast to most dealers, was having a good year. Jonathan, like myself, was in town hoping to add to his inventory. But unlike myself, he was staying at Chicago's finest hotel, the Four Seasons. I, unfortunately, was stuck at the Ohio House. This AAA-approved motel had gained notoriety for the frequent rat sightings in its parking lot. Since times were tough, I couldn't justify the Four Seasons' $300 per night rooms. The Ohio House weighed in at a laughable $69.

In reality, there was nothing wrong with the Ohio House. The rooms were basic but clean and it was located near the River North gallery district and its trend-setting restaurants. And given the state of the art market, people weren't asking as many questions about where you were staying; all of the perceived status requirements of the 1980s seemed to matter much less in the 1990s. The way I saw it, I was demonstrating great fiscal responsibility by lodging inexpensively. That said, had I been feeling flush, I would have taken the very first taxi over to the Four Seasons to join Jonathan.

The day after the opening night party, Jonathan invited me to his hotel to see his deluxe accommodations. When I arrived, I decided to check out the four-star hotel's amenities. While touring the spacious lobby, I passed by the concierge's desk.

"Hi," I said. "I just had a few questions about your hotel—for future reference, in case I want to stay here next year."

"Certainly," said the moderately attractive young lady, who was wearing a very businesslike skirt, jacket, silk blouse, and matching bow. "Are you in town for the art fair?"

"I am."

"Where are you staying?"

"The Ohio House," I said, with false pride.

The concierge looked like she was about to gag. "*The Ohio House?* Don't they have...rats?"

Trying to keep a straight face, I said, "Yeah, they do—but they're not very large."

The woman stared at me but couldn't tell if I was being serious. She opted for changing the subject. "Are you here to see a guest? If you are, the house phone is right over there, by that large crystal vase of flowers."

"Wow, those are nice flowers—the lobby at the Ohio House doesn't have any."

Recovering her sense of humor, she said, "That's probably because the rats would eat them!"

I went up to see Jonathan's suite, performed the obligatory ritual of "eating my heart out," and even commented that, unlike the Ohio House, his room didn't smell of disinfectant. Usually Jonathan was the eternal optimist. But despite the fact that he was doing better than most dealers, the down market was taking a toll on his psyche. He voiced his misgivings about the future and his concerns became contagious. I had come to see Jonathan hoping he would lift my spirits. Instead, after only an hour, I left the Four Seasons feeling more anxious than ever.

100 BENJAMINS

BACK IN LOS ANGELES, I was having trouble accepting the reality that collectors' lives would go on even if they didn't buy paintings from me. I felt powerless. Neither Lia nor I had the vaguest notion how to revive the art market which in 1995 was still underwater. It was becoming painfully obvious that something had to be done about our own business situation. After an intense conversation over a plate of herb-sprinkled french fries at Le Petit Four, we concluded that maybe it was time to move back to San Francisco and return to our art-dealing roots.

The art world's woes, however, couldn't disguise the fact that our marriage was also in trouble. After years of living and working together, we were starting to lose our identities. Our personal and professional lives had become so intertwined, that one night I got into bed, shut the lights, and asked Lia, "What should we do about that Hockney?" There was no point where our personal lives ended and our art dealing lives began. But perhaps the most divisive factor was our inability to make a living. If you're under constant financial duress, it eventually permeates every facet of your life. You lose all perspective. After many months of thinking that better days were ahead, I eventually gave in to the realization that maybe they weren't. With little to lose, we decided to move back to the city synonymous with cable cars and Dungeness crab.

After only three days of apartment hunting, we found a small one-bedroom in Pacific Heights with a magnificent view of the bay. We

signed the lease, made the move up the coast, and soon discovered that
things were no better between us. A change of scene was helpful but not
enough to compensate for fundamental differences. We told each other
that we wanted to go in different directions. But that wasn't really hon-
est. The truth was that we had grown tired of each other's acts. We
decided to split up after ten years of marriage.

Someone once said that through every breakdown there's a break-
through. Although I was depressed about the dissolution of my mar-
riage, I somehow felt optimistic that it would lead to a new direction in
my life. A year later, that was exactly what happened as I found myself
writing a series of books on the art market. The books, known as the *Art
Market Guides*, rated artists on a "Buy, Sell, Hold" basis—much like
stocks. The first one caused quite a stir and landed on the front page of
the *Wall Street Journal*'s "Marketplace" section. This, in turn, led to an
invitation to appear on CNBC.

As 1996 progressed, I could sense that the general economy was start-
ing to improve. After witnessing the success of the May 1997 auctions, I
decided I was ready to resume my search for the right Warhol. Only this
time around, my budget had been reduced to approximately $50,000.
Ironically, the amount I was ready to spend had more buying power
than my original $100,000 stake because prices had fallen by as much as
two-thirds since the late 1980 market peak. Now they were finally head-
ing back up.

I began calling some of my sources to notify them that I was back in
the market for a Warhol. A few days of calling around yielded nothing.
Then I got a call from D. J. Puffert, the king of Bay Area Arts and Crafts
dealers. Dennis John Puffert was his field's equivalent of Jim Corcoran—
extremely knowledgable and equally off-beat. Puffert could be described
as a forty-year-old Jeff Bridges look-alike. He was a bit blonder than
Bridges and a bit shorter. But when it came to telling stories, Puffert may
have been the better actor. Legend has it that Puffert was born on an
Indian reservation in Montana. Part of his myth is that he once lived on
a commune and had a daughter named Cinnamon, or Peppermint, or
something like that. I always suspected, though, that he made up most of
his stories just for effect.

"Are you still dealing Andy Warhol paintings?" asked Puffert.

"Sure am. Why, do you know of one?"

"Would you be interested in an *Elvis*?"

"You have an *Elvis*? *Come on*."

"Yeah. It's still rolled up inside a tube. Stop by my shop next week and I'll show it to you."

Recalling my experience with Jack Glenn, I thought, "Here we go again."

The following week, I took Puffert up on his offer. I crossed the Golden Gate Bridge to Marin County, marveling at the structure's red-orange color. Rumor has it that when the bridge was originally erected, the contractor painted it with an undercoating of rust-resistant primer. The color was so pleasing that they wound up using it permanently. When viewed against an azure sky and the green rolling hills of Marin, there were few finer sights in the Bay Area.

When I arrived at Puffert's Arts and Crafts Shop in Sausalito, I walked in and was greeted by Joia, his assistant, whose gorgeous long curly red tresses made her look like she stepped out of a British preRaphaelite painting. A few seconds later, Puffert himself came out from his office, holding a cardboard tube. Without saying a word, he casually slipped a rolled canvas out of the container, and sure enough, it was a silver *Elvis*. He spread it out on the floor and smiled.

The first words out of my mouth were, "You don't happen to know Jack Glenn, do you?"

"No. I can't say that I do," said Puffert. "So, what do you think?"

"I don't know what to think. Why don't you turn it over. Let's see if it's signed."

"It's not. In case you're wondering, I may take it as partial payment from a customer who bought a roomful of Stickley furniture from me. The customer claimed it once belonged to a Warhol studio assistant and also told me that I was taking my chances, since it hadn't been authenticated. But I was always a big Elvis fan, so I was open to the concept."

"If you keep the painting, what do you think you'd want for it?" I asked.

"I suppose I would entertain an offer of a couple hundred thousand."

I couldn't tell if Puffert was being serious, but his price was quite low—if the painting was authentic. At first glance, I had my doubts: I didn't care for the way it was screened. On top of that, I really didn't

have the energy to work through the process of putting together a deal, not to mention getting the painting approved by the estate. I thanked Puffert politely and told him that I couldn't afford the painting and that I did not have a client in mind for it.

Even though our Elvis deal didn't work out, a few months later a different Warhol deal presented itself. Puffert had met a collector who wanted to complement his Grueby pottery with works by Warhol. He suggested that the collector look into acquiring a portfolio of Warhol prints known as the *Endangered Species*. In 1983, Warhol painted a series of ten vanishing exotic animals, including the Siberian Tiger, Pine Barrens Tree Frog, Black Rhinoceros, and Bald Eagle. These were followed up by a group of ten prints depicting the same images. Both the paintings and the accompanying prints met with critical scorn. Although many thought the imagery was insipid, the work gradually found buyers. A number of prints were sold through natural history museums and wildlife organizations, who used them as fund-raisers.

Since Puffert convinced his Grueby collector to buy a portfolio, he had been kind enough to invite me to meet him at an antiques show to discuss a potential deal. When I arrived, he was busy with a customer so I decided to check out his booth. A careful perusal revealed an extremely rare mustard-color Teco-Gates vase. At the time, Teco ceramics were probably second in popularity to Grueby. The major difference between the two is that Teco was cast from molds and Grueby was handmade. Puffert was asking $10,000 for the vase—heavy coin for an Arts and Crafts pot.

Puffert invited me to take a seat at a Stickley table that formed the centerpiece of his display. In the middle of the table was a small ceramic frog that served as an incense burner. Puffert had once explained to me that one of the keys to having a successful fair was to make sure that your booth smelled good. I acknowledged this "progressive" touch while admiring the extraordinary piece of Teco. Puffert removed the pot from an oak cabinet and handed it to me for inspection. I carefully took the vase from him and began to caress its surface, reveling in its sensuous matte glaze. To the touch, the pot felt alive. The undecorated cylindrical form was perhaps 10 inches tall, with a mouth that resembled a milk bottle. What made Teco unique among potteries was that their ceramics felt contemporary while retaining a foot firmly in the past.

When I was through examining the yellow beauty, I handed it back to Puffert. As I did, I noticed that the older bespectacled dealer from just across the aisle was watching us. Puffert must have noticed too. Rather than place the vase back in the case for safe keeping, he moved the frog and put it down in the center of the table. Then he began concentrating on it like a witch doctor about to cast a spell. The neighboring dealer noticed and couldn't resist leaving his booth to get a closer look. He walked across to Puffert's venue and asked, "What type of vase is that?"

Puffert replied, with a fake Western drawl, "This here is what you call a piece of Teco, pardner."

The dealer responded, "You don't say. What's it worth?"

"100 Benjamins."

"Benjamins?"

"Hundred dollar bills—$10,000 if you can't do the math."

The dealer whistled respectfully and returned to his booth.

When he sat down, he continued to watch us with suspicion. Puffert took his index finger and began to jab at the top of the pot, tentatively first and then with increasing force. My eyes darted back and forth from the nosy dealer to Puffert. By the look on the rival dealer's face, I could see he was growing increasingly uncomfortable. He could tell that it wasn't a matter of whether Puffert would topple the vase, but a matter of when. Another few flicks of the finger and the pot came tumbling down. The dealer jumped up from his seat, hoping to witness an expensive accident. But nothing happened. Unbeknownst to the dealer, the table had a padded leather surface that protected the pot from breaking.

Puffert righted the pot and began to slap the top of it back and forth between his two hands. Without warning, he let it fall once more. The dealer became more alarmed. Then Puffert repeated the process, three or four more times. I felt as if I were in a bowling alley—the vase was getting wiped out like a tenpin. But still, the piece of Teco did not break. Finally, the dealer got up from his table and left the booth, returning with a member of the show management.

From the safe distance of his booth, the dealer pointed to Puffert and said, loud enough for us to hear, "This man is bothering me."

When Puffert heard this, he picked up the vase and began tossing it up and down and catching it with one hand, like a circus juggler warming up.

The show manager said, "I can't do anything about someone who wants to abuse his own inventory. Try not to watch him."

Puffert just grinned. I finally said to him, "I know of an *Endangered Species* portfolio that I could net to you for $30,000." Since I was paying $25,000 and it retailed for $35,000, I figured we could each make an easy $5,000.

Puffert said, "How's its condition?"

"Mint."

"Fine, I'll take it."

"Seriously?"

"Seriously. My client gave me permission to commit to one if I came across it."

I nervously looked Puffert in the eye. I wanted to trust him in the worst way. But before calling my source and agreeing to purchase the Warhols, I decided that I'd better put the set on hold and wait until I was paid. It turned out to be a good thing that I did— Puffert's check never showed up.

A few months later, I heard that Puffert had mysteriously vanished, leaving no trace. Apparently, his business had become overextended and his colleagues and clients began dunning him for the money he owed them. I heard that at the time of his disappearance, his debt was in the millions. As the story got out, a surprising number of people came forward and admitted that they were among his creditors. D. J. Puffert soon became the Arts and Crafts world equivalent of America's Most Wanted Man. Later, a rumor surfaced that he had become a landscaper, of all things. Another unconfirmed report was that he had met a wealthy older woman and was traveling around the world with her as a kept man. But to this day, there hasn't been a single confirmed Puffert sighting.

Not long after the aborted *Endangered Species* deal, in late 1997, I read an article about the Andy Warhol estate and began to think of them as a possible source for buying a painting. As most people know, Warhol left behind a considerable estate, comprised mainly of his own work. But there was also a wealth of collectibles. Warhol was an omnivorous pack rat: not only did he own a well-publicized group of cookie jars (including a rare National Silver Mammy), but also plenty of Art Nouveau and

Art Deco furniture, turquoise and silver jewelry, vintage watches, classic Navajo blankets, George Ohr pots, and cigar-store Indians.

Warhol had also acquired a substantial hoard of blue-chip contemporary works through trades with his fellow artists. Included in this group were major works by Twombly, Lichtenstein, and a poignant Basquiat portrait of himself and Andy. Perhaps the most intriguing work in the group was a David Hockney colored-pencil drawing of Andy in Paris, wearing a blue and red rep tie and looking very much the world traveler.

Back in 1988, Fred Hughes had arranged with Sotheby's to auction off Warhol's entire personal collection in a ten-day-long extravaganza. There was so much material that Sotheby's needed to print six individual catalogues to cover all three thousand four hundred lots, many of which contained multiple items. (One of the biggest money makers was the sale of over ten thousand slipcased groups of auction catalogues, at $95 a pop.) The auction was the largest in the history of Sotheby's, a meaningful statistic since the company is over two hundred years old. The results of the Warhol sale surprised even the most optimistic observers. A Cy Twombly "Chalkboard" painting was the most expensive individual item, selling for $990,000. The Hockney portrait of Warhol was sold to Steve Martin for a record $330,000. The entire sale brought $25 million, which was used as seed money to form the Andy Warhol Foundation for the Visual Arts.

While that sum was a nice place to start, the Foundation planned to derive the bulk of their money from the paintings that remained in Warhol's studio. There were also thousands of limited-edition prints and photographs. The Foundation hired Christie's to determine the value of Warhol's remaining art. Unaccountably, Christie's employed what they called a "blockage" discount, evaluating the estate based on selling everything in one fell swoop. Naturally, flooding the market with thousands of works by an individual artist would never have happened in the real world—it would have been suicidal.

A court case ensued that pitted Ed Hayes, the lawyer for the estate's executor (Fred Hughes), against the Foundation. Since Hayes's fee was to be determined by the value of the estate, the Foundation foolishly decided that it was in their best interest to receive as low an appraisal as

possible. Based on Christie's low-ball evaluation of the remaining Warhol painintgs, Hayes felt he was on the verge of being cheated out of his fees. The problem with the Foundation's line of thinking was that the Foundation was trying to devalue the work of the very artist whose financial legacy supported the organization. Their thinking was based on pretzel logic.

Christie's was forced to defend its questionable evaluation of the Warhols and hired its share of expert witnesses, including the venerable art dealer, Andre Emmerich. In court, Emmerich explained how the value of Warhol's work could easily go down, based on its "ephemeral" subject matter. He claimed that Marilyn Monroe and Elvis Presley, indisputable icons of popular culture, wouldn't endure and could easily be forgotten in years to come. All of this seemed highly unlikely, but as an expert being paid by Christie's, it wasn't too hard to figure out why he said what he did.

Hayes had hired Jeffrey Hoffeld, a well respected private dealer, to make his own appraisal of Warhol's work. Hoffeld's financial analysis was much more realistic. It didn't use the ludicrous "blockage" discount and was based more on what similar examples of Warhol's work had brought both at auction and in private sales. After much acrimonious testimony, the judge decided on a figure far closer to Hoffeld's evalua-tion than Christie's. The value of Warhol's work in 1994, not including his real estate, stocks, etc., was determined to be a little over $390 mil-lion. In spite of the Foundation's unprofessional behavior, the ruling ultimately worked in their favor—they were sitting on a goldmine.

I was aware that Vincent Fremont, who was appointed to handle the sales of all paintings, prints, photographs, drawings, and sculpture, had been selling off work on behalf of the Foundation over the years, but I correctly assumed that much of the best work had already been sold to long-time supporters and insiders. It wasn't until 1998, when I realized that paintings might be available on a case-by-case basis to people not as well known to the Foundation, that I began to consider the possibili-ties.

My hope was that I would have some credibility with the Foundation because of my favorable evaluations of Warhol's work in my *Art Market Guides*. When I called Fremont Enterprises, I was pleased to hear that Fremont was familiar with my guidebooks.

I then explained my request. "I would like you to consider selling me a painting for my own collection. I'm not planning to resell it. I intend to hang on to it—at least until my retirement."

Sounding cranky, Fremont said, "Well, what painting did you have in mind?"

"What's available?"

"I don't work that way. You need to decide which image or series you are interested in and I'll get back to you on availability."

Fremont had his reasons. He was astute enough to realize that the key to getting top dollar for his paintings was to create an aura of rarity. By never letting anyone know what remained in the estate, he kept people in the dark about how much or how little was left—or which images, for that matter.

Trying to interject some levity, I asked, "Are there any early gold *Marilyns?*"

"I'm not even going to answer that ridiculous question."

Feeling like a contestant on a game show, I said, "Alright, are there any *Lizes?*"

"Look, I'm not going to play twenty questions with you. Why don't you carefully think about what you really would like to own and what you can realistically spend and get back to me."

Not wanting to anger Fremont and blow my chances of getting a great painting, I agreed to do just that.

GREEN

"WE'RE GOING TO ROLL THE BONES!"

So said John Berggruen, the emperor of Bay Area art dealers.

It was 1997 and I was sitting with Berggruen and Jim Corcoran in Le Central, a French brasserie in the heart of downtown San Francisco. Earlier that morning, Jim had awakened me with a call from his hotel. "Listen, why don't you meet me at Berggruen's gallery at twelve—he's taking us to lunch." I hung up thinking, "This should be good."

When we first sat down at Le Central, the talk had immediately turned to women. Not business, not politics, and certainly not art. In fact, the topics of discussion that followed were so juvenile and the insults so nasty that I thought I was back at my fraternity house. Lunch was served and I tried to interject some serious art-dealing talk. But I was rebuffed with looks that said, "Let's not worry about doing deals, let's just continue to talk nonsense—it's more productive."

At one point, I casually mentioned to Berggruen that I was in the market for a Warhol. He responded that I was talking to the wrong guy because he wasn't a fan. His comment proved ironic because five years later, his gallery put on a show of Warhol's *Cowboys and Indians* series (created in 1986), which was possibly one of the least successful group of paintings he ever produced.

As the meal came to an end, our waiter sauntered over with the bill. My first thought was, "Boy, am I glad I'm not getting stuck with paying." Le Central wasn't Le Cirque, but it wasn't cheap either—particularly

with the wine Berggruen ordered. When the waiter placed a tray with a check in the middle of the table, I waited for Berggruen to reach for it, but five minutes passed before he casually scooped up the check. A wave of relief shot through my body. I relaxed and reflected on how entertaining lunch had been. Even though Jim and Berggruen were both ten years my senior and in a different league financially, I felt comfortable with them during those brief moments when the conversation turned to art. I started projecting that maybe now I'd be invited to hang out with them on a regular basis. I figured, why not? I had already done a number of successful deals with Jim. Perhaps my moment had arrived.

Berggruen held up the check and glanced at it. A fiendish grin crossed his face as he announced, "All right boys, we're going to roll the bones!"

Our waiter, who was hovering nearby, picked up his cue and appeared at our table with a well-worn leather cup containing a pair of dice.

Jim started laughing. I had a sneaking suspicion that the old adage was about to come true: there really was no such thing as a free lunch. I became slightly agitated and, trying to head Berggruen off, I said, "Now wait a minute. Jim said you were taking *me* to lunch!"

"Look Richard, if you want to play with the big boys, this is how it's done!"

Jim started laughing even harder. "Come on, Richard," he said. "You only have a one in three chance of getting stuck with the check!"

I was trapped. It wasn't the money, it was the…actually, it *was* the money. Here I was, sitting with two of the wealthiest dealers on the West Coast, and I was in danger of having to buy them an expensive lunch— *after they had invited me.* Somehow, it just didn't seem right.

My shoulders began to droop. All I could say was, "I have a bad feeling about this."

Berggruen went first. He rolled with great concentration, as if he were bidding on a Blue Period Picasso. Rather than watch the dice, I watched his face. As I stared at him, I saw his tightly pursed lips break into a broad smile. Berggruen had rolled a perfect twelve.

"Well, I know one person who's not going to be paying for lunch!" he crowed.

It was Jim's turn next. Unlike Berggruen, Jim was not the most demonstrative person in the world. Here was a man who was so unemotional

that when he was offered a slice of the highly desirable Joseph Cornell estate, he shrugged and told me it was no big deal. But now that something *really* important was at stake, he became highly animated.

Jim grabbed the brown leather cup, gave it a few good shakes, and tossed the dull white cubes onto the table. The dice kissed, landing with a soft click. Jim had rolled an eight—pretty good, but I still had a chance. Now it was my turn. My two competitors were mesmerized as I picked up the leather cup. They stared at me as if I was coming to bat in the bottom of the ninth with the seventh game of the World Series on the line.

I blew on the dice for luck and let them fly. I couldn't bear to look. While I never saw the contest as some sort of confirmation of my personal karma, I thought to myself, "There's no way I should get stuck paying for these two assholes." When I peeked, one of the dice had landed with two dots face up and the other was a snake eye. I had lost. It wasn't even close. With a worried look on my face, I grabbed the check to inspect the damage. All it said was $105, which seemed reasonable.

"That's just for the bottle of wine. Turn it over!" roared Berggruen.

I flipped the check over and, sure enough, the actual bill was closer to $305. All I could do was stare in disbelief. When the two of them saw the sour look on my face, they started carrying on as if something wonderful had happened. Lunch was over and I was three hundred dollars poorer.

Fortunately, I had more potentially lucrative opportunities to focus on. For one thing, I was still in the middle of negotiations with Vincent Fremont. I was having a difficult time deciding which Warhol painting I should ask him for. Given his prickly personality, I sensed that I would not have too many chances to voice my requests. I spent a lot of time poring through old Andy Warhol exhibition catalogues, looking at images that might trigger an idea. I was reluctant to ask for a work from a mainstream series since I knew it was already late in the game.

I began to take my search in a different direction. I tried to think in terms of work that might not be as well known to the collecting public. Maybe there were variants of important images that people weren't aware of. For instance, when I owned the gold *Self-Portrait*, I remembered that it was the only small-scale example from the series that I had ever seen. The more I pondered that painting, the more I realized how

much I missed owning it. There was something about the intense look on Warhol's face that I couldn't erase from my mind. Now if only the estate had one left....

I called Fremont. As usual I was put on hold. I could never tell if he was really that harried or if it was done just for effect. Finally, he took my call.

"Richard, I'm really busy. What do you want?"

Even though I shouldn't have been, I was thrown by his harsh greeting and it took me a moment to recover my composure. "I, uh, was thinking, or I should say wondering, if you have any small *Self-Portraits* available?"

"Which *Self-Portraits* are you talking about? I think they're all gone."

With nothing to lose, I said, "I'd love to own a small 'Fright Wig.' I know for a fact that he did some that were 12 by 12 inches."

There was silence. I had finally caught Fremont off guard. "What makes you think that I have one?"

"Years ago, I owned a gold example that was inscribed to one of Warhol's friends. My take is that he did a handful of them to give as presents."

"Let me do this. I'll be at the warehouse later in the week and I'll take a look around."

I got a kick out of that. How could he not know *exactly* what was available? There had to be a master computer printout of every single painting remaining in the estate. But I played along and said, "I appreciate it. By the way, I'm going to be in New York later in the week. Is it worth making an appointment to come see you?"

"Only if I have something specific to show you. I'll let you know. Listen, I have someone on the other line. I've got to go."

Feeling rushed, I said, "When will you let me know?"

"I've got to run."

With that, Fremont hung up. Although the conversation wasn't very satisfying, I sensed that I was on to something. Based on past conversations, I knew that if there wasn't a distinct possibility that he had a "Fright Wig," he would have immediately vetoed the idea. Feeling encouraged, I spent the rest of the day trying to line up appointments for New York.

When I arrived the next week, I became preoccupied with calling Fremont. Although we didn't have a formal appointment, I figured it was worth a spontaneous call to see if he'd show me something. I tried reaching him by phone, to no avail.

At that point, not knowing whether he would come through or not, I pursued a lead at the Gagosian Gallery. Knowing that they were handling a lot of Warhols for the estate, I thought it was worth a shot to see what they had available, although, even if I found something worthwhile, chances were that it would be priced too high for a dealer to buy. But you never knew.

I walked down Madison Avenue to the former home of Sotheby's, now the location of Gagosian. My hunch about Warhol availability paid off when I noticed two small "Fright Wig" *Self-Portraits* propped up on a shelf. One was red and the other was green. Only these weren't your basic "Fright Wigs"—they were negative rather than positive images. Andy looked demonic in both paintings. I didn't like either one enough to own, but recognized their resale potential—if the price was right.

Sensing my interest, the salesperson perked up and said, "So what do you think?"

"I'm interested. How much do you want for each one?"

Without missing a beat, he said, "$7,500."

I looked him in the eye but betrayed no emotion. Clearly, he had made a mistake—a big one.

"$7,500 each?"

"That's right."

My first reaction was to reach for my wallet and extract a check. This was crazy—they were worth ten times that. How anyone could leave off a zero was beyond me. Maybe each painting wasn't worth exactly $75,000, but they were in that vicinity.

But before I said, "I'll take them," I began thinking about the ramifications. Not only would the salesperson lose his job, but I'm sure that if I paid for the two Warhols and left the premises with them, Larry Gagosian himself would be after me. Although he was well connected, legally there wouldn't have been a darn thing he could have done about it. On the other hand, who knows what sort of grief the purchase would have led to. It wasn't that I was such a moralist—far from it. But somehow, I knew

this deal warranted taking the advice of those television commercials that preached to America's youth to avoid drugs: "Just say no."

Reluctantly, I said, "I hate to tell you this, but I think you just made a serious error. Why don't you check your records and call me later. If you still want to sell me the two paintings for $15,000, let me know."

The young dealer looked at me quizzically but said he'd look into it. Sure enough, within thirty minutes, I had received a message at my hotel. There had indeed been a mistake. His message also gratefully acknowledged that he owed me one—hopefully a big one that I could call in sometime in the future.

Emboldened by this close brush with a large profit, I called Fremont. Miraculously, I got through to him.

"Hey, Vincent. I'm in town and was wondering if you've given any further thought to my request?"

Fremont sounded nonplussed. "What request?"

"Don't start with me. All I'm asking is whether there is a small 'Fright Wig' available."

Fremont paused. I didn't know what he would say next, but I sensed that it would be definitive. "You're in luck. I saw one at the warehouse."

My heart started to race. Trying to remain calm without stifling my enthusiasm, I said, "That's great news. What color is it?"

"You want to know that *too*?"

"Oh, come on. Just tell me. Enough already."

"It's green." As Fremont pronounced the color, he drew the word out slowly for effect.

"Green sounds good to me. I'm afraid to ask, but how much do you want for it?"

For the first time, Fremont sounded serious. "I don't know. I need to check with the board. I'll have to get back to you."

"It would be great to know during the next twenty-four hours, since I'm already here in New York. If we can agree to a price, then I could stop by and hopefully buy it."

"Sorry. I won't be meeting with the board for another week. Your search for a painting will just have to wait."

23

DON'T DO ME
ANY FAVORS

DURING THE WEEK THAT I ANXIOUSLY waited in San Francisco to hear from Fremont, I tried to occupy myself with other matters. I had recently bought a copy of the catalogue from the Andy Warhol Museum and decided that I should take a quick trip to Pittsburgh to check it out. I figured I owed it to myself to learn all I could before making a decision on the Warhol painting I was going to be offered. But the more I thought about it, I knew I was rationalizing. The truth of the matter was that I just wanted to see a museum that housed seven floors of Warhols.

The new museum was founded in 1994 by three institutions: the Carnegie Institute, Dia Center for the Arts, and the Warhol Foundation. Despite all of the hoopla over the museum's formation, the decision to locate it in the artist's hometown of Pittsburgh provoked instant controversy. The majority of the art world felt the collection should be based in New York. Supporters of this plan pointed out that attendance would be far higher in New York than Pittsburgh. Since the art world was centered in Manhattan, how could Andy Warhol, a New York artist, not have his life's work displayed there? After all, this was to be the first • museum in the United States devoted to the work of an individual artist.

But the New York advocates were leaving out one crucial detail in their desire to see a museum built in their city: real estate. The Warhol Museum would need a substantial space in a decent neighborhood, and even if the money for it existed, the building might not. Because the New York logistics had proved too daunting, the committee decided to

buy a renovated industrial warehouse in Pittsburgh's downtown business district.

Although it was an unpopular decision, it proved to be a wise one. There was something about making a pilgrimage to Warhol's place of birth that felt right. The fact that you had to make an effort to get to Pittsburgh in order to see his paintings made the experience all the more worthwhile. Once you got there, you found yourself spending as much time as possible with the work—you wanted to savor it. Had the collection been in New York, given the city's vast wealth of art destinations, it would have been just another museum.

As soon as I arrived in the "Iron City," I caught a cab to the museum and found myself crossing into Warhol territory. Upon entering, I was confronted by a wall covered with matching pairs of 40-by-40-inch commissioned portraits. As I scanned the glamorous faces, I realized that the display was a reconstruction of the Whitney Museum's "Portraits of the 70s" show. It was as if Warhol's entire social universe was staring down on me. There were portraits of everyone from Halston to Paul Anka. Having missed the original Whitney show, I was delighted by the opportunity to experience a facsimile of it.

The portraits turned out to be just an appetizer. As I took the elevator up to each floor, the quality of the paintings got better and better. There were *Maos, Electric Chairs, Elvises, Marilyns*—you name it. There was also a room full of helium-filled balloons that Warhol referred to as *Silver Clouds*. Each balloon resembled a large metallic silver pillow, almost three feet long. The balloons were allowed to float around the room and visitors were encouraged to bat them around and interact with them. Here was Warhol at his most playful. The installation was designed to capture the lighthearted approach of the original exhibition at the Castelli Gallery in 1966.

Then I came to the floor that displayed Warhol memorabilia and source material for his silkscreens. The most fascinating thing I stumbled upon was a display of Warhol's time capsules. Periodically, he would fill cardboard boxes with the daily minutiae of his life. Warhol saved everything: postage stamps torn off envelopes, airline silverware that he swiped, gifts of clothing with his portrait painted on it, fan letters, autograph requests, and other correspondence (some of a highly personal nature). Once he had filled a one-and-a-half-cubic-foot box,

he would seal it for posterity—then start another box. The Warhol Museum owned more than six hundred of these monuments to obsession.

Another intriguing aspect of the museum was the display of photographs, taken by Warhol and by others who chose to portray him. Whether Warhol was a great photographer was debatable. Whether his photographs captured the cross-current of society and cultural figures of his times was indisputable. His black-and-white images were an uplifting nostalgia trip. From the height of the 1960s underground to the heyday of Studio 54, Warhol was able to document the zenith of each period because he was an active participant. Looking at these photos and a comprehensive selection of his paintings, I was hit hard by the enormity of Warhol's achievement. If there was ever any doubt that I was doing the right thing by spending what was left of my savings on one of his paintings, it was permanently dispelled.

I took the stairs down to the gift shop. As you would expect, the space was crammed with refrigerator magnets, towels, glasses, purses, and necklaces, each bearing a Warhol icon, such as a Campbell's Soup can. Business appeared to be brisk—Andy would have loved it. Once I left the store, I found myself back on the first floor, confronted by a canary-yellow *Self-Portrait*, a gigantic "Fright Wig." The painting was overwhelming in scale and physicality—I was stunned. Warhol's persona seemed to envelop the room. If the "Fright Wig" that Fremont was about to offer me contained just a fraction of this picture's sense of wonder, I would be fortunate.

I left the museum and flew home heavy with anticipation. It was finally time to get back in touch with Fremont. I had been thinking continuously about how much he would want for the *Self-Portrait*. Knowing that the estate intentionally kept their prices artificially low, I knew the quote would be favorable. Calculating the value of the painting was difficult because a 12-inch example had never come up to auction. An educated guess was that the painting was worth between $75,000 and $100,000 on the open market. If Fremont quoted me $55,000 or less, it was a done deal. Anything higher and I'd have to think about it more carefully.

After the usual litany of missed phone calls, we finally connected.

"Hi, Vinny. How are you doing?" I said.

"*Vinny?*"

"Just kidding."

"You better be. No one—not even my wife—calls me Vinny."

"Sorry. Anyway, can we once and for all get squared away on our Warhol deal?"

"What Warhol deal?"

Ignoring him, I said, "You were supposed to get back to me on the price of the *Self-Portrait*."

"I was? Oh, that's right. It's $50,000."

Not bad. Fremont had come through. Trying not to sound too thrilled, I decided to see if I could wrangle a small discount. "We're close. Pending seeing it in person, I'll commit to buy it for $45,000."

"Don't do me any favors. Do you know how many people are begging me for small paintings?"

Unfortunately, I did know. When it came to negotiating with Fremont, I had little leverage. My only strategic advantage came from knowing the value of silence. I patiently waited for him to speak again.

"Tell you what. You're in luck—the board is meeting this afternoon. I'll present your offer and see what I can do. Let me call you back around five o'clock."

As soon as I put down the phone, I began to fear that I had blown it. Maybe I was being greedy. After all, I knew that I was getting a bargain at $50,000. Yet, after all these years of negotiating on paintings, the process had become permanently ingrained in me. Then my panic attack escalated. What if the board said, "The hell with him—we'll sell it to someone more appreciative." Or what if they simply rejected my offer and didn't give me a second chance to accept their price? I tried to tell myself that everything was fine. Still, when it came to the art world, I knew how unpredictable things could be.

Later that day, I got the call from Fremont. I was so relieved to hear from him that I almost said I'd take it for $50,000 even before I listened to what he had to say. Disguising my fear, I said, "Hi Vincent. How'd we do?"

"We? Where do you get this 'we' from?"

At that point, I was completely unnerved. I opened my mouth to say that I'd gladly pay his price. But before I could speak, Fremont beat me

to the punch. "I'll split the difference with you. You can have it for $47,500."

"Done."

"You're buying it sight unseen?"

Recovering my bravado, I said, "Well, no. Why don't I come to New York next week to view the painting and assuming it looks good in person, we have a deal."

"Fine. My week is already filling up. Let's put something on the calendar."

We picked a date and time. As soon as I hung up, I booked my plane ticket. Then inspiration struck. I thought I'd invite my father to join me. I wanted to impress him by dropping approximately "fifty" on a painting that I was buying just for myself. My father, Bernie, readily agreed to fly in from Cleveland for the big occasion.

The week went by slowly. I couldn't stop thinking about what the painting would look like. Each day, I went through the mental gymnastics of preparing my response if the painting turned out to be only "good" rather than "great." Or worse, if the painting was somewhere in between. It was hard to believe, but my search for the right Warhol was entering its twelfth year. With prices rising and the estate running out of paintings, I sensed it was now or never.

Finally, I was back in New York on my way to Union Square and Fremont Enterprises. As my father and I opened the door to Fremont's office, we were greeted by the wild gyrations of Matilda, Fremont's dog. In contrast to Fremont's distant phone persona, on his home court he couldn't have been more forthcoming. While it was obvious that he had picked up some of Warhol's eccentricities, he had also absorbed many of Fred Hughes's gracious manners.

As we watched Matilda skid across the room's highly polished wood floors, Fremont turned his attention to my father. He put him at ease by offering him coffee and making sure he was comfortable. After a few moments of conversation, we went for a short walk to Crozier's warehouse for the grand viewing.

Fremont continued to flatter my father by asking him what he had done for a living (camera sales), where he had graduated from school (New York University), and how he was spending his retirement (mostly

aggravating my mother). Once we arrived at the cavernous art ware-
house, located in the heart of Chelsea, we climbed the concrete steps and
checked in with security. Although Fremont was a regular, they still
made him go through the motions of signing in.

As we rode the massive freight elevator up to the viewing floor, I said
to Fremont, wistfully, "It must be nice having everyone in the art world
pursuing you."

He half smiled and said, "We'll see who my friends are when I don't
have any paintings left."

The elevator came to a loud halt. With much effort, the elevator's
operator pried open its horizontal wooden gate with tooth-like vertical
slats. As it yawned, it resembled a giant mouth, ready to gobble up all
unwary buyers.

Even before I stepped out, I started obsessing. I knew that I was pre-
disposed to buy the painting. It was as if my entire validity as a dealer
hinged on acquiring the *Self-Portrait*. By doing so, I felt like I could
cleanse myself of every bad deal and missed opportunity. This was no
longer just about buying a Warhol.

Fremont led us into a nondescript medium-size room. The only fur-
niture in the space was a long black table and a pair of generic office
chairs. The ceiling was ringed with track lights. Even though the space
was set up to feel like a makeshift gallery, it felt more like a police inter-
rogation room. There was no natural light and precious little art-view-
ing ambience. Then I reminded myself that I was in a warehouse and
perhaps the austere surroundings were part of the psychology. You were
there to conduct your business and not waste anyone's time, least of all
Fremont's.

Finally, the moment of truth. In the center of the back wall, hung at
eye-level, was a small bright green painting illuminated by a pinpoint
spotlight. Warhol's face glowed like he was spewing radioactive isotopes.
I expected to see a warning sign asking us to don protective suits. As I
approached the painting, my heart sank. Yes, it was a genuine "Fright
Wig." However, it was one of those paintings where Warhol had pushed
a minimum of black ink through the photo-silkscreen—in common
parlance it was a dry screen.

This was exactly what I was afraid of. Sure, the painting was salable—
it wasn't as if it was awful. However, the image felt impermanent. A great

painting affects you like a tattoo—it penetrates every pore of your skin and is with you forever. This was not a great painting.

Noticing the disappointed look on my face, Fremont said, "What's the matter? Not good enough for you?"

Then he pointed at one of the black desk chairs on wheels and said, "Why don't you relax? Have a seat."

Reluctantly, I sat down and then Fremont started wheeling me around the room like I was a sputtering go-cart. I looked at my father and he looked back at me. You could tell he was unsure of whether this was some sort of game or if this was really how I conducted my business. Actually, it was both.

Feeling thoroughly pissed off, I started to get up. Then Fremont commanded, "Sit back down!"

I don't know why, but I obeyed him. As I did, my dad said, "Things have sure changed since I used to sell cameras."

Fremont spun my chair around so that I was no longer facing the wall. The Warhol painting was now behind me. Then he ordered, "Don't turn around until I tell you."

I listened to him remove the painting and then walk away. The next sound I heard was a key turning in a locked door. Fremont had descended into the bowels of the Warhol painting storage room. The identity of the room's paintings was unknown to everyone but Fremont and the board. Though a few dealers had tried to sneak in or coerce employees into revealing its contents, I didn't know of a single one who had succeeded. I figured Fremont had gone into his stash to offer me an alternative, perhaps a *Dollar Sign* or something else to ease my disappointment. Then the metal door clicked open and I heard Fremont walk over to the viewing wall and hang something.

"Alright, you can turn around."

Still seated, I spun around 180 degrees. At a distance, I saw another bright green *Self-Portrait*. I thought, "What kind of nonsense is this? It's the exact same painting." But as I wheeled myself closer, the features of Andy's face came into focus. Clearly, this was not the same painting. Digging in my heels to pick up speed, I kicked myself within six feet of the wall. Suddenly, the details of Warhol's face were razor sharp.

There, directly in front of me, was one of the greatest small "Fright Wigs" I had ever seen. Playing devil's advocate, I mentally compared it

to the gold one, the one I once owned, the one that got away. I said to myself, "It's wonderful, but it's not gold." But then I noticed something special about the green picture. Just as in the gold one, Warhol's likeness was crisply screened. But unlike the gold painting, where his face was surrounded by an unbroken sea of black, the right-hand side of this picture revealed a hint of green canvas. Apparently, the squeegee was eased across it with just a bit less ink. The gold version was created with mechanical precision, but in the green painting, because of the intentional imperfections, there was no getting away from Warhol's humanity. It may not have been more valuable, but it had more soul and was a superior work of art.

Fremont looked at me and said, "I hope you're satisfied. You know, if I never showed you this painting, you would probably have bought the other one."

He may have been right.

Pointing to the hanging painting, Fremont said, "I could have sold this one to anyone I wanted to. Just remember that."

I would never forget it.

APPENDIX:
COMPARATIVE VALUES OF
ANDY WARHOL PAINTINGS
DISCUSSED IN THIS BOOK

Indicates painting was bought and/or sold by the author
All works listed are acrylic and silkscreen ink on canvas (unless otherwise indicated)
Prices are based on high quality examples from each series of paintings
Valuations are based on auction price approximations

	MARKET VALUE IN THE YEAR MENTIONED	VALUE IN 2002
CHAPTER 1	2002	
National Velvet. 136 x 83 inches, 1963	$5 million	$5 million
* *Lobster.* 20 x 16 inches, 1982 Bought for $26,000 in 2002 Still available	$55,000	$55,000
* *Crab.* 16 x 20 inches, 1982 Bought for $25,000 in 2002 Still available	$55,000	$55,000
* *Sea Turtle.* 42 x 50 inches, 1985 Bought for $55,000 in 2001 Sold for $98,750 in 2001	$175,000	$175,000

CHAPTER 2	1986	
Last Supper. 40 x 40 inches, 1986	$15,000	$850,000
Statue of Liberty. 72 x 72 inches, 1986	$25,000	$650,000
Lenin. 72 x 48 inches, 1986	$22,500	$350,000
Liz (silver). 40 x 40 inches, 1963	$75,000	$1.5 million
Superman. 60 x 60 inches, 1981	$150,000	$1.75 million
Mickey Mouse. 60 x 60 inches, 1981	$150,000	$1.5 million
* *Dollar Sign.* 20 x 16 inches, 1981 Bought for $4,500 in 1986 Sold for $6,500 in 1986	$6,500	$45,000
CHAPTER 3	1987	
* *Self-Portrait.* 8 x 8 inches, 1967 Bought for $3,000 in 1987 Sold for $5,000 in 1987	$5,500	$125,000
O.J. Simpson. 40 x 40 inches, 1978	$50,000	$35,000
* *Mao.* 26 x 22 inches, 1973 Bought for $20,000 in 1987 Sold for $25,000 in 1987	$25,000	$450,000
* *Troy Donahue* (dark screen). 20 x 16 inches, 1962 Bought for $2,500 in 1987 Sold for $5,000 in 1987	$5,000	$85,000

CHAPTER 4	1987	
Jackie (blue, mourning). 20 x 16 inches, 1964	$35,000	$250,000
Mao. 12 x 10 inches, 1973	$20,000	$200,000

CHAPTER 5	1988	
Lavender Marilyn. 20 x 16 inches, 1962	$500,000	$5 million
200 One Dollar Bills. 80 x 92 inches, 1962	$750,000	$5 million
Marlon (Brando). 41 x 46 inches, 1966	$200,000	$3.5 million
Little Electric Chair. 22 x 28 inches, 1965	$50,000	$2 million
Shot Red Marilyn. 40 x 40 inches, 1964	$3.5 million	$20 million

CHAPTER 6	1988	
Brillo Box. 17 x 17 x 14 inches, 1964	$35,000	$150,000
Tunafish Disaster. 124 x 83 inches, 1963	$600,000	$6 million
Blue Electric Chair (diptych). 8 feet 9 inches x 6 feet 8 inches, 1963	$2 million	$10 million

CHAPTER 8	**1989**	
Campbell's Soup Cans (32). 20 x 16 inches each, 1962	$15 million	$50 million
Liz (blue). 40 x 40 inches, 1963	$750,000	$4.5 million
Blue Liz as Cleopatra. 82 x 65 inches, 1962	$1 million	$15 million
Elvis (single image). 82 x 42 inches, 1963	$500,000	$2.5 million
CHAPTER 9	**1989**	
Red Marilyn. 20 x 16 inches, 1962	$750,000	$5 million
Marilyn x 100. 6 feet 9 inches x 18 feet 7 inches, 1962	$3.5 million	$10 million
CHAPTER 10	**1989**	
Thirteen Most Wanted Men (single canvas). 48 x 40 inches, 1964	$400,000	$2 million
Marilyns. (portfolio of 10 prints). 1967	$500,000	$500,000
* *Fright Wig* (gold). 12 x 12 inches, 1986 Bought for $45,000 in 1989 Sold for $65,000 in 1990	$100,000	$350,000
Fright Wig. 22 x 22 inches, 1986	$150,000	$500,000
Fright Wig. 40 x 40 inches, 1986	$250,000	$1 million

Fright Wig. 80 x 80 inches, 1986	$650,000	$3 million
Fright Wig. 108 x 108 inches, 1986	$750,000	$3 million
CHAPTER 12 *Skull.* 15 x 19 inches, 1976	**1989** $30,000	$200,000
Hammer and Sickle. 30 x 20 inches, 1977	$45,000	$125,000
CHAPTER 15 *12 Jackies.* 60 x 64 inches, 1964	**1990** $1 million	$3.5 million
Campbell's Soup (colored). 36 x 24 inches, 1965	$250,000	$1.5 million
The American Male: *Watson Powell.* 128 x 64 inches, 1964	$850,00	$1.5 million
Flowers (9 panels). 66 x 66 inches, 1964	$475,000	$3 million
Mao. 50 x 42 inches, 1973	$350,000	$1.25 million
* *Fright Wig* (gold). 12 x 12 inches, 1986 Bought for $45,000 in 1989 Sold for $65,000 in 1990	$75,000	$350,000
CHAPTER 16 *Flowers.* 5 x 5 inches, 1964	**1991–92** $15,000	$30,000

CHAPTER 17	1993	

A number of Fred Hughes's Warhol paintings were discussed in this chapter, but they are simply too difficult to evaluate.

Portrait of Prince Charles.	$35,000	$100,000
50 x 42 inches, 1983		

Portrait of Princess Diana.	$60,000	$200,000
50 x 42 inches, 1983		

CHAPTER 18	1993	
Flowers (multicolor).	$75,000	$600,000
24 x 24 inches, 1964		

CHAPTER 21	1995–96	
Endangered Species	$35,000	$75,000
(portfolio of 10 prints), 1983		

CHAPTER 22	1997	
Cowboys and Indians	$30,000	$45,000
(portfolio of 10 prints), 1986		

Fright Wig (negative).	$75,000	$125,000
12 x 12 inches, 1986		

CHAPTER 23	1998	
* *Fright Wig* (green).	$75,000	$300,000
12 x 12 inches, 1986		

Bought for $47,500 in 1998
Still available

ACKNOWLEDGMENTS

I'D LIKE TO BEGIN BY SINGLING out Bonnie Nadell, of the Fredrick Hill/Bonnie Nadell Literary Agency, who offered representation and convinced me that the timing was right for a book about life as an art dealer (thanks also to her assistant Irene Moore). Next, Mark Magowan, formerly of Harry N. Abrams, Inc., deserves a tip of the hat for accepting my proposal. I would also like to thank Eric Himmel, Vice President and Editor-in-Chief at Abrams, as well as my editor there, Deborah Aaronson.

As anyone who has ever done any writing knows, one of the keys to a successful book are your "readers." Barnaby Conrad III distinguished himself in this category. He treated my book as if it were his own and his belief in this project helped keep me going during the inevitable tough times. Jonathan Marshall and Jeffrey Hoffeld were also committed readers and each brought a fresh perspective to the manuscript that improved it immensely.

In one way, shape, or form, the following individuals were supportive and I am grateful for their contributions: Amy Barach, Irving Blum, Dana and Rick Dirickson, Daniel Douke, Vincent Fremont, Joseph Helman, Bill Kane, Ivan Karp, Fred Kraushar, Toby Lewis, Jason McCoy, Louis Meisel, Martin Muller, John Ollman, Marlit and Bernie Polsky, David Rago, Gunter Stern, Allan Stone, Joe Wachs, and Matt Wrbican. Thank you all.

SOURCES

Alexander, Paul. *Death and Disaster*. New York: Villard Books, 1994.

Andy Warhol's Marilyn x 100. Auction catalogue, New York: Sotheby's (November 1992).

Armstrong, Thomas et al. *The Andy Warhol Museum*. New York: D.A.P., 1994.

Behrman, S. N. *Duveen*. Boston: Little, Brown and Co., 1972 (Random House, New York was the original publisher, 1952).

Bockris, Victor. *The Life and Death of Andy Warhol*. New York: Bantam Books, 1989.

Bourdon, David. *Warhol*. New York: Abrams, 1989.

Burnham, Sophie. *The Art Crowd*. New York: David McKay Co., 1973.

Colacello, Bob. *Andy Warhol Headshots*. Exhibition catalogue, Cologne: Jablonka Gallery, 2000.

Colacello, Bob. *Holy Terror, Andy Warhol Close Up*. New York: Harper Collins, 1990.

Conniff, Richard. "The Artful Auctioneer," *Smithsonian* (May 2002).

Conrad, Barnaby. "Los Angeles: The New Mecca," *Horizon Magazine* (January/February 1987).

Contemporary Art from the Collection of the late Edward Janss, Jr. Auction catalogue, New York: Sotheby's (May 1989).

De Coppet, Laura, and Alan Jones. *The Art Dealers.* New York: Clarkson N. Potter, Inc., 1984.

Diamonstein, Barbaralee. "Ivan Karp," In *Inside New York's Artworld.* New York: Rizzoli, 1979.

Geldzahler, Henry, and Robert Rosenblum. *Andy Warhol Portraits.* London: Thames and Hudson, 1993.

Fremont, Vincent. "Andy Warhol Portraits—A Recollection," In *Andy Warhol Portraits.* London: Thames and Hudson, 1993.

Hackett, Pat. *The Andy Warhol Diaries.* New York: Warner Books, 1989.

Haden-Guest, Anthony. *True Colors.* New York: Atlantic Monthly Press, 1996.

Hughes, Robert. "Julian Schnabel." In *Nothing If Not Critical,* New York: Penguin Books, 1990.

Loring, John. "Cornucopia in SoHo, The New York Apartment of Marilynn and Ivan Karp." In *Architectural Digest* (Jan/Feb 1979).

McShine, Kynaston. *Andy Warhol a Retrospective.* Exhibition catalogue, New York: Museum of Modern Art (1989).

Pincus-Witten, Robert. *Women of Warhol.* Exhibition catalogue, New York: C&M Arts, 2000.

Pop Art from the Collection of the late Karl Ströher. Auction catalogue, New York: Sotheby's (May 1989).

Rublowsky, John. *Pop Art.* New York: Basic Books, 1965.

Taylor, Paul. *After Andy: SoHo in the Eighties.* Melbourne: Schwartz City, 1995.

Ten Paintings by Andy Warhol from the Collection of Frederick W. Hughes. Auction catalogue, New York: Sotheby's (May 1993).

Tomkins, Calvin. "Raggedy Andy," In *The Scene,* New York: Viking, 1970.

Warhol, Andy and Pat Hackett. *Popism: The Warhol '60s.* New York: Harper & Row, 1980.

INDEX